A TRIBUTE TO
AN AMERICAN
ORIGINAL

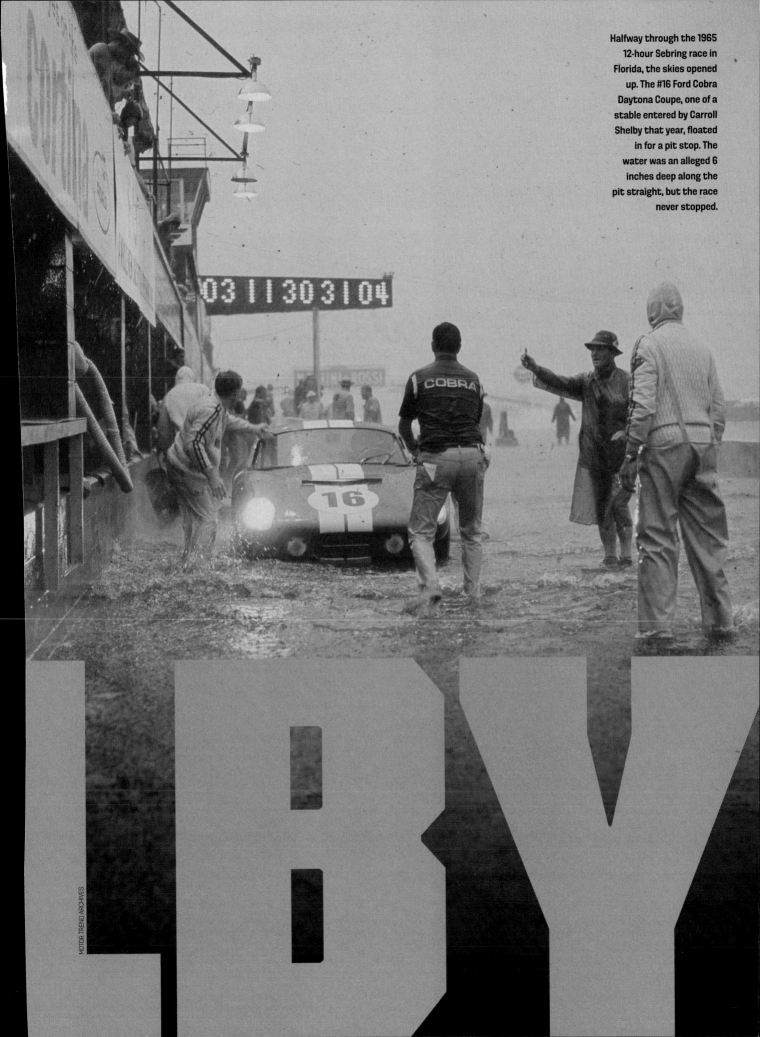

Halfway through the 1965 12-hour Sebring race in Florida, the skies opened up. The #16 Ford Cobra Daytona Coupe, one of a stable entered by Carroll Shelby that year, floated in for a pit stop. The water was an alleged 6 inches deep along the pit straight, but the race never stopped.

2

Shelby poses with a GT350R for a 1993 centerfold photo in *Mustangs & Fords* magazine celebrating his 70th birthday.

CARROLL

CARROLL

DRIVER
CARROLL SHELBY

Shelby prepares for his
final race as a driver at the
Los Angeles Times-Mirror
Grand Prix at Riverside
International Raceway
behind the wheel of a
Maserati Tipo 61 Birdcage.
He finished fifth, but had
enough points to win the
1960 USAC championship.

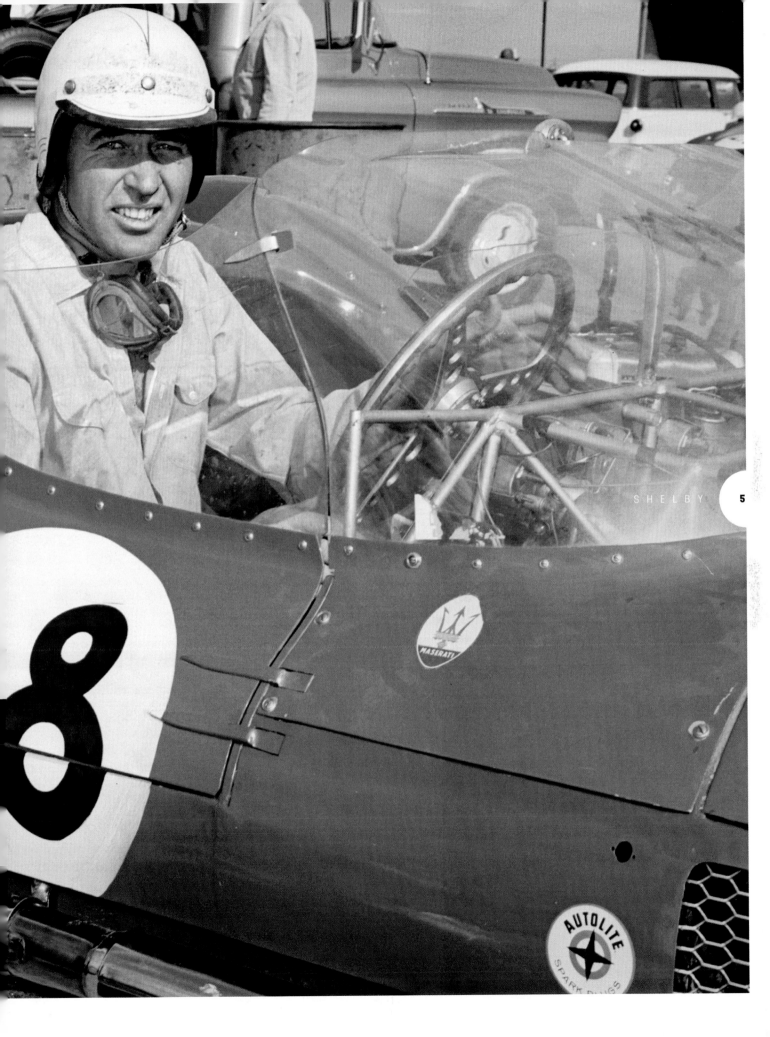

SHELBY
A TRIBUTE TO AN AMERICAN ORIGINAL

A portion of the proceeds of the sale of this publication goes to the Carroll Shelby Foundation

Some people say Carroll Shelby was a con man. But I say you're really only a con man if your product is no good. Shelby was a con man who just happened to have a great product. The classic example of this is when he repainted the same Cobra over and over to give the idea that he had a whole bunch of them. Is that a con? Well, it would be if the Cobra weren't a great car. But it was a great car. Shelby was just ahead of his time.

I've had my GT350 for about 30 years now, but I first met Carroll Shelby years ago as a fan, just someone who showed up at a Cobra meet. Over the years we became friends, and I'd see him from time to time at different car shows and events. We had a game we'd play: Every time I'd see him, I'd write him a check for the Carroll Shelby Foundation. It got to the point where I'd be at an event and would make sure he saw me. Then I'd go hide behind a tree or something. Shelby would call out, "Leno, I saw ya! You owe me a check!"

I'd say, "OK, OK, you got me!" and write a check for his heart foundation. That fun little game showed one of Shelby's many sides.

One of Shelby's greatest gifts was how he made speed and handling available at an affordable price. For example, the new Shelby GT500 has 662 horsepower—*662 horsepower*! To get that kind of power in a European sports car, you'd have to spend at least a quarter of a million dollars. But Shelby was all about bringing horsepower to the masses—to the guy who was willing to work on weekends and put his nose to the grindstone. Shelby made cars that were attainable, and that was part of his greatness. He had a common touch.

Who else would take a car like the Dodge Omni and call it the "Goes Like Hell"? I remember the day I picked up a copy of *Hot Rod* magazine that said on the cover "Omni GLH faster than Shelby GT350!" I bought the magazine, went home, and tore into it, because it just didn't seem possible. But it was. Shelby would take ordinary products and make them extraordinary.

Think about it: What other Mustang goes for $300, $400, $500,000 at auction? The one Carroll Shelby built. Is it that different from the standard Mustang? Not really; it's still a Mustang—OK, with traction bars, no rear seat, and few other hot-rod tricks to it. But if it didn't have Carroll's name on it, would it be a collectible car? Probably not. He had that magic—anything he touched became desirable.

That's why I don't think you'll see the likes of him again for a long time. I have always liked vehicles that are the product of one man's vision: Duesenberg, W.O. Bentley, Bugatti, Carroll Shelby. We don't seem to have those kinds of guys anymore. (Sure, we have people like Pagani and Koenigsegg, but they aren't making affordable supercars—they're making cars too expensive for even the average rich guy!)

The car business has become so complex, so governed by rules and regulations about what you can and cannot do, that the idea of one person overseeing a vehicle, putting his name on it, and selling it—well, I wouldn't say it's over, but I don't see it happening anytime soon.

But Carroll Shelby built his car, he raced his car, then he went out and sold his car. And afterwards, he'd shake the hand of the guy who bought it. That's what he was: not a con man, but a great showman, full of blue-collar bravado and that classic American can-do spirit. He was a hot rodder who took on the best in the world.

He was an American icon.

Jay Leno June 2012

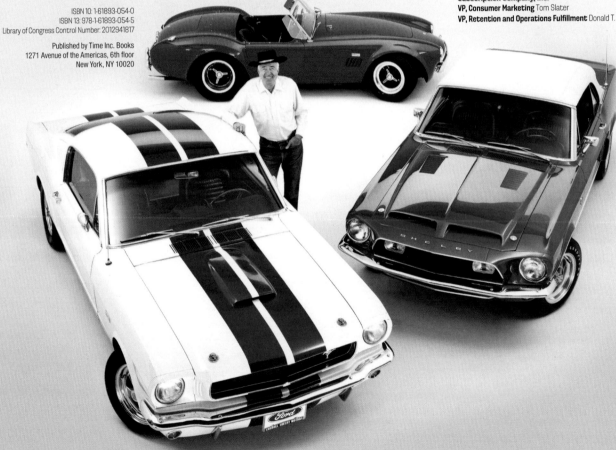

MOTOR TREND ARCHIVE

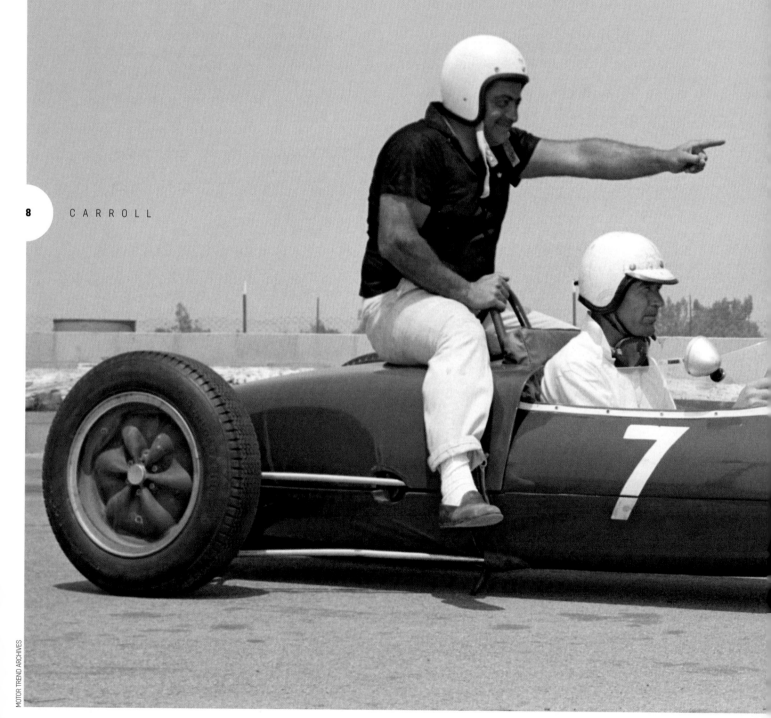

COVER PHOTOGRAPHS EVAN KLEIN / ALLEN R. KUHN / MOTOR TREND ARCHIVE

Chef Danny Palmerone,
riding atop the car, liked
to race his Lotus XX,
which he brought to
Shelby's driving school
for tips from the master
(behind the wheel).

8

C A R R O L L

Contents

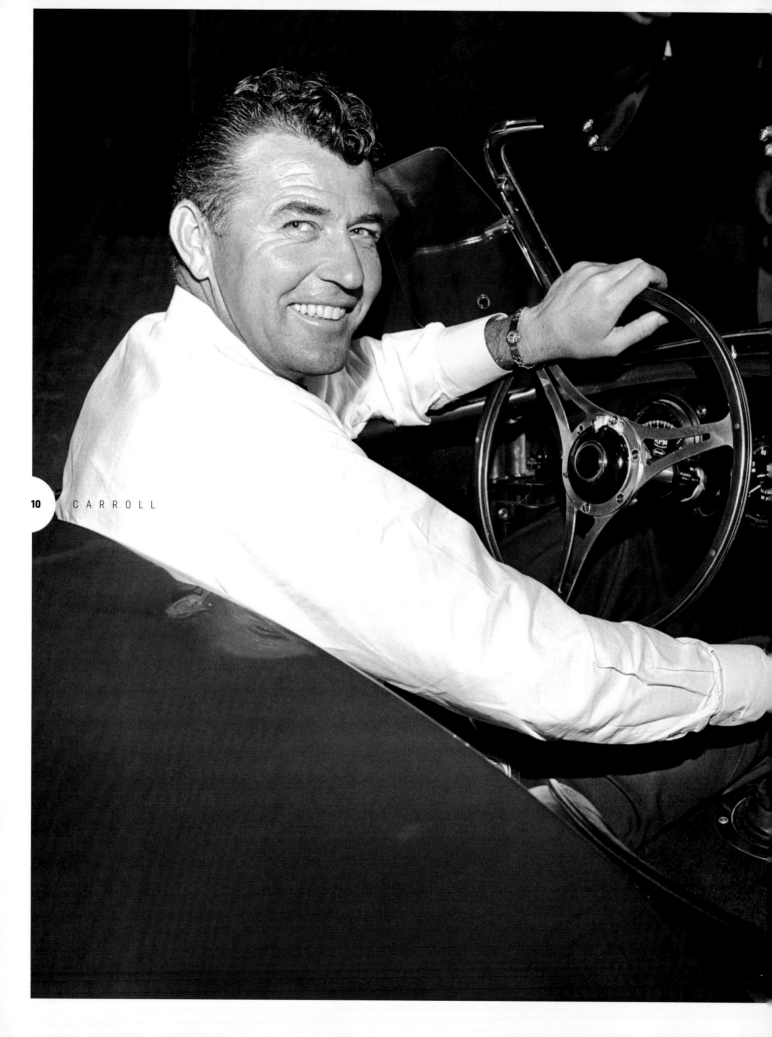

He always went after the big win—and usually got it

CARROLL SHELBY: DRIVER, INNOVATOR, LEGEND

Carroll Shelby's death on May 10, 2012, was more reality check than surprise. Heart problems had ended his driving career a half-century ago, and his health increasingly had become a greater issue, but his invincible nature always seemed to prevail. Rumors of his demise would be followed by a surprise appearance at a car show, a trade show booth, or the unveiling of a new GT500. His stubbornness and will to succeed carried him through numerous careers and two organ transplants, and his broad smile—especially at the sound of loud tailpipes—seemed as if it would never disappear.

Yet it has.

We haven't just lost a friend, an icon, and a dreamer. We've lost a force of nature, a kindred spirit, and an inspiration. He was like the Energizer Bunny meets the Texas Jackalope—part myth, part hype, but mostly vitality and grit. In the first 15 years of his career, Shelby faced more challenges than most corporations ever face. He didn't just make his mark once and ride a single wave of victory. He encountered high highs and low lows, but success prevailed, especially in the past decade. Shelby's ventures ranged from champion race cars to prepackaged chili, from speed equipment to sports apparel, and a charitable foundation. His exploits and inventions fueled SAAC, the successful Shelby-American Automobile Club. His ideas and endorsements changed the fortunes of corporations large and small, especially in Detroit. He was an icon to sports car racers from the 1950s onward, to musclecar and performance street vehicle fans since the 1960s, and to enthusiasts of all things automotive in the New Millennium.

Carroll Hall Shelby was a self-made man, an independent dreamer giving lessons in hauling ass to the boardrooms of corporate America. He was a man of principle who, 20 years ago, established a foundation to promote health and education. He kept going for more and more horsepower. His biographies—and there should be more than a few—will all be high-octane.—**Tom Corcoran**

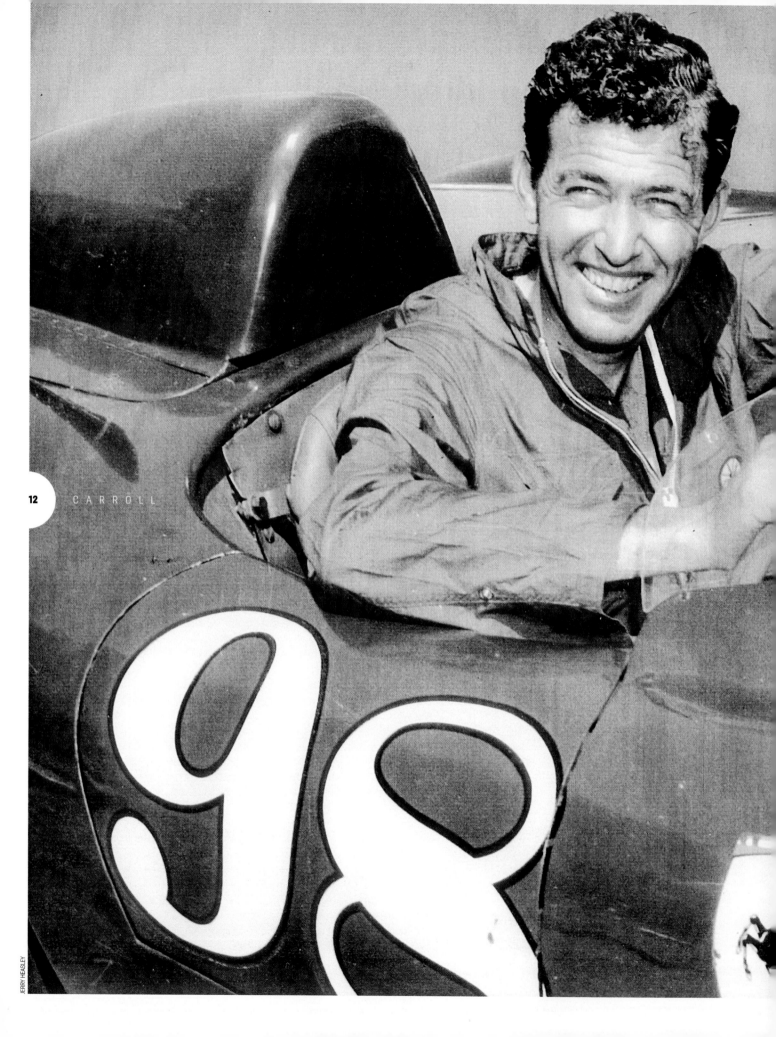

CARROLL

12

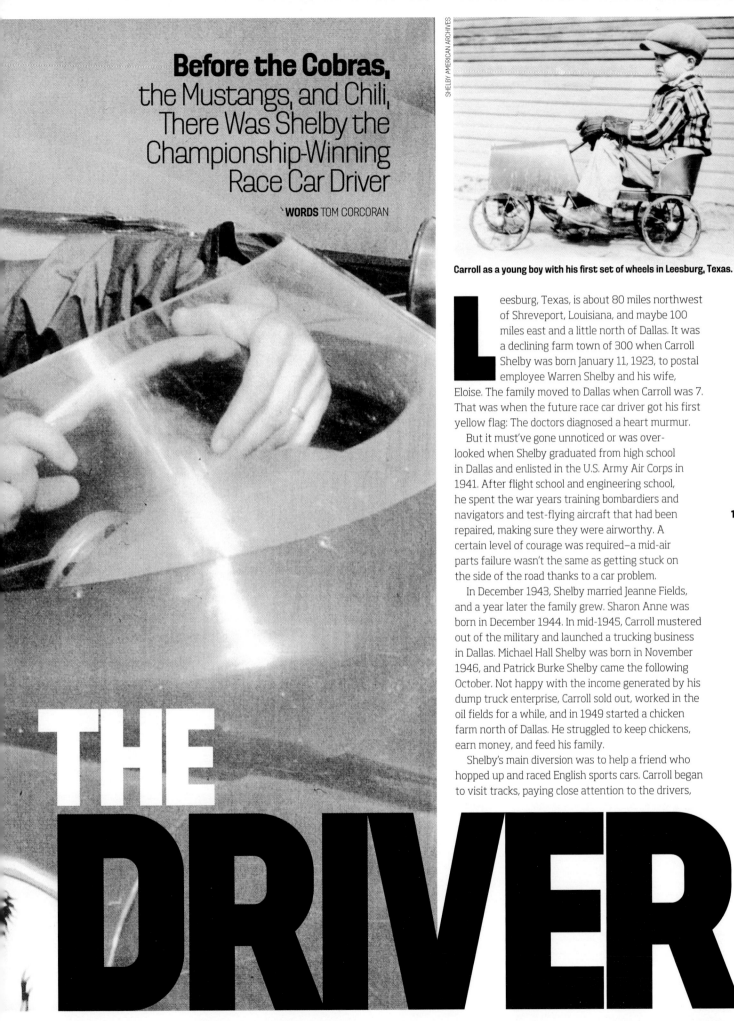

Before the Cobras,
the Mustangs, and Chili,
There Was Shelby the
Championship-Winning
Race Car Driver

WORDS TOM CORCORAN

Carroll as a young boy with his first set of wheels in Leesburg, Texas.

Leesburg, Texas, is about 80 miles northwest of Shreveport, Louisiana, and maybe 100 miles east and a little north of Dallas. It was a declining farm town of 300 when Carroll Shelby was born January 11, 1923, to postal employee Warren Shelby and his wife, Eloise. The family moved to Dallas when Carroll was 7. That was when the future race car driver got his first yellow flag: The doctors diagnosed a heart murmur.

But it must've gone unnoticed or was over-looked when Shelby graduated from high school in Dallas and enlisted in the U.S. Army Air Corps in 1941. After flight school and engineering school, he spent the war years training bombardiers and navigators and test-flying aircraft that had been repaired, making sure they were airworthy. A certain level of courage was required–a mid-air parts failure wasn't the same as getting stuck on the side of the road thanks to a car problem.

In December 1943, Shelby married Jeanne Fields, and a year later the family grew. Sharon Anne was born in December 1944. In mid-1945, Carroll mustered out of the military and launched a trucking business in Dallas. Michael Hall Shelby was born in November 1946, and Patrick Burke Shelby came the following October. Not happy with the income generated by his dump truck enterprise, Carroll sold out, worked in the oil fields for a while, and in 1949 started a chicken farm north of Dallas. He struggled to keep chickens, earn money, and feed his family.

Shelby's main diversion was to help a friend who hopped up and raced English sports cars. Carroll began to visit tracks, paying close attention to the drivers,

13

THE
DRIVER

equipment, and excitement. All the action and speed appealed to him.

Learning the limits of a race car is like confirming the ability of an aircraft to remain aloft. You learn the machine, scope the conditions, take it to the edge (or to altitude), and trust in survival. A few people can do it, but most can't.

Shelby's driving career began in 1952 on a quarter mile in a Ford flathead V-8-powered street rod. Soon he was competing in road races, winning his first two in a friend's MG TC roadster. Later that year, with Cadillac horsepower, he wheeled a British-built Allard J2 to victory in an SCCA race. By then, Shelby had moved up to big league equipment.

During 1953, Shelby continued in Cad-Allards, winning races and making a reputation in the Southwest. Late to a Fort Worth, Texas, race after farm work one day, Shelby drove to the track in his bib overalls. He won his race, but found that his odd driver's suit drew as much notice as his racing

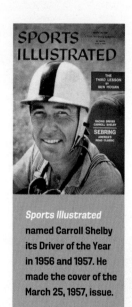

Sports Illustrated named Carroll Shelby its Driver of the Year in 1956 and 1957. He made the cover of the March 25, 1957, issue.

ability. He decided to make the striped overalls his trademark. As if to ensure his chicken farmer reputation, he even wore the "hitch-ups" to races in Europe in following years. His picture on the March 25, 1957, cover of *Sports Illustrated* showed his overall straps.

How did a farm boy from Texas get his portrait on the cover of the nation's premier sports magazine? In January 1954, Shelby first competed in a foreign race, driving a Cad-Allard in the Buenos Aires 1000 km. His 10th-place finish would make him the highest-finishing amateur in a race of international professionals. In Argentina, Shelby met Grand Prix greats Juan Fangio and Peter Collins, and, more important, impressed John Wyer, the race director for Aston Martin.

Wyer asked Shelby to co-drive a team DB3S in the 1954 Sebring 12-hour race. A broken rear axle ended that effort, but Wyer offered a driving job in Europe if Shelby paid for his

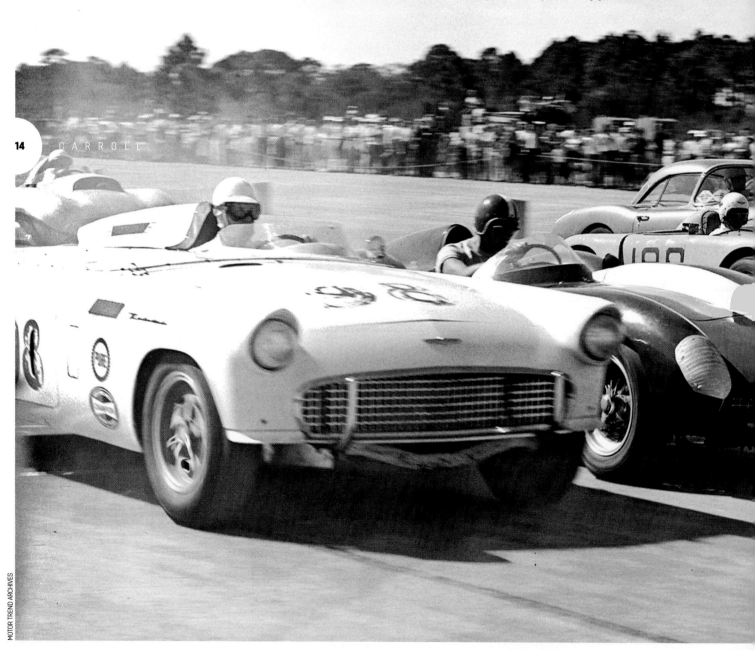

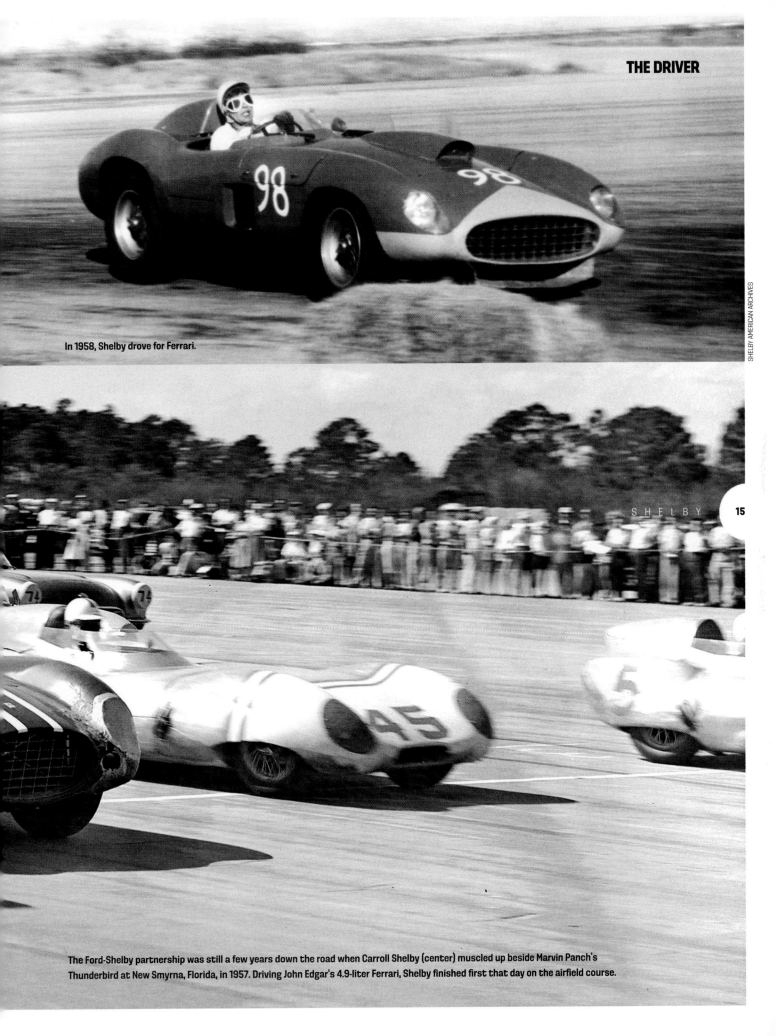

In 1958, Shelby drove for Ferrari.

SHELBY 15

The Ford-Shelby partnership was still a few years down the road when Carroll Shelby (center) muscled up beside Marvin Panch's Thunderbird at New Smyrna, Florida, in 1957. Driving John Edgar's 4.9-liter Ferrari, Shelby finished first that day on the airfield course.

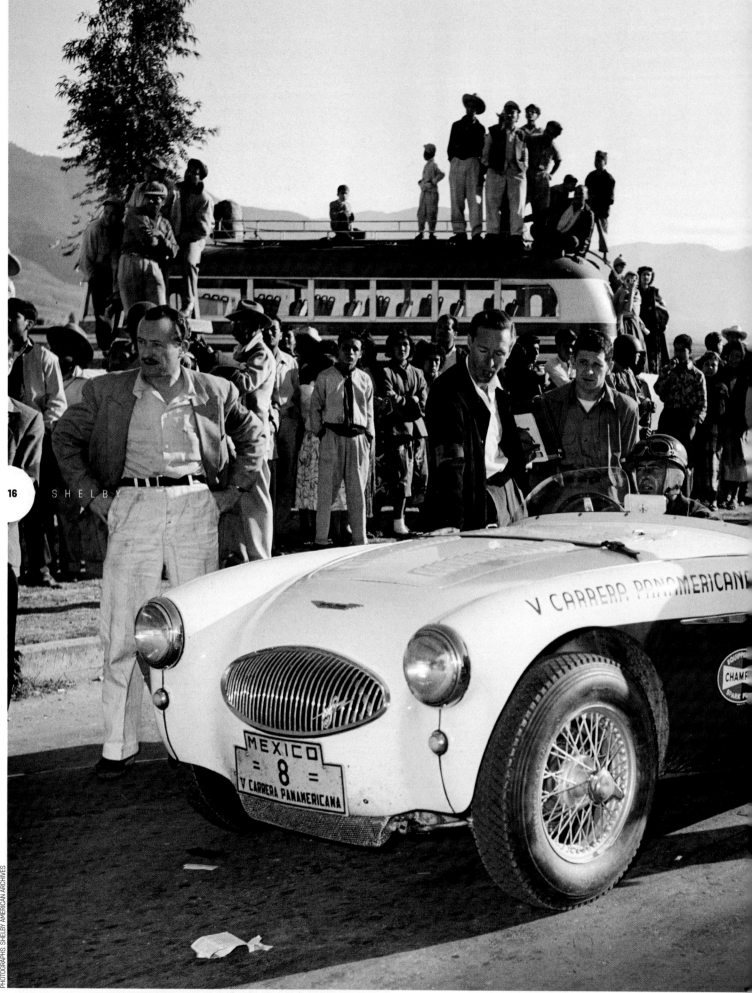

In His Own Words

"That's David Brown [car owner, to Shelby's left] looking at the oil after I won Le Mans [in 1959 in an Aston Martin]. David had gone to town, taken a shower, and put on clean clothes. We used about 40 gallons of oil during the race and most of it was on the floorboards, and it had gotten all over his new pants. I had dysentery for the previous 24 hours and was on an empty stomach. When they stuck the bottle of champagne under my nose, I about threw up."

own travel. Guy Mabee, a Texas oilman who dreamed of building an American sports car, agreed to pay for the trip. Driving an Aston Martin DB3S/3, Shelby placed second at Aintree. He took third at Silverstone, a fifth in a Grand Prix at Monza, and ran Le Mans in June until a front axle broke. Shelby pocketed his first professional winnings at Monza that August, the same time that Mabee decided to quit paying expenses.

After four auspicious months, Shelby came home to the United States.

Ray Cherryhomes, who had provided Shelby with Allard rides in past years, put him in a Jaguar C-Type for two races in Texas. Shelby then ventured into a new area of motorsport. He, George Eyston, Donald Healey, and Ray Jackson-Moore took two Austin-Healey 100S Streamliners to the Bonneville Salt Flats, where the group set numerous Class D speed records.

But 1954 ended on a rough note. With high hopes for prize money needed to keep his family's finances in order, Shelby agreed to drive in the 2176-mile Carrera Panamericana, a race run on Mexican roads and considered the most dangerous of its kind in the world. Carroll's Austin-Healey struck a road marker, flipped, and left him with a broken arm. Doctors warned that healing and therapy could take months.

Reconstructive operations be damned, Shelby entered a Ferrari 750 Monza with Phil Hill in

In 1954, Shelby raced in the infamous Carrera Panamericana. *Hot Rod* photographer Bob D'Olivo provided the caption: "Shelby was driving an Austin-Healey in the '54 Pan-Am. [He] was too fast in a corner while chasing a Lincoln, hit a rock, and went off course down an embankment, damn near killing himself. Fractured his right elbow and lots of contusions."

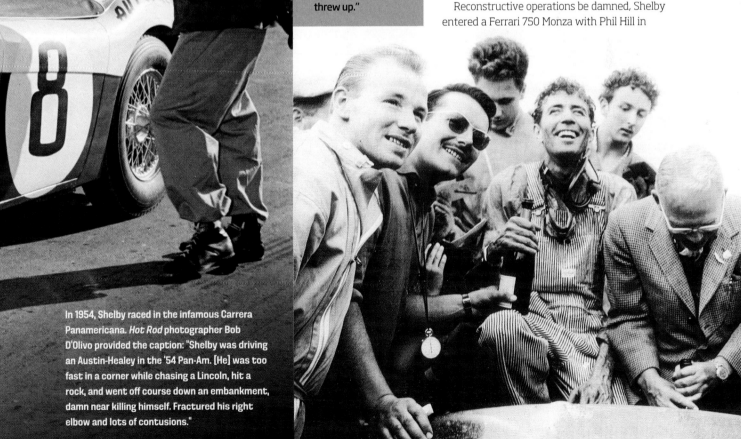

THE DRIVER

the 1955 Sebring 12-hour endurance race. He removed his arm's heavy cast, fashioned a fiberglass support, and taped his hand to the steering wheel. Tough stuff–and it led to a confused finish where the Ferrari took the checkered flag only to have a Jaguar declared the winner. Still, second place spoke well for the American drivers.

In 1955, Shelby drove race cars built by three different manufacturers: Ferrari, Porsche, and Maserati. Carroll's career was now up to speed.

The 1956 season began with a fourth-place finish at Sebring in a team Aston Martin DB3S with the flamboyant Roy Salvadori. Later in the season, Carroll was asked to race John Edgar's Ferraris. He did well, winning and setting records at the Mount Washington and Grants Despair hill climbs in Edgar's ex-Formula 1 Ferrari 375. *Sports Illustrated* named Carroll Sports Car Driver of the Year for 1956.

The Cuban Grand Prix launched the 1957 season. Shelby finished second in a Ferrari 375 Plus. Things got rosier in Edgar's new Maseratis. Shelby took them to 19 victories and an SCCA championship.

Sports Illustrated named Shelby Driver of the Year again in 1957, and he appeared on the cover of the March issue. In less than four years, the man from Texas–less often dressed in bib overalls–had become a world-class driver and an international headliner.

Shelby joined the Aston Martin team in 1958 and chalked up thirds at Goodwood and Spa. But the high point of Shelby's sports car driving career

Shelby became known for his striped overalls after coming straight to the racetrack from his chicken farm. They became his trademark, as this Victory Lane photo from 1960 shows.

18 CARROLL

As a joke, Shelby attached shoes to his car at a 1961 race, saying if he couldn't pass the others, he could boot them out of the way.

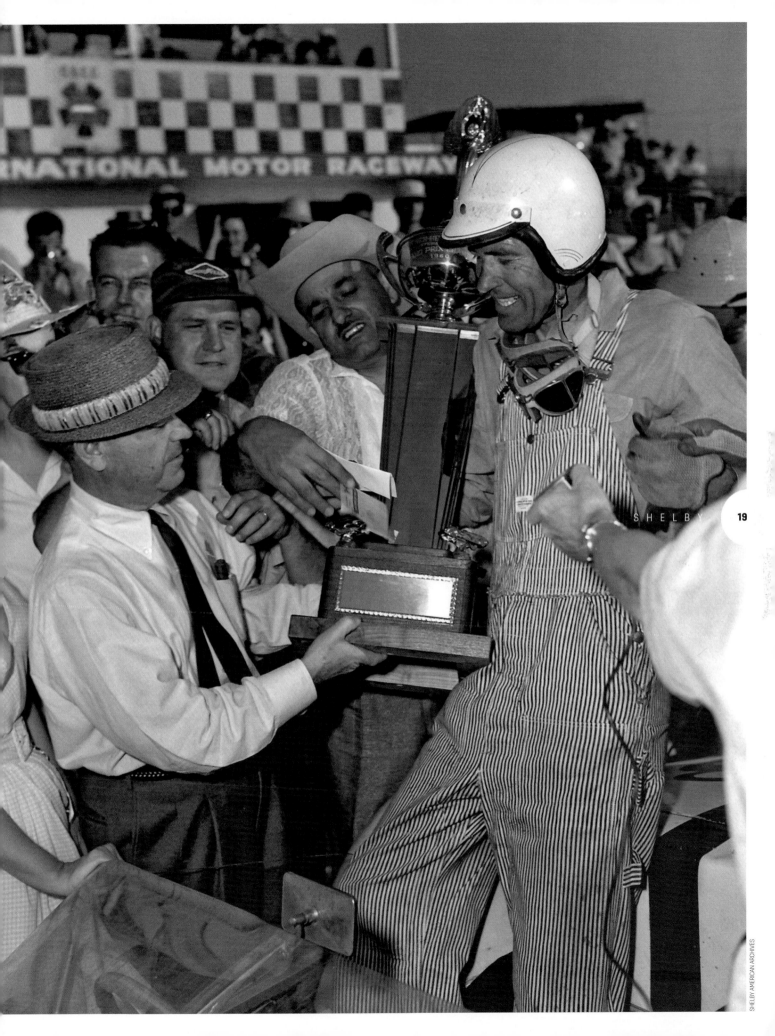

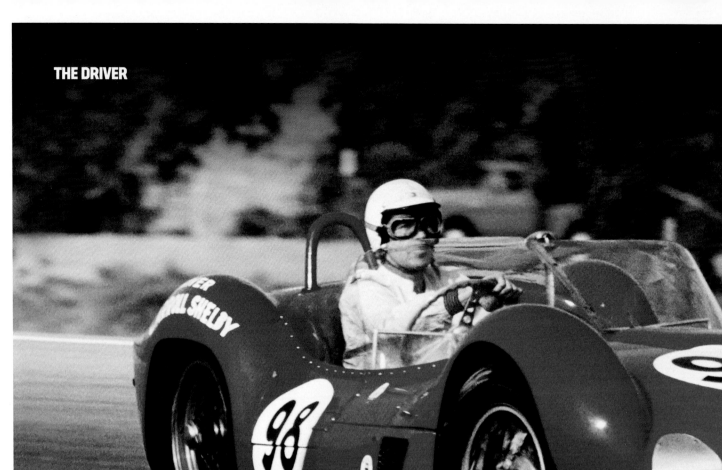

CARROLL

Carroll's Last Race

Many believe that Shelby's last appearance as an active race driver was in the *Los Angeles Times-Mirror* Grand Prix at Riverside in December 1960. Not only is this tidbit wrong about the date and venue, but that "fifth-place final finish" robs Shelby of the significance of his racing finale.

The *Times-Mirror*-sponsored Grand Prix for Sports Cars actually took place the weekend of October 15-16, 1960. (There were no races at Riverside in December.) Shelby drove the 200 miles in a red Type 61 Birdcage Maserati and, yes, finished fifth.

But that wasn't Carroll Shelby's last race. One week later, at the 200-mile Pacific Grand Prix for Sports Cars at Laguna Seca, Shelby again drove the Type 61. Competition was held in two 100-mile heats—each heat run by

all drivers. Final standings were numerical, based on a driver's combined finishes. In prerace qualifying, 11 drivers, including Shelby, beat the existing lap record. Shelby qualified sixth. In the first 100-mile heat, won by Stirling Moss, Shelby placed fifth—ahead of Ken Miles, Jo Bonnier, and Roger Penske. Moss also won the second heat and Shelby brought his Maserati in fourth . The results for the Pacific Grand Prix list Stirling Moss in first place and, based on his two Top Five heat finishes, Carroll Shelby in second place.

After driving the Pacific GP in pain, Shelby decided to retire. His runner-up finish behind the legendary Stirling Moss at Laguna Seca on October 23, 1960, was an amazing feat and an admirable exit from the sport.

With "Driver Carroll Shelby" emblazoned on the flanks of his Type 61 Birdcage Maserati, Shelby won the 1960 USAC driving championship.

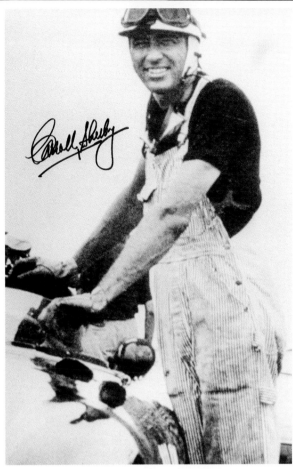

was co-driving an Aston Martin with Salvadori and winning the 1959 Le Mans 24-hour race. This win came through smarts. Shelby and Salvadori made a point of taking it easy on their car, including skipping an entire day of practice. Their foresight no doubt secured their win. Aston Martin would go on to win the 1959 World Sports Car Championship.

Carroll moved to La Mirada, California, in 1960 and opened a Goodyear Racing Tire distributorship. In May of that year, his recurring chest pains were diagnosed as angina. He knew the clock was ticking, but the racetrack called. On June 27, he drove one of Lance Reventlow's Scarabs to first place at Continental Divide Raceways, breaking a course record. He also drove a Type 61 Birdcage Maserati throughout the season, accumulating enough points to win the USAC driving championship for 1960.

Finally, in October, after driving his last races in pain, he chose to heed the doctors' warnings. Without fanfare or hesitation, he quit driving.

In six short years, Carroll Shelby had become a legend. He showed panache, guts, and determination; learned the art of the deal; and watched men attract talent to build teams. He learned lessons on diversification, name recognition, and ancillary products. And he had this idea.

It was time for Carroll Shelby to build cars.

COB

CARROLL

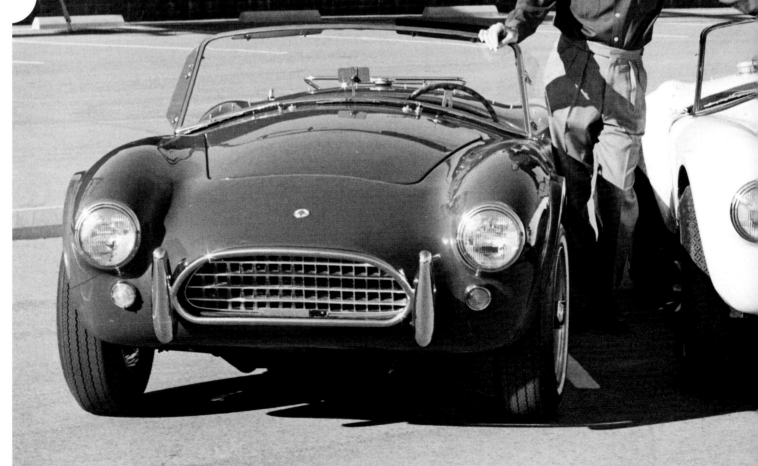

RA

THE NAME CAME IN A DREAM

WORDS TOM CORCORAN

In 1960, due to a heart condition, Carroll Shelby was off the racetrack, but the gears were still turning. Shelby had ideas about a car he would love to drive that he knew could win. And although driving it was out of the question, he was determined to build that winner. He had catalogued all the mistakes he had seen other builders make despite good intentions and great resources.

By the end of 1960, Shelby was scrambling to recreate his life and earn real money for a change. He had opened a Goodyear racing tire distributorship in Southern California. He started a performance driving school with Pete Brock. He knew that cars, tracks, and winning were in his blood to stay.

And he had this idea. It came from wrestling light-weight MGs in the early 1950s, cars that didn't weigh 10 feathers yet begged for same engines as the pickup trucks that towed them to the racetracks. He wanted to match American power to a chassis light enough for world-class racing, and win.

The concept was not wholly original, and he knew that. He and Texans Jim Hall and Gary Laughlin had

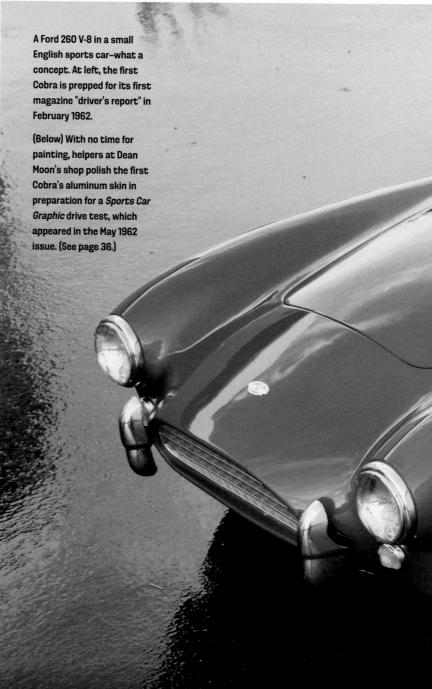

A Ford 260 V-8 in a small English sports car—what a concept. At left, the first Cobra is prepped for its first magazine "driver's report" in February 1962.

(Below) With no time for painting, helpers at Dean Moon's shop polish the first Cobra's aluminum skin in preparation for a *Sports Car Graphic* drive test, which appeared in the May 1962 issue. (See page 36.)

tried to match the Chevy 283 engine and chassis of three '59 Corvettes to a custom coupe body created by Scaglietti in Italy. Shelby had also raced Cadillac-powered Allards, taken a Corvette-Scarab to victory as recently as June 1960 and competed against one in his final race, ran against a Buick-engined "Ol Yaller" two months earlier, knew of Corvette-powered D-Type Jags, and was privy to Jim Hall's plans for the Chevy Chaparral.

24 Shelby was convinced he could do the job better. He was immersed in California car culture and knew the racing world from Texas to Europe. He knew how to package deals and keep down expenses. He knew about risk, and that he couldn't afford to start from scratch. He needed to find an existing chassis and the right engine, and be the matchmaker. He needed the support of chassis and engine builders. He also needed great timing, and that's what fell into his lap.

In 1961, through industry contacts, he learned that AC Cars, Ltd. in England was losing its supply of Bristol six-cylinder engines for the two-seater Ace roadster. And in Detroit, Ford had developed a small, 221-cubic-inch V-8 intended for use in "compact" cars.

The First Cobra

On display at the Shelby American Museum in Las Vegas is the first Cobra ever built. Enthusiasts refer to this historic car by its serial number, CSX2000. To die-hard Shelby fans, it's simply known as "The One." The interior is basically untouched from 1962. The leather seats are cracking and the white stuffing is popping from between torn stitches, but that's the way Shelby wanted it. To make a point, he told his employees, "If anyone tries to restore the interior, they will be looking for a new job."

The aluminum-bodied two-seater meant a great deal to Shelby, or he wouldn't have kept CSX2000 for 50 years. Every future Shelby project carried the DNA of this first Cobra.

The American V-8 under the hood—the 260-hp, 260 four-barrel small-block—was not king-of-the-hill powerful. But the power-to-weight ratio is impressive because of the Cobra's 2020-pound curb weight. The weight distribution is 48/52. Four-wheel disc brakes bring the car to a stop like hitting a rubber wall. Steering is quick, too—2.0 turns lock-to-lock. All four wheels are

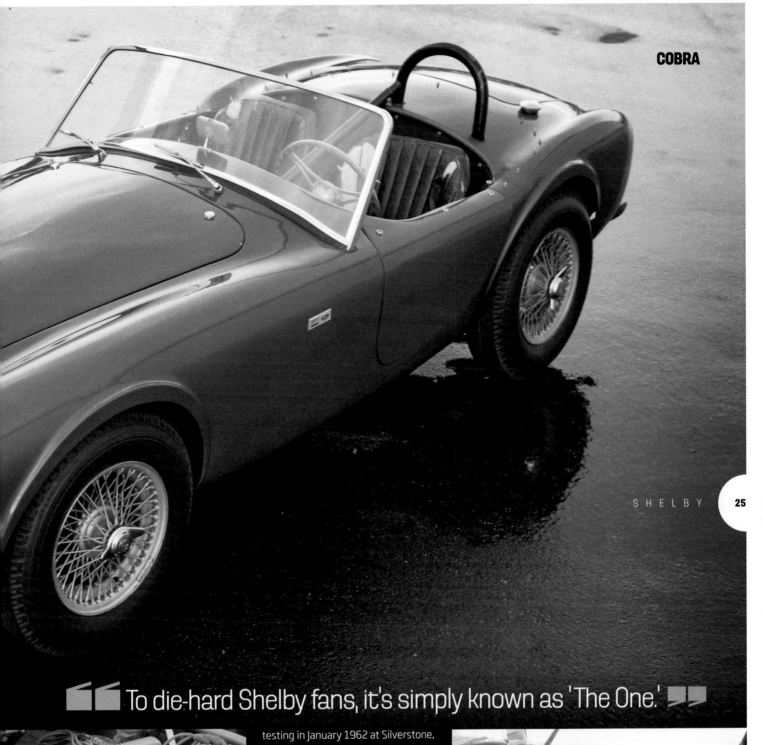

❝ To die-hard Shelby fans, it's simply known as 'The One.' ❞

independently sprung. The ladder-type frame supports a structure of tubes that gives integrity to the body.

CSX2000 was more than the first production Cobra. It was also the prototype and test mule. After initial testing in January 1962 at Silverstone, the first Cobra, minus its engine and transmission, traveled by ship to Los Angeles. Shelby flew home to take delivery and further develop the car.

Had Ford Motor Company not been involved, the Cobra would have lacked a major ingredient: distribution. It might have faded away. "Powered by Ford" badges on the front fenders satisfied Ford. "AC" badges satisfied AC Cars. But the new car was neither a Ford nor an AC. It was a Shelby Cobra, catalogued as a 289 Roadster, manufactured by a new company called Shelby American. **– Jerry Heasley**

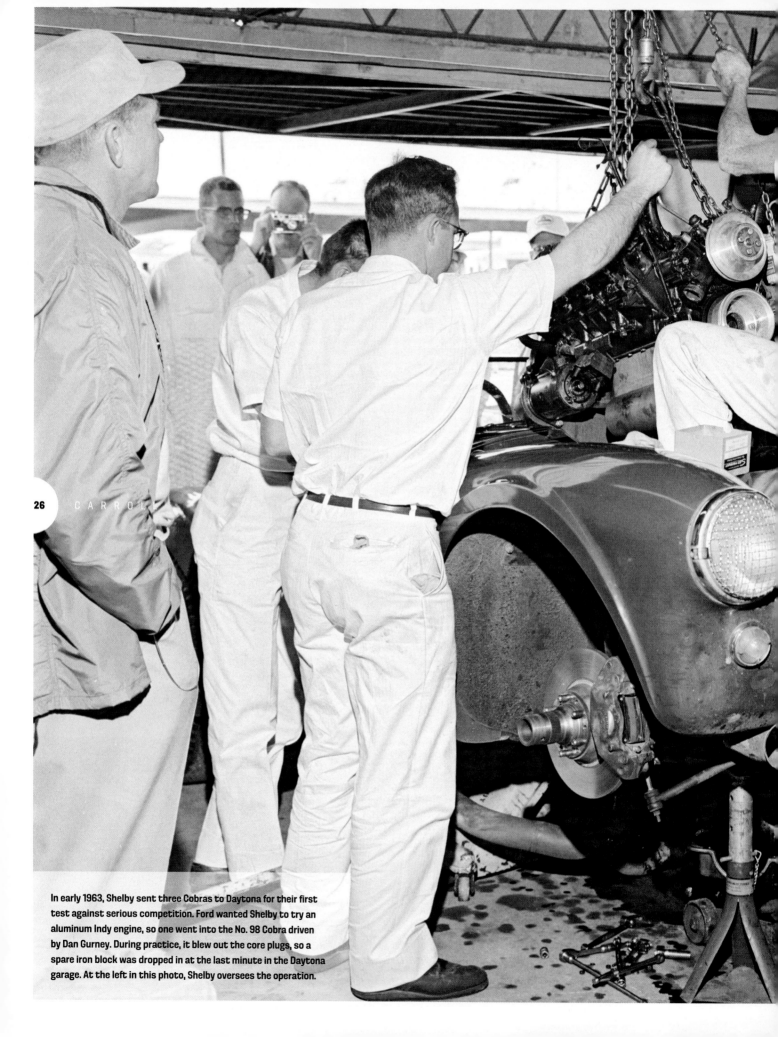

CARROLL

In early 1963, Shelby sent three Cobras to Daytona for their first
test against serious competition. Ford wanted Shelby to try an
aluminum Indy engine, so one went into the No. 98 Cobra driven
by Dan Gurney. During practice, it blew out the core plugs, so a
spare iron block was dropped in at the last minute in the Daytona
garage. At the left in this photo, Shelby oversees the operation.

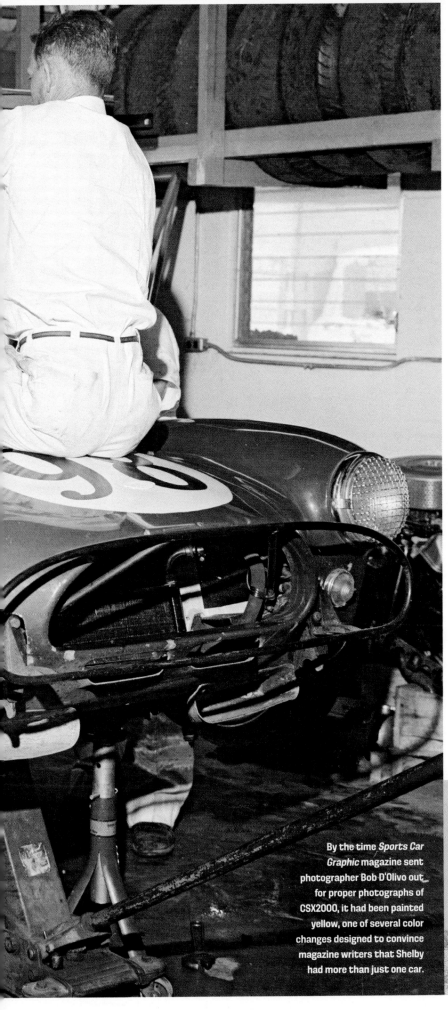

Shelby proposed to AC Cars that it continue building chassis and bodies to carry a limited run of V-8 engines. AC wanted proof that Carroll really had an engine. In late 1961, Shelby prevailed upon a Ford engineer who'd worked on the 221-cid project. Intrigued, the man arranged for a Ford V-8 to be shipped to California. Shelby borrowed an AC Ace, spent a day wedging in the V-8, and while the engine wasn't a perfect fit, he knew it would work. It was slightly heavier than the car's Bristol six, and its horsepower and torque would require chassis upgrades and stronger mounts for the engine, transmission, and suspension. There was work to be done, but he had his winner.

He called Ford to report the news. At that point, any doubts about the engine's ability to compete went away. To compete with the Corvair Monza, Ford had modified the 221 engine for the Falcon Sprint. Two of the new 260-cubic-inch engines were on their way to Los Angeles.

Shelby's plan was complicated. Each car would need a V-8 engine trucked to Los Angeles from Michigan and a rolling chassis and aluminum body shipped from England. He would need radiators, driveshafts, transmissions, and dozens of small components. He needed a workshop with hoists, tools, an office, and employees. The logistics were a nightmare. The bad dream was eclipsed by lucky timing. Ford had launched its Total Performance era and Dearborn wanted a Powered by Ford sports car. With no engine supplier, AC Cars needed an angel. Shelby needed them both–especially Ford for manufacturing know-how and racing support. It was a perfect storm of coincidence.

The name Cobra came to Carroll in a dream, and this would be a dreamer's undertaking, ideal for a man who scorned failure and knew how to be flexible. After the first Ace 221 was jerry-built from borrowed parts, and after OKs arrived from Dearborn and England, the floodgates opened.

The first AC body and chassis arrived at L.A. International Airport early February 1962. Shelby and Dean Moon (the Mooneyes parts-maker and

27

By the time *Sports Car Graphic* magazine sent photographer Bob D'Olivo out for proper photographs of CSX2000, it had been painted yellow, one of several color changes designed to convince magazine writers that Shelby had more than just one car.

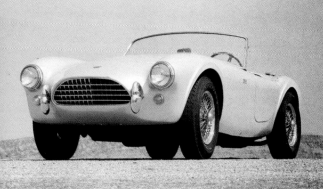

FROM THE NEWS BUREAU,
FORD DIVISION OF FORD MOTOR COMPANY

For Release in AM, Tuesday, August 21, 1962

The first production model of a new sports roadster designed for normal road touring and worldwide road racing competition was displayed to the press today by the Ford division of Ford Motor Company.

Powered by Ford's Challenger 260-cubic-inch V-8 engine, the new car—the Shelby Cobra—was developed by Carroll Shelby, internationally known race driver and performance vehicle specialist. The car is reported to be one of the fastest production vehicles in America today. The car has a suggested list price of $5995.

"The Cobra is designed as a threat to the cars that now dominate the world's sports car races," Shelby said. "I believe this is the right type of sports car for the American driver who wants performance with no sacrifice in normal driving reliability. The Cobra is made to be driven on the street and enjoyed, but it will also be highly competitive in all types of events, including Le Mans and other demanding races."

The Shelby Cobra will be distributed by Carroll Shelby Enterprises, 1042 Princeton, Venice, California. 8/20/62

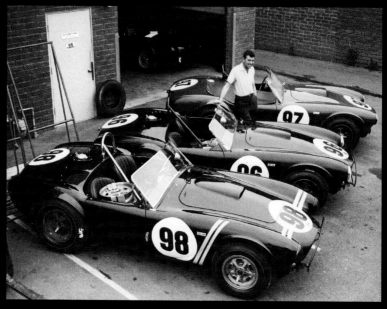

In His Own Words

"I never thought we'd put all the money together to let the Cobras win all the races they did. Many people thought it was the mistake of the century to use the AC chassis. We made it work. We kept on making wider and wider Goodyears to make all four tires stay on the ground. How we won the World Championship with that chassis, I'll never know. But I'll take it!"

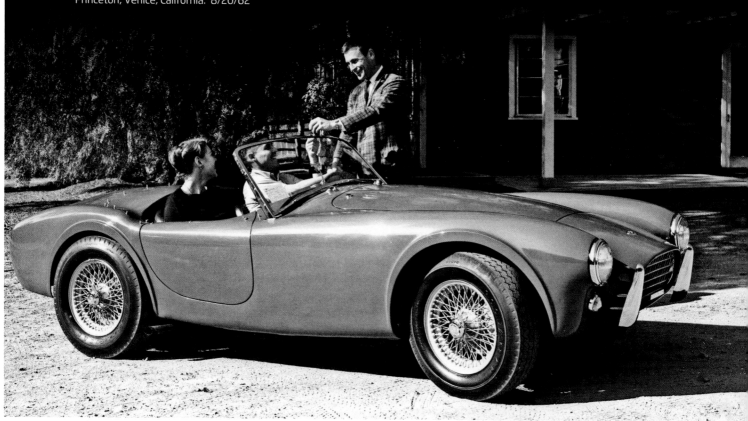

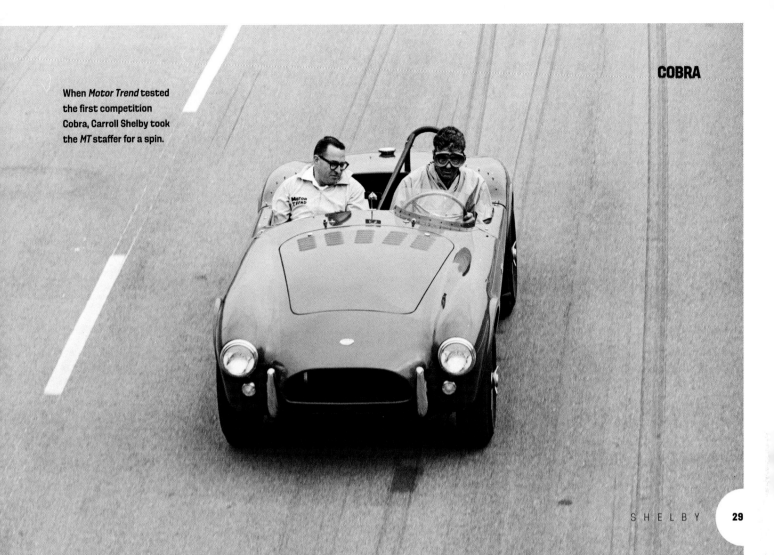

When *Motor Trend* tested the first competition Cobra, Carroll Shelby took the *MT* staffer for a spin.

You can almost hear the small-block screaming in this shot of Ed Leslie in CSX2136 at a race in Tucson, Arizona. Leslie won the A/Production class.

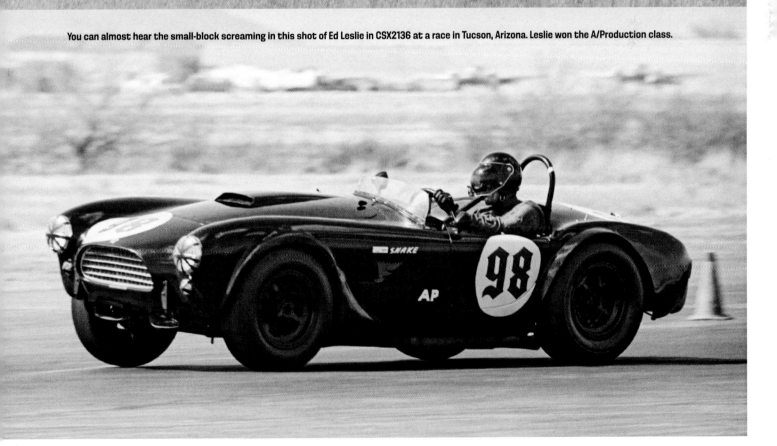

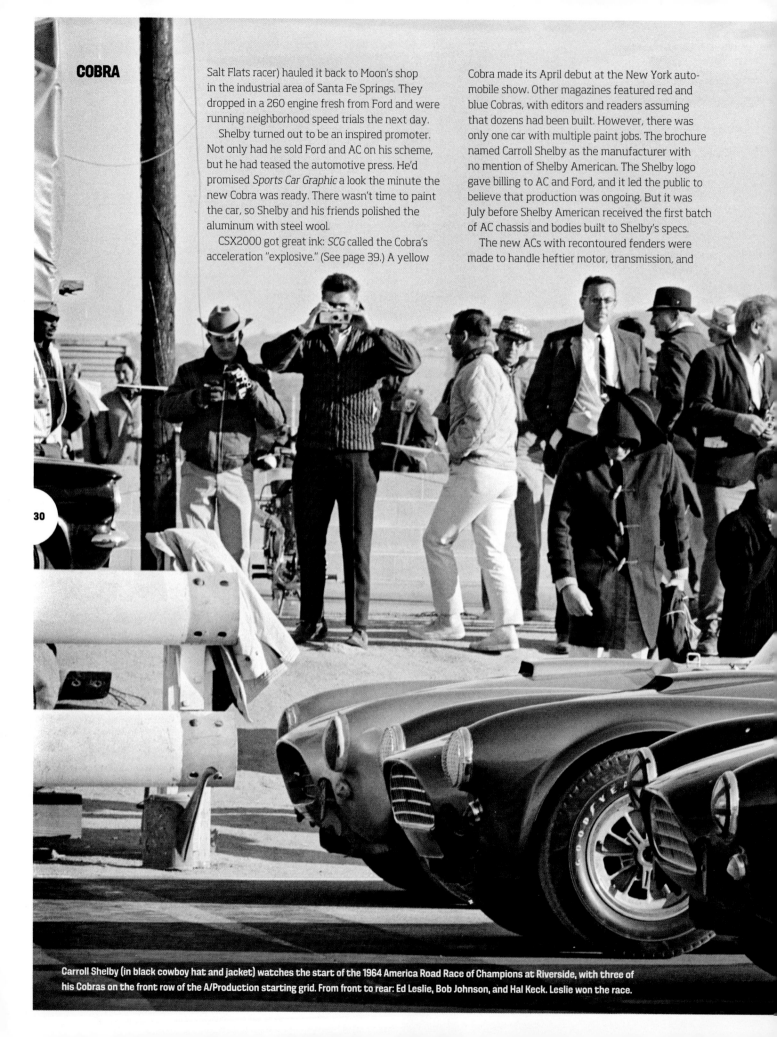

Salt Flats racer) hauled it back to Moon's shop in the industrial area of Santa Fe Springs. They dropped in a 260 engine fresh from Ford and were running neighborhood speed trials the next day.

Shelby turned out to be an inspired promoter. Not only had he sold Ford and AC on his scheme, but he had teased the automotive press. He'd promised *Sports Car Graphic* a look the minute the new Cobra was ready. There wasn't time to paint the car, so Shelby and his friends polished the aluminum with steel wool.

CSX2000 got great ink: *SCG* called the Cobra's acceleration "explosive." (See page 39.) A yellow Cobra made its April debut at the New York automobile show. Other magazines featured red and blue Cobras, with editors and readers assuming that dozens had been built. However, there was only one car with multiple paint jobs. The brochure named Carroll Shelby as the manufacturer with no mention of Shelby American. The Shelby logo gave billing to AC and Ford, and it led the public to believe that production was ongoing. But it was July before Shelby American received the first batch of AC chassis and bodies built to Shelby's specs.

The new ACs with recontoured fenders were made to handle heftier motor, transmission, and

Carroll Shelby (in black cowboy hat and jacket) watches the start of the 1964 America Road Race of Champions at Riverside, with three of his Cobras on the front row of the A/Production starting grid. From front to rear: Ed Leslie, Bob Johnson, and Hal Keck. Leslie won the race.

suspension mounts. Between August 1 and the end of the year, about 75 Cobras were produced with 260 engines. Changes and upgrades were made almost daily—not just early on, but throughout production. The next five years would be a whirlwind of development.

Shelby needed to prove that he'd created a viable competitor. There had been no guarantee that a race car driver could build a team and lead employees. Yet he picked great people for jobs as far ranging as test drivers, team drivers, office managers, fabricators, mechanics, and media experts. Over the next five years, Shelby's abilities to make decisions,

In 1964, Carroll Shelby set up his own Hi-Performance Motors dealership in Los Angeles by partnering with Lew Spencer, who had previously owned a sports car dealership.

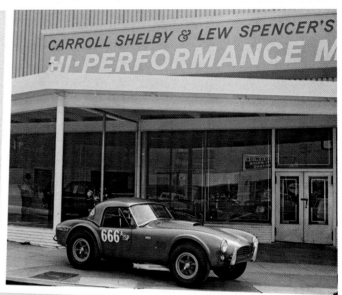

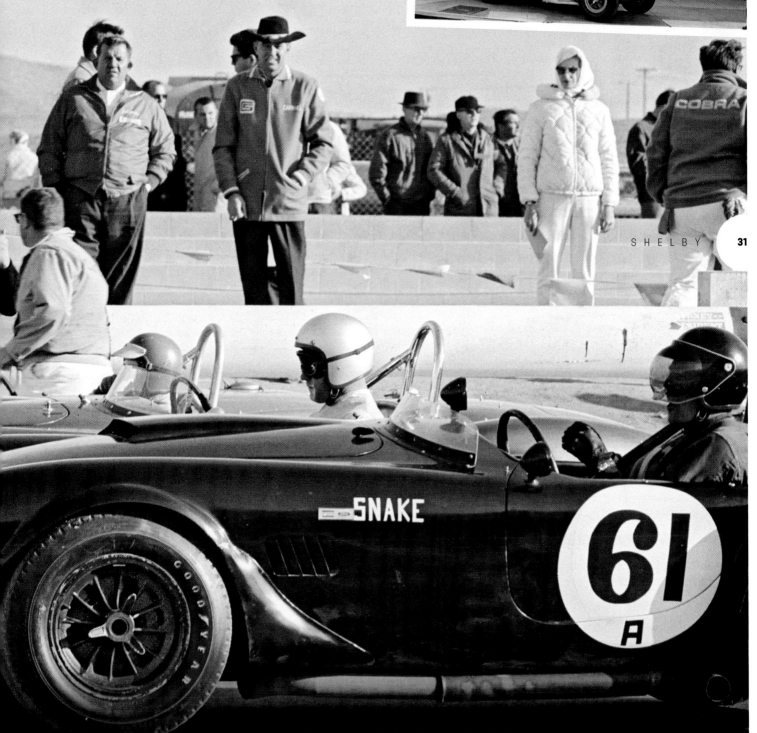

COBRA'S FIRST RACE

Carroll Shelby created the Cobra as a race car, and he wanted to prove its worth by entering CSX2002 in the Los Angeles Times Grand Prix at Riverside in October 1962. Driver Billy Krause jumped into the lead and was ahead by a half lap when the left rear hub sheared off on lap nine. The Cobra had shown promise–and subsequent cars were equipped with stronger rear-end hubs.

CSX2002 awaits its first competition in the pits at Riverside. Carroll Shelby stands with hands on hips as the crew checks the front tires.

The Cobra's first foray in competition ended when the left rear hub sheared off. A *Motor Trend* photographer grabbed this photo of the aftermath.

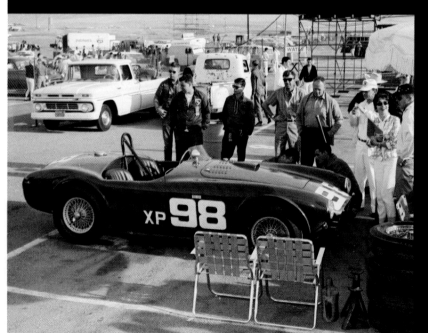

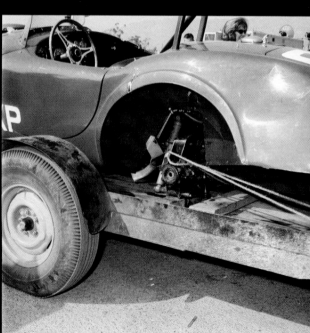

inspire hard work, and deliver on promises defined his success. It also solidified his image, especially at Ford.

Nine of the first 20 Cobras delivered from England were completed as competition cars. As each was track-tested in regional races or practice sessions, Shelby's crews upgraded the package. In late 1962, Ford added spice to the mix. It delivered the new 289-cubic-inch engine, which became standard in small-block Cobras.

In January 1963, Dave MacDonald won an A/Production race at Riverside in a super-tuned 260–Cobra's first victory. Ken Miles, in CSX2008, came in second. The roster of factory drivers reads like a hall of fame. Some were hired outright; others were independents hired for certain races; a few were company employees. Dan Gurney, Phil Hill, Bob Bondurant, Dan Gerber, and Jo Schlesser all were linked to the factory effort.

Ken Miles dominated the West Coast sports car scene in the 1950s. In late 1963, Shelby hired him to become Shelby American's competition director. Then, in December at Nassau Speed Weeks, three Grand Sport Corvettes thrashed the Shelby racers.

Miles returned to Los Angeles on a mission. He asked the race shop to install a Ford 427 engine into CSX2196. The strengthening, cutting, and fitting were classic California hot-rodding.

The 427's acceleration was beyond belief. Shelby drove the prototype and demanded a viable racer. Miles and Bondurant ran research laps at Riverside and, in effect, gave Shelby American the blueprint for the big-block production car. A testing accident ended Miles' life in 1966, but his spirit

To answer the 396 Corvette that debuted in 1965, and to add more power to competition Cobras, Shelby began development of the 427 Cobra with a new chassis, larger grille opening, and wider aluminum body.

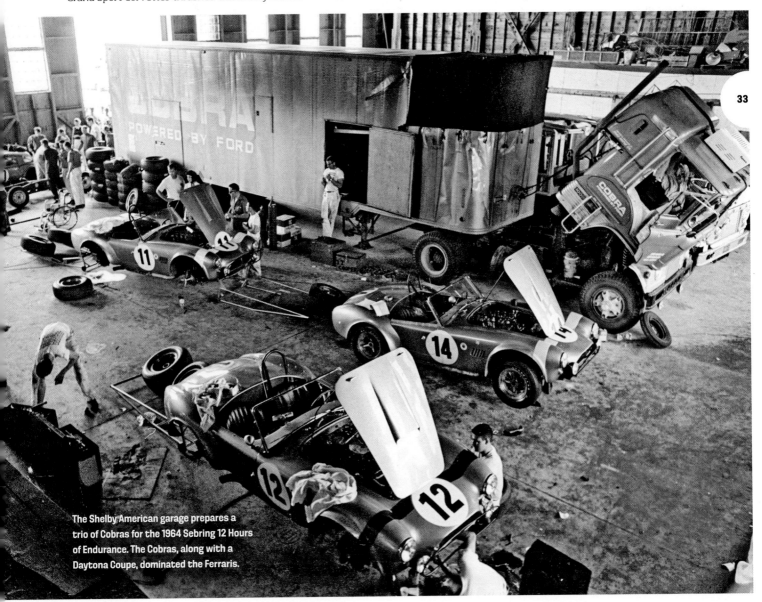

The Shelby American garage prepares a trio of Cobras for the 1964 Sebring 12 Hours of Endurance. The Cobras, along with a Daytona Coupe, dominated the Ferraris.

COBRA

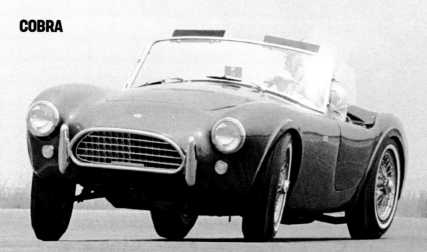

Sports Car Graphic technical editor Jerry Titus tested the '64 289 Cobra for the November 1963 issue. Editor John Christy wrote the article, calling the Cobra "a sports car, one of the best in the world." Christy noted the lack of tire spin during acceleration, a trait that no doubt helped the Cobra to its 14.9-second quarter mile. It also posted a top speed of 148 mph.

Super Snake

Carroll Shelby wanted to make the already-fast 427 Cobra faster. Starting with Competition 427 Cobra CSX3015, the car was fitted with a pair of Paxton superchargers, reportedly upping the power to more than 800.

As the story goes, one day Shelby bumped into comedian Bill Cosby, who liked to drive fast sports cars. When Carroll lambasted Cosby for driving foreign cars, Cosby responded that he would buy a Cobra if it could top 200 mph. So Carroll built CSX3303 as a duplicate to his twin-supercharged Cobra and delivered it to Cosby,

who used the experience for a comedy skit that appeared on the album "200 MPH."

Although Cosby joked that the Cobra frightened him, according to SAAC's Cobra Registry, he actually drove the car less than half a mile before returning with the complaint that it was "too rough." He gave the Cobra to his manager's wife.

A couple years later, a subsequent owner was killed in an accident that badly damaged Cosby's former Cobra. CSX3303 has been rebuilt in recent years.

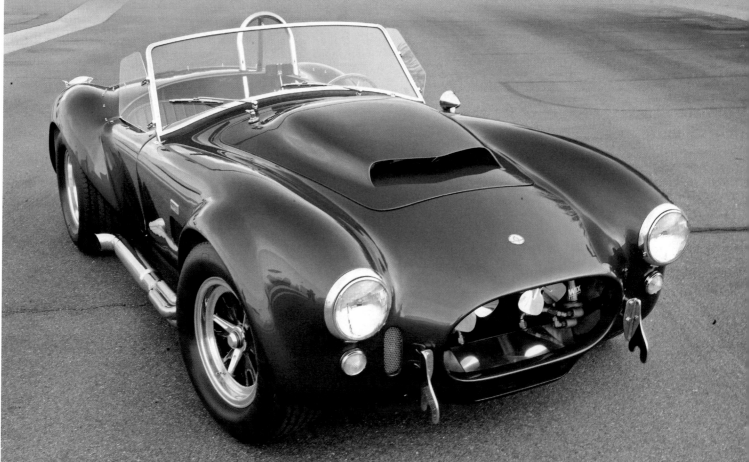

would shape the company's direction until the doors shut for good. That direction was big-block Cobras, with plenty of detours and side projects.

The last AC bodies built to carry 289s were shipped to L.A. in October 1964. In 26 months of small-block Cobra production, an icon was created. Ford got headlines and street credibility beyond its wildest hopes. Shelby gained name recognition, support in Detroit, respect in Europe–and a paycheck.

The 427 Cobra concept was molded throughout 1964. Miles drove CSX2431 in two-thirds of that year's United States Road Racing Championship (USRRC) races, while Shelby concentrated on confronting the world's best: winning the Le Mans class trophy with his Cobra coupes. He shut down 289 Cobra production and helped Ford prepare its GT race car for the 1965 season.

Shelby also got hit by a double-whammy. He had ordered that his first 100 427 Cobras be built to competition specs, but when FIA officials showed up to count cars, only 51 were complete. He would have to race his previous-year model. Worse was learning that a rules change for the next year would put his 427s in direct competition with the new Ford GT. Shelby had to assure Ford he wouldn't field a 427 Cobra race team for 1966. Racing aside, Shelby needed to sell cars. Fewer than 20 Competition 427s had been sold to independent racers, so he turned all efforts into building street 427 Cobras (retail price: $6995).

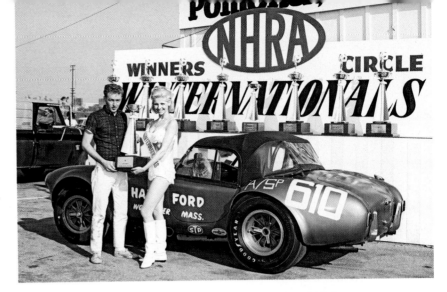

By early 1967, when Cobra production ceased, 260 had been made for the highway. Eighty of those received 428 engines when 427s became hard to get, and the 31 leftover Comp Cobras were reconfigured and sold as street-legal Semi-Competition or S/C models.

The last competition cars–six team roadsters built for the USRRC and five for independent drivers made to conform to SCCA rules–were finished at midseason. Remarkably, all six USRRC cars made it to that year's FIA race in Bridgehampton, New York.

It had been just 60 months from CSX2000, the prototype 260, to CSX3360, the last 427 Cobra. Shelby delivered on his dream–to Ford, the racing world, consumers, and, most important, to himself.

Some 427 Cobras were successful in NHRA drag racing. Harr Ford in Worchester, Massachusetts, special-ordered its Cobra for drag racing. With driver Gus Zuidena, it won the A/Sports class at the 1966 Winternationals.

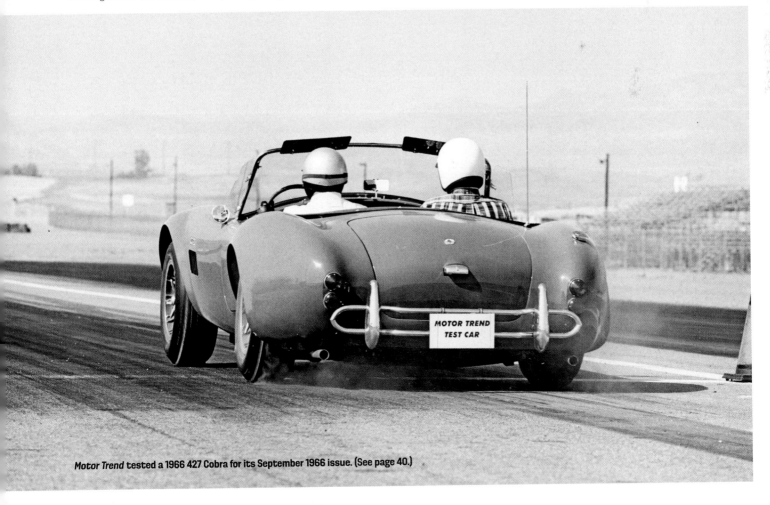

Motor Trend **tested a 1966 427 Cobra for its September 1966 issue.** (See page 40.)

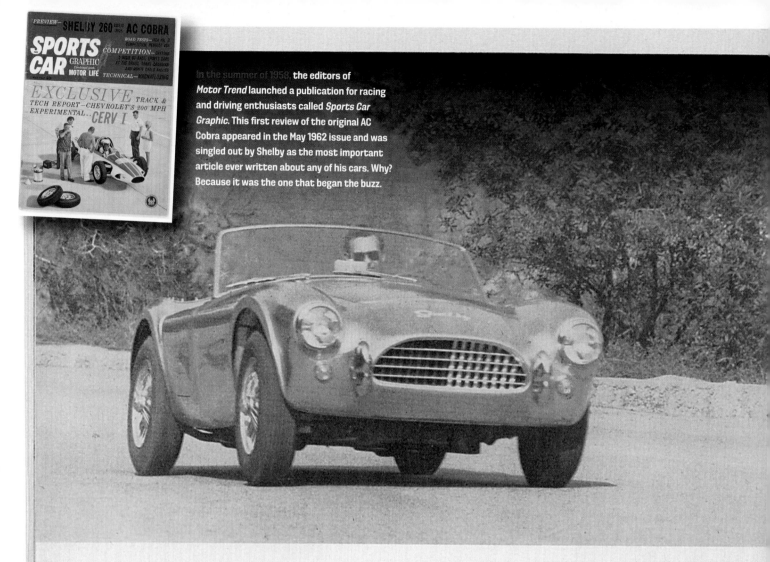

In the summer of 1958, the editors of *Motor Trend* launched a publication for racing and driving enthusiasts called *Sports Car Graphic*. This first review of the original AC Cobra appeared in the May 1962 issue and was singled out by Shelby as the most important article ever written about any of his cars. Why? Because it was the one that began the buzz.

DRIVER'S REPORT CARROLL SHELBY'S 260 CUBIC INCH AC

WHEN, IN THE EARLY FIFTIES, an English race car builder named John Tojiero bolted together a lightweight special around a hot Bristol engine, it is doubtful if he even dreamed of the far reaching chain of events he was to start.

From the first, the car was a success. So much so, in fact, that the AC Car Company, in search of something new to take the place of their obsolescent sports car, bought the production rights to Tojiero's special. The result was the Ace Bristol, a car that literally owned the SCCA's two-liter Production class from 1955 to 1960, when it was summarily bounced to C-Production, an upgrading of two classes. Even then, in the hands of the likes of Pierre Mion in the East and Pete Haywood in the West, it still was a winner, Mion taking the SCCA class championship.

For about the same number of years Carroll Shelby, former Grade One driver, now an SCG Contributing Editor and operator of the Carroll Shelby Driving School, has been dreaming of producing and marketing a car for production racing, preferably in Class A or B, to go against and try to break the monopoly held in the West by Corvettes and in the East by Ferrari Berlinettas. At the beginning of this year, with announcement of Ford's new 221 and 260 cubic inch lightweight V-8 engines, Carroll knew he had his power

plant. The Ford Motor Company was only too happy to cooperate, providing a special series 260 with a different cam, solid lifters, larger ports and higher compression pistons — horsepower output: 260 bhp or one horse per inch of displacement.

Another happenstance gave Carroll the vehicle to carry this little boomer. The Bristol Motor division of the famous aircraft company of the same name, which had been supplying the two-liter engine to AC and others, announced that it was quitting production and selling of its car building operation. The AC company was left without a power plant. Ken Rudd stepped briefly into the picture with a hopped-up English Ford six cylinder engine and then, apparently, bowed back out. Into this void marched Shelby with an offer to take all the roadsters they could produce if they would modify the design to take the brute torque of the XHP-260 engine. Such swaps had been tried in the past, mostly with Corvette engines, and were usually less than successful due largely to rear ends designed for 130 lbs. ft. of torque being required to handle upwards of 300, and other problems related to doubling and tripling power loadings on something designed to take far less. The AC people were only too willing to oblige. The result was and is the Shelby Cobra, the first of which is seen on these pages. It is the unimproved

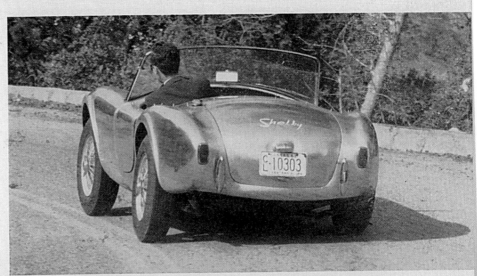

LEFT, lined up, coming out of a tight bend, the Cobra explodes out of the exit but with no snaking or squirrely traits.

RIGHT, steer characteristic is neutral if properly driven, but too much gas too soon produces induced understeer.

BELOW, lines of the Cobra are similar to Ace-Bristol but nose and tail are longer; 72-spoke, 15-inch wheels used.

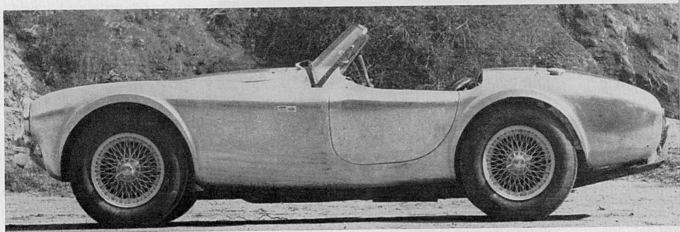

COBRA

Class A and B Production, watch out!
PHOTOS: BOB D'OLIVO & DEAN MOON

test prototype but even in its raw form it fulfills Shelby's long standing dream admirably.

Most of the changes in the car, aside from the much stiffer suspension and provision for the V-8 engine with its four-speed Borg Warner gearbox, center around the rear end. This has been beefed up considerably, with heavier hubs and half-axles. The lower A-frames have not only heavier tubing but have been fish-plated as well for extra fore-and-aft stiffness. The long tailshaft of the transmission ends up only inches from the front of the fixed center section, with the result that the drive shaft is little more than a pair of universal joints coupled by a 10-inch length of heavy-wall tubing. The center section itself is a big Salisbury unit similar to that used in the XKE Jaguar. On the prototype this section carries a pair of inboard mounted brakes, with the calipers in trailing position. However, since Shelby does not want to bother with complaints about heat and/or oil leakage on the discs, these will be moved outboard on the production versions.

We spent a day playing with the car and can safely say that it is one of the most impressive production sports cars we've ever driven. Its acceleration, even with the much mal-treated and dynamometer-thrashed single four-throat en-

(continued)

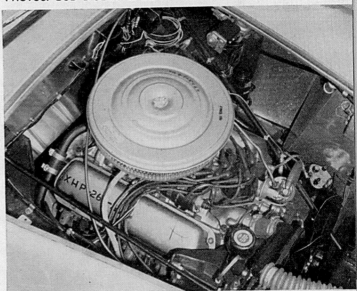

Engine used in prototype car was one of the two Standard units. It differs from the normal 260 Ford in that it has solid lifters, more compression, larger ports and valves.

Long tailshaft on gearbox nearly hits rear end; drive shaft is but 10 inches.

Gearbox is four-speed Borg Warner; all gears synchronized except reverse.

Dash is standard Ace but the tach and speedo are altered for higher speeds.

BELOW, setting up for a dynamometer run, crew checks linkage on Webers.

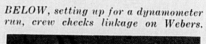

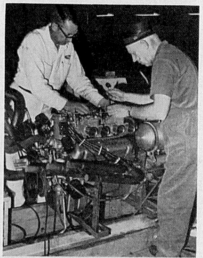

ABOVE, bent into a tight corner the Cobra leans slightly but sticks beautifully. BELOW, the optional engine under development on the dynamometer. The four double-choke Webers on ram manifold produced additional 43 bhp by themselves.

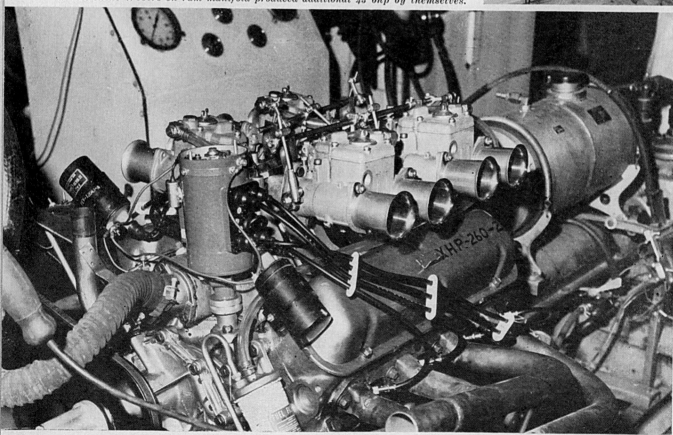

gine, can only be described as explosive and at least equal to that of the better running hot Corvettes and Berlinettas we've driven. At one point we entered a clear Freeway in Second gear, giving about three-quarter throttle and by the time we had quartered across to the fast lane the tach was nudging 6000 rpm and we were madly grabbing for Third, looking out for the Law and pulling our right foot off the loud pedal all at the same time.

The rubbery tendency to lean excessively and the slight snaking feel at speed that was exhibited by the Bristol version is gone. While there is some leaning, it is unapparent to the driver and the steer characteristic is dead neutral for the most part, with a mild final oversteer.

Unlike the Ace, however, one cannot punch the throttle in the middle of a turn; wheelspin and a certain amount of false or induced understeer is the immediate effect of too exuberant and too early use of the throttle, particularly in a tight bend. If driven properly through a bend at a steady rate of knots, without excess nudging, the cornering speed is quite high and when the car is lined up for the exit, a poke at the pedal sends the car straight forward with neck-straining velocity. The use of Second gear is necessary only for the tightest turns, Third being sufficient, at least with the 3.54 to 1 rear end, for almost any accelerative need.

As it stands, with the so-called "Standard" engine, similar to the one in the first car, the Cobra will turn up somewhere between 6500 and 7000 in high gear with the 3.54 rear end gearing, which figures out in the near neighborhood of 150 mph. We didn't squeeze it that hard for several reasons, one being that the tachometer only went to 6000, another being that one doesn't quite dare nudge the Law *that* hard and a third being that it isn't a good idea to thrash a brand new prototype, especially on short acquaintance. Yet, interestingly enough, despite all this potential the car is utterly docile when docility is required, as in city traffic, school zones and the like.

As a car goes, so should it stop. With four-wheel disc brakes with 12-inch discs and 550 square inches of swept area, the Cobra stops very well indeed. On a car that weighs only 1900 pounds soaking wet and ready to go, one might think the car is overbraked. It isn't. The brakes are competition Dunlops, with a rock-hard pedal, and it is almost impossible to lock things up tight. It can be done, but it takes work. A good solid poke at the brake pedal produces a condition just short of lock which hauls the car down far faster and smoother than one would think possible. With its light weight and extreme stopping power, the Cobra should be able to be literally buried into a corner before any drastic stopping action need take place, a great advantage over heavier equipment.

In the production versions an optional engine will be offered for those who wish to do all-out battle against the 327 cubic inch Corvettes and the latest Berlinettas. While the car in Standard configuration will be a Class B contender against the 283's, long-wheelbase Ferrari GTs, Mercedes, Carreras and the like, the optional one can only be classified in Class A wherein the short Ferrari, Corvette 327 and prodified XKE hold sway. Again the 260-inch block is used, spotting all but the Ferrari many cubic inches, especially in the case of the big 'Vette. This one, however, uses an optional cam, 11 to 1 compression, reinforced main bearing caps and is topped off by a quartet of dual-throat side draft 45 DCOE-9 Weber carburetors and a cross-over ram type manifold. Pending final dynamometer tests, we can give only the estimate rendered by Shelby's technical crew: 330 bhp and revs as high as 9000 rpm, although it is doubtful if peak power will be developed anywhere near that high on the scale. More likely peak will be delivered somewhere around 7500, but that can be tailored by changing ram tubes

on the carbs and by exhaust pipe lengths, it being planned to offer several optional exhaust systems.

As this is being written, homologation proceedings are being carried out to give the car an FIA classification in the Grand Touring category in standard form and Improved Grand Touring category in optional form. Shelby is making similar arrangements with the SCCA for the same two models to be classified in B and A Production.

First deliveries of the cars will, according to Shelby, start this month, in May, and some orders have already been taken. First come, says Carroll, will be first served. The price? The same as the Bristol version!

For those wishing to cause consternation in the hairy big bore Production ranks, the line forms on the right.

—*John Christy*

DRIVER'S REPORT

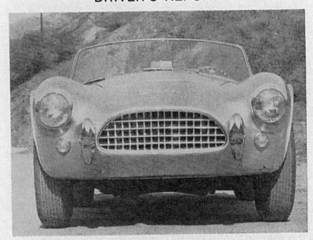

TEST DATA

VEHICLE	Shelby AC Cobra	MODEL	1962
PRICE (as tested)	$5995..FOB, Calif.	OPTIONS	Competition Engine

ENGINE:

Type	V-8, water-cooled
Head	Cast iron
Valves	OHV, rocker actuated
Max. bhp	260 @ 6500 rpm
Max. Torque	269 lbs. ft @ 3600 rpm
Bore	3.80 in.
Stroke	2.97 in.
Displacement	260 cu. in., 4262 cc.
Compression Ratio	9.2 to 1
Induction System	Single four throat or quadruple Weber DCOE-9-45
Exhaust System	Headers
Electrical System	12V Lucas

CLUTCH:

Diameter	9.5 in.
Actuation	Hydraulic

TRANSMISSION:

Ratios:	1st	2.36 to 1
	2nd	1.78 to 1
	3rd	1.41 to 1
	4th	1.00 to 1

DIFFERENTIAL:

Ratio	3.54 to 1. Alt. 2.72
Drive Axles (type)	Open, independent

STEERING:

	Sector
Turns Lock to Lock	3
Turn Circle	31 ft.

BRAKES:

Drum or Disc Diameter	12 in.
Swept Area	550 sq. in.

CHASSIS:

Frame	Tube
Body	Aluminum
Front Suspension	Independent, transverse leaf
Rear Suspension	Independent, transverse leaf
Tire Size and Type	6.50-7.00 x 15 Rear; 600 x 15 Front

WEIGHTS AND MEASURES:

Wheelbase	90 in.	Overall Length	165 in.
Front Track	50 in.	Ground Clearance	5.5 in.
Rear Track	52 in.	Curb Weight	1890 lbs.
Overall Height	46 in.	Crankcase	10 qts.
Overall Width	60 in.	Gas Tank	18 gals., 30 optional

PERFORMANCE:

Top Speed	(standard) 145 mph; (competition) 175 mph
Brake Test	8.0 Average % G, over 10 stops
	No fade encountered.

REFERENCE FACTORS:

BHP per Cubic Inch	1.0
Lbs. per bhp	7.2
Sq. In. Swept Brake area per Lb.	3.45

LOTS OF CARS HAVE POWER, BUT FEW HAVE SO MUCH FLEXIBLE POWER AS THE COBRA 427

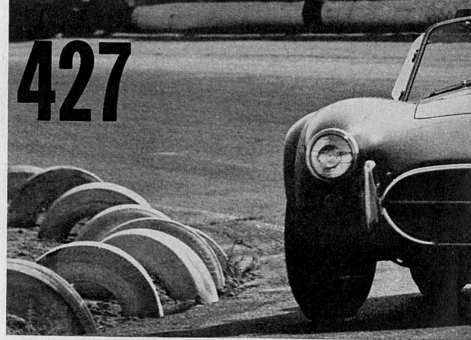

ROAD TEST

PERIODICALLY, some psychiatrist grabs himself a headline by announcing that the reason men like sports cars is that the car compensates for a sense of sexual inadequacy. We've never bought that theory but if there is anything to it, the cure is simple. ℞: one 427 Cobra.

The most masculine thing about the car is, of course, the power and the deep, throaty rumble that goes with it. The minute it comes to life you know it can do things that no other car can. Lots of cars have power; few have so much flexible power as the Cobra. We accidentally started in 3rd gear instead of 1st once. Except for a momentary lag, it just took off. At the next signal we tried it in 4th with a similar result.

Putting this 425-hp car in motion is less tricky than one might expect. The 11½-inch-diameter single disc clutch is as smooth as any we've ever used, and smooth, easy starts were a cinch. It is just as easy to make a sedate start that won't ruffle your Aunt Harriet as a rubber-burning retina-detaching take-

off like a working man's Don Garlits.

Stopping is equally uncomplicated. You step on the brake pedal and the car stops. Period. The Girling disc brakes have neither the bust-your-foot feel often associated with discs nor the sudden lock-up of power brakes. Pedal pressures are relatively high, but not so high as to be tiring.

The car has excellent traffic manners. In the worst summer bumper-to-bumper nightmare, the water temperature remained at 167°F, thanks to an electric fan in front of the radiator. Cockpit temperature in these circumstances became a bit uncomfortable but not unbearable, as in the case of many other high-performance cars. The engine flexibility, already mentioned, takes some of the strain out of traffic too. One can use almost any gear. You aren't likely to over-rev in first, nor lug in 4th, except from a dead standstill. It's not always fun, but we never found it tedious.

When traffic thins out, the Cobra comes into its own as a GT car. The ride, which seems just a bit *too* firm

over concrete expansion joints and rough asphalt at 35 or 40 mph, feels just right at 65 or 70 (or more, if you want to tempt fate and lawmen).

Handling, both on the trip to Riverside and in runs at our race course testing site there, was flawless. Considering that the chassis was originally intended for a 2-liter engine, the design modifications for this 7-liter bear are admirable. The old upper transverse leaf spring and lower A-arm system used front and rear in the AC-Bristol and 289 Cobra versions has given way to an all-coil-spring suspension. In all tests on the circuit it went through turns steady and nearly dead flat. If the driver chose a poor line, it was easy to correct with the steering wheel and/or throttle. Entering a turn with too little power would push the front end, but this could be corrected by getting back on the throttle. On very hard right turns, however, the 4-barrel carburetor starved out, which left us with an embarrassing lack of power to get out of the turn. The 8.50 x 15 Goodyear Blue

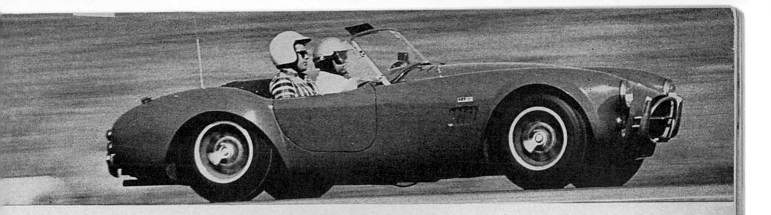

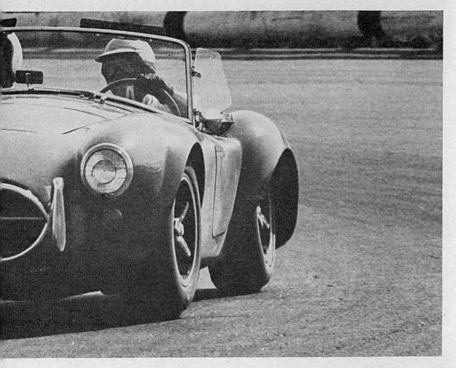

427-cu.-in. Ford gives the Cobra much more urge (above) than the earlier 289 version, but much redesigning of the suspension enables it to handle the 425 hp as it corners nearly flat (left) at Riverside International Raceway. Unlike the earlier chassis, the 427 never fought back in the corners. Below, the heart of the Cobra, with single Holley 4-barrel carb, chrome-plated Cobra valve covers. Full-competition versions have quartet of 2-barrel Webers, wider wheels and tires, plus special suspension package.

PHOTOS BY FRED ENKE

Dots on 7½-inch magnesium rims gave a very reassuring bite but the fenders flare out far enough to accommodate bigger rubber for serious competition.

With no way to hook our 5th wheel to the tubular bumper, tests were made using the car's own speedometer which had been calibrated. The straightaway at Riverside is inadequate for getting a top-speed figure on such a car, but the ¼-mile and acceleration figures should give a fair idea of just how hairy this beast is.

The cockpit has enough room for tall drivers including space beside the clutch pedal to stretch the left leg on long trips. We were surprised at how easily we adapted to the severely offset pedals. Although we were aware of them at once visually, we had no sensation of being twisted to the left when we got behind the wheel.

The steering wheel is a solid, wood-rimmed affair made for man-sized hands, although it doesn't require comparable strength to turn it. The gearshift lever is capped by a hefty ball, but, unfortu-

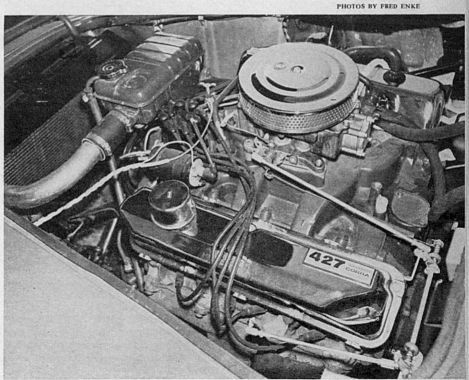

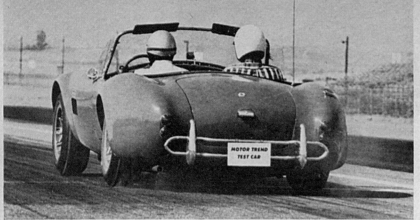

Cobra easily smoked tires on acceleration, but new car was too stiff to show its best performance. Note the wide flared fenders.

Magnesium wheels with 3-prong knock-offs are standard equipment, replace the wire wheels used on the early 289 Cobras.

Don't plan to bring much more than a toothbrush and change of socks on trips—spare tire occupies most of trunk space.

Bucket seats are comfortable, give good support. Instrumentation is complete, but steering wheel hides the tachometer.

COBRA 427

continued

nately, doesn't fall easily to hand. The lever is cranked forward and to one side, but is still too far back for either a tall driver or a short one (like the five-foot-five writer) who must keep the seat well forward. Nonetheless, when you get used to where the shift lever is, there is no trouble, either mechanical or anatomical, shifting into any of the forward gears. Reverse is another story; the location and angle of the lever makes operating the T-handle reverse lockout a bit of a scene.

The car does have some vices that should be mentioned. The horn shares a control lever with the turn signals, and we engendered several dirty looks before we learned to work the latter without setting off the former. The turn signals sometimes cancel, but often don't, something we've seen before with British electrics. The Smiths electric tachometer is very steady, but a spoke in the steering wheel obscures most of it.

Something we never got used to was the reflection in the plastic sun visor of the tail lights of the car ahead, which gave the sensation that the law had caught up with us for some peccadillo.

Wind buffeting in the cockpit is rather more severe than sporty at speeds above 50 mph, and on the trip to the track for the tests we finally resorted to putting on a helmet for comfort. This problem bothered everyone who tried the car, regardless of height. We tried driving with a cowboy hat on and finally concluded that Carroll Shelby must have his sewed to his scalp.

Although amazingly tractable and untemperamental for such a powerful machine, this is clearly not a car for everyone. Assuming you have the money, if you want a car that will cruise effortlessly at high speed and will always give you the feeling that *you* are driving *it*, you can't do better. If you want to pretend that every stop light is the grid at Nurburgring or every freeway the Mulsanne straight, forget it. You can't afford the tickets. — *Bob Schilling*

how the car performed . . .

ACCELERATION (2 aboard)
0-30 mph.1.9 secs.
0-50 mph.4.5 secs.
0-60 mph.5.3 secs.
0-75 mph.8.4 secs.

TIME & DISTANCE TO ATTAIN PASSING SPEEDS
40-60 mph.2.6 secs., 190.3 ft.
50-70 mph.3.5 secs., 308.0 ft.

STANDING-START ¼-MILE: 13.8 secs., 106 mph

BEST SPEEDS IN GEARS @ SHIFT POINTS
1st 66 mph @ 6000 rpm
2nd 84 mph @ 6000 rpm
3rd108 mph @ 6000 rpm
4th.(not maximum) 110 mph @ 5000 rpm

MPH PER 1000 RPM: 21

STOPPING DISTANCES: From 30 mph, 31 ft.; from 60 mph, 126 ft.

SPEEDOMETER ACCURACY

Car speedometer	30	45	60	75
Calibrated speedometer	30	43	57	70

specifications . . .

ENGINE IN TEST CAR: Bore and stroke 4.24 x 3.788 ins. Displacement 427 cu. ins. Advertised hp 425 @ 6500 rpm. Maximum torque 480 lbs.-ft. @ 3500 rpm. Compression ratio 10.4:1. Carburetion 1 4-bbl. Holley.

TRANSMISSION TYPE & FINAL DRIVE RATIO: Ford 4-speed. 3.54:1 with limited slip differential.

SUSPENSION: All independent with coil springs and unequal length wishbones.

STEERING: Rack and pinion. Turning diameter 36 ft., curb to curb. Turns lock to lock 2.5.

WHEELS: 7½ x 15 cast alloy.

TIRES: 8.50 x 15 Goodyear Blue Dot.

BRAKES: Girling disc. Diameter—front 11⅝ ins.; rear, 10¾ ins. Swept disc area, 580 sq. ins.

SERVICE: Type of fuel recommended—premium. Fuel capacity 18 gals.

BODY & FRAME: Ladder-style tubular frame.

DIMENSIONS & WEIGHTS: Wheelbase 90 ins. Track, front and rear 56 ins. Overall length 156 ins., overall width 68 ins., height 49 ins. Minimum ground clearance 4.35 ins. Curb weight 2529 lbs.

MANUFACTURER'S SUGGESTED LIST PRICE: $7495—street version (incl. taxes and safety equip't)

WARRANTY: 4000 miles and/or 3 months (on street versions only, not competition models)

How much better indeed? This review came from the September 1966 *Motor Trend*. From the same era, an original Carroll Shelby advertisement, at right.

Do you trust your wife?

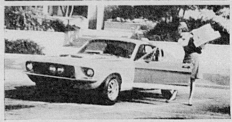

You can — when she's driving a Shelby GT 350 or GT 500!

Performance cars? Emphatically —but in the Carroll Shelby tradition of *safe* performance.

That's why the Shelby GT 350 and GT 500 feature a competition-approved overhead safety bar, eye-level turn indicator and brake light, disc front brakes, wide-path nylon high-performance tires, modified suspension, adjustable shock absorbers and crisp 16-to-1 steering ratio. These safety and performance features are not found on other new cars, but are *standard* items on the GT 350 and 500. Power assist on steering and brakes, plus exclusive new shoulder harnesses, are low-cost options.

These great cars offer performance without temperament. The GT 350 features the Cobra V-8, Shelby-ized to produce 306 horsepower. The GT 500 is equipped with a street version of the 1966 LeMans winner's 428 cubic inch engine. So mannerly are these engines that heavy-duty automatic transmissions are available (four-speed, all-synchro manual transmissions are standard).

Exclusive, functional Shelby styling ices the cake . . . yet with all their goodies, these are the lowest-priced *true* GT cars you can buy.

Suddenly, everything you (and your wife) ever wanted in a car is here! See your Shelby dealer now.

SHELBY G.T. 350 and 500 The Road Cars

Powered by Ford

Shelby American, Inc., 6501 West Imperial Highway, Los Angeles, Calif. 90009. Builders of the Cobra, Manufacturers of Cobra high performance parts and kits.

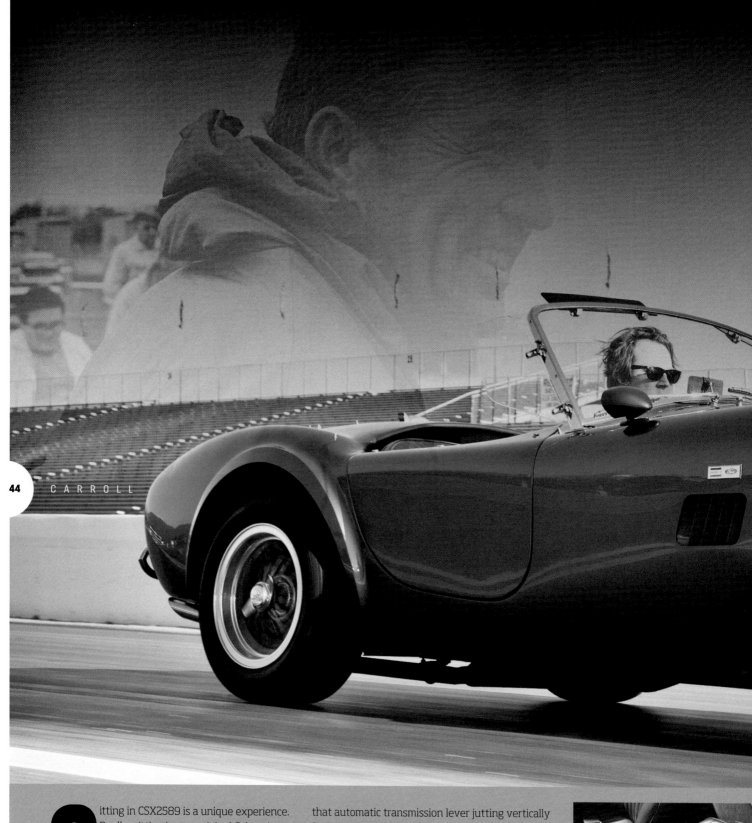

CARROLL

Sitting in CSX2589 is a unique experience. Really, sitting in any original Cobra–just 655 were built–is a unique experience, but this one even more so. It's not just that this very car was the last 289 Cobra to roll off the production line before Shelby made the switch to 427s. It's not even that the very seat I'm sitting in is the same seat Carroll Shelby sat in for nearly five decades (Carroll was the car's first and only owner). What really catches my attention is

that automatic transmission lever jutting vertically from its plastic housing on the center tunnel.

Yes, the last 289 Cobra ever made (built in 1965, the same year that the slippery-profiled Cobra Daytona Coupe won the FIA manufacturer's championship for sports cars) was equipped with a slushbox. Now, that's an unusual transmission to find factory-installed in a Cobra, but it might not be as rare as you'd think. The actual number of factory-built automatic Cobras varies, depending on

HIS OWN SNAKE

You'd think Carroll's CSX2589 would have a manual transmission. Nope.

WORDS RORY JURNECKA
PHOTOGRAPHS EVAN KLEIN

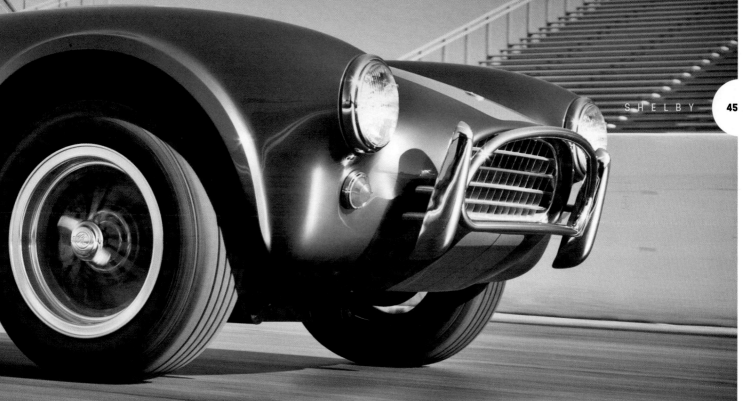

whom you ask. Original Shelby American shipping invoices seem to point at 16 cars built with an automatic transmission, while others insist that as many as 20 289s were built without clutch pedals.

The gearbox itself was a beefed-up variant of Ford's new-for-1964 three-speed C4 automatic, the aluminum-cased transmission first designed for use in the Ford Mustang and its Fairlane stablemate. The Hi-Po version that served in the Cobra was also used in the 1965 Fairlane (this stronger C4 wouldn't come

to the Mustang until 1966). The special transmission necessitated several small changes to specification. For one, a unique Autolite carburetor was fitted with an automatic choke (four-speed cars got a manual choke). According to Cobra historians, automatic-equipped Cobras were also given slightly different engines from those of their four-speed counterparts: Manual transmission bellhousings were attached with five bolts, but the new automatic required six, necessitating a different engine block.

HIS OWN SNAKE

Per the Shelby American Automobile Club registry, original invoices show that CSX2589 was the last 289 Cobra roadster to be shipped to Shelby American from AC Cars Ltd., departing in late October 1964. It arrived at Shelby's Los Angeles headquarters with Iris Rouge paint (think metallic maroon) and a black interior, and the car received its six-bolt 289 and C4 transmission. Immediately, the Cobra entered service as a company demonstrator. It shuttled automotive journalists, potential customers, and other Shelby clients for almost a year, racking up nearly 1400 miles by early 1965. Carroll, perhaps recognizing the car's significance, purchased CSX2589 in May 1966, making him the Cobra's first and only registered owner.

One change was made to the car right off the bat. Shelby ditched the original single four-barrel Autolite for twin two-barrel Weber carburetors. Much more extensive changes were to come. Enter Mike McCluskey. Today, Mike is owner of McCluskey Ltd. restoration, a Cobra specialist shop that has

worked with Shelby American on several occasions. In 1971, McCluskey was just a car-crazy college kid wrenching on his Sunbeam Alpine. Shelby happened to live in the same part of Playa del Rey, and the two struck up a neighborly friendship. Shelby was impressed with McCluskey's work on the Alpine, and asked if he'd like to take on another project, namely, giving CSX2589 a cosmetic refresh, along with some serious modifications.

"What he had me do was build it with a 351 Cleveland motor and also strip it and do the body

CARROLL

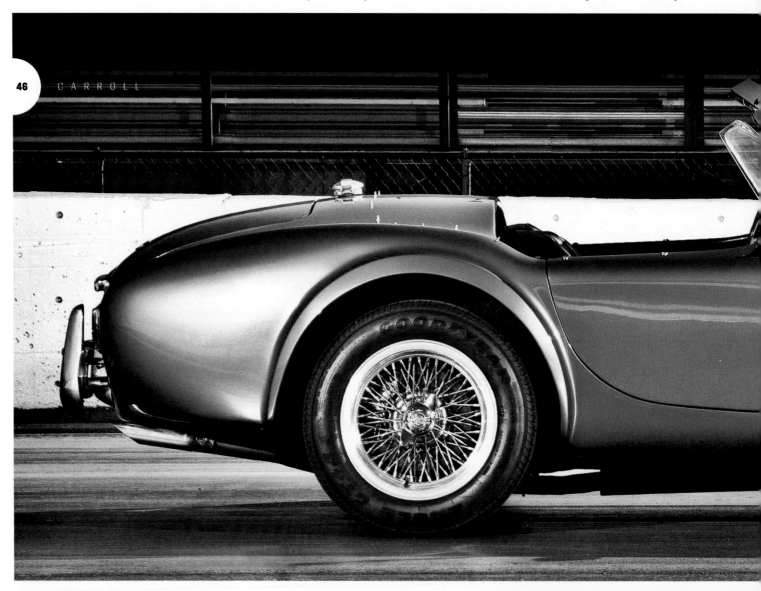

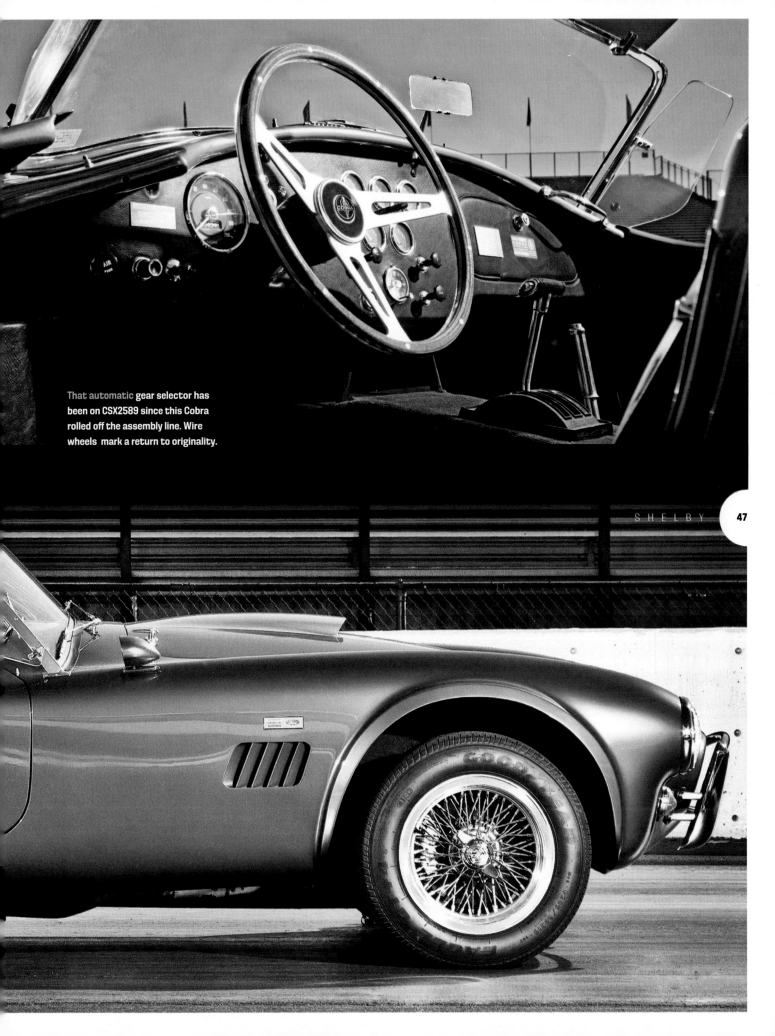

That automatic gear selector has been on CSX2589 since this Cobra rolled off the assembly line. Wire wheels mark a return to originality.

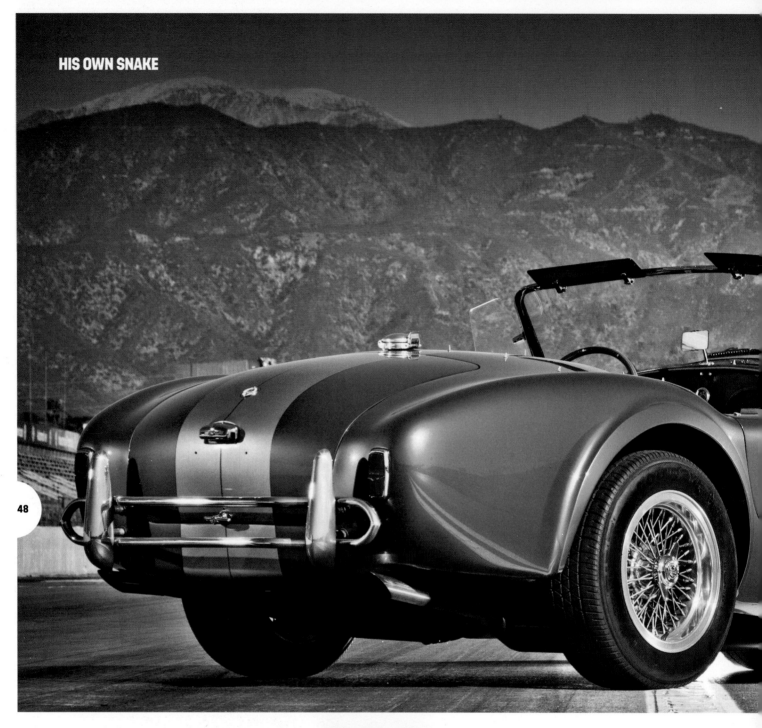

and paint," McCluskey recalls. "About that time, he was making wheels, so we put some different knockoff rims on it. He said to 'paint it blue' and do whatever else I wanted to do to it."

In the intervening months, the original 289 was replaced with the considerably heavier cast-iron Cleveland engine (though the automatic was retained), a hood scoop was added, and the body was treated to a respray in Targa Blue, a Corvette color, with gold center stripes. The black interior was freshened, a full-width rollbar was fitted, and a set of Shelby's slotted aluminum alloy wheels replaced the original wire-spoked rims.

"We wouldn't do it that way now, but that's how things were in the '70s," says McCluskey with a

hint of regret in his voice. In those days, to Carroll Shelby, at least, CSX2589 was mostly just an old Cobra. As with many other important sports cars of the day, preserving originality wasn't a foremost concern. Shelby drove the car with its 351 for roughly a decade, until giving McCluskey another call in the early 1980s.

"Shelby didn't like the engine; he was never totally happy with it," McCluskey recalls. "It was just a pig. For that size car, with the weight of the 351 and the heat it gave off, it just wasn't worth the effort."

By this time, collector cars such as the Cobra were also gaining steam in the marketplace, with values growing and collectors beginning to place strong importance on originality. McCluskey told Shelby

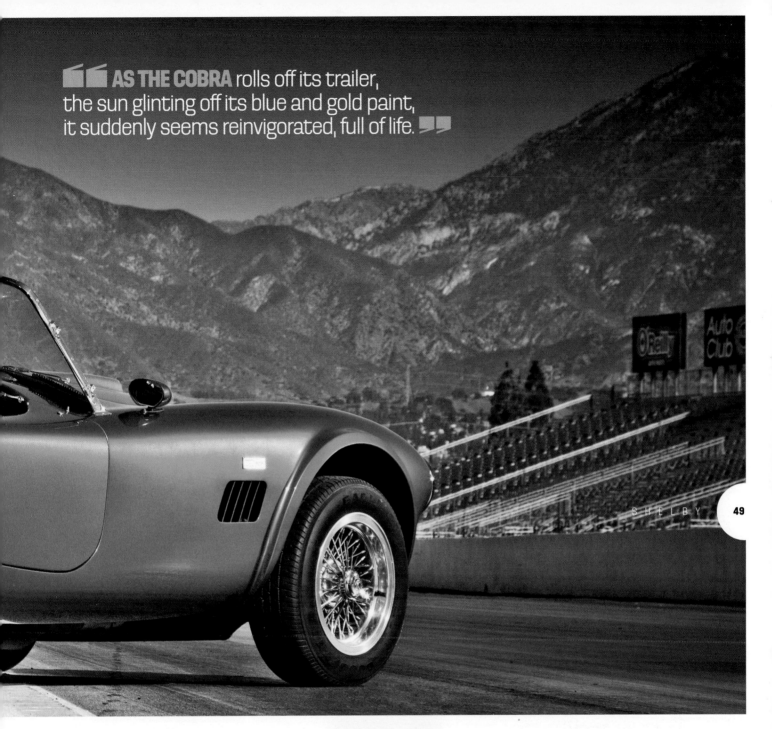

AS THE COBRA rolls off its trailer, the sun glinting off its blue and gold paint, it suddenly seems reinvigorated, full of life.

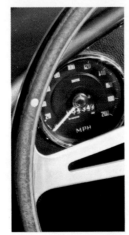

that the 351 swap had devalued the car, but fortunately he had just the solution.

"Shelby had just wanted to throw away the original 289, but I kept it in my shop. About 10 years later, when he decided to go back to stock, I was able to pull it out of storage, rebuild it, and swap it back out."

So back went CSX2589 to McCluskey's shop, where the original 289 was rebuilt to stock configuration and reinstalled, along with the original wire wheels, and the rollbar was removed. McCluskey wanted to take things further by repainting the car its original color, but Shelby thought the non-factory blue-and-gold combination was just fine the way it was. Since that work was completed,

according to McCluskey, the Cobra has done more sitting than driving, largely serving as a display piece in Shelby American's Las Vegas H.Q.

"He didn't drive it much. You'd normally see him in one of the Mustangs or even some of the Chrysler stuff," McCluskey explains. "For his size and stature, the 289 Cobra just wasn't very comfortable."

That didn't stop us from taking a turn behind the wheel when Shelby American gave us the approval. There were stipulations, as you might expect of a car said to be valued in the multi-millions of dollars (Shelby's personal 1966 Super Snake Cobra, also automatic equipped, sold at a 2007 auction for more than $5 million). We couldn't drive it on public roads, for one. And it couldn't be driven above 40 mph.

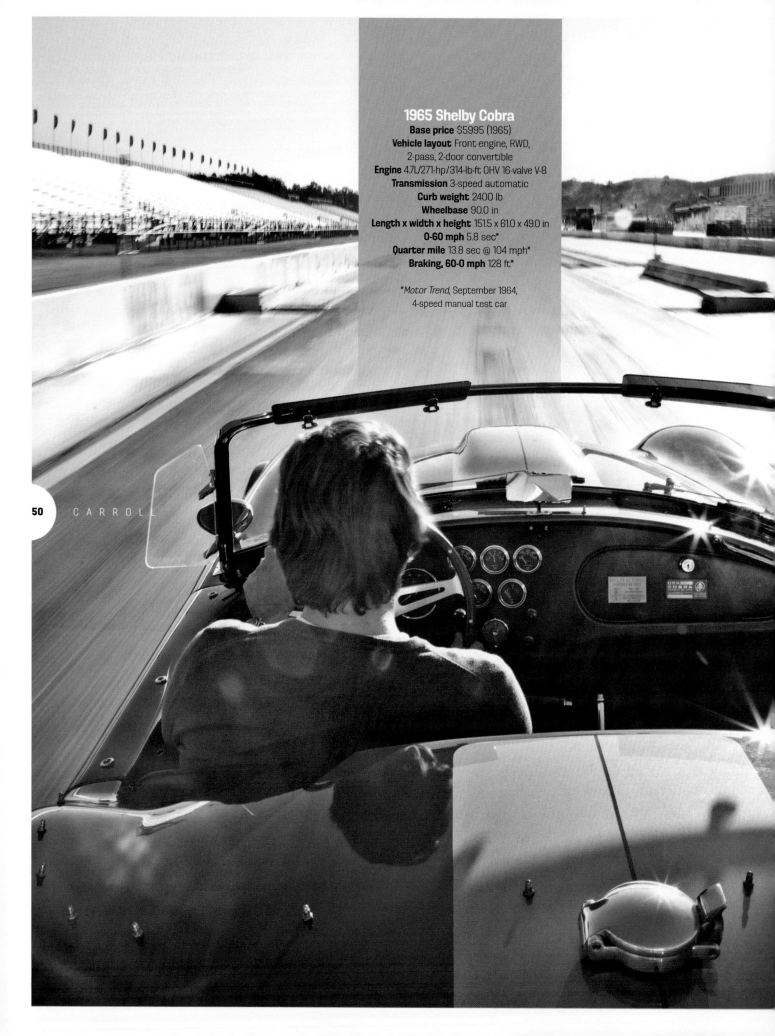

1965 Shelby Cobra

Base price $5995 (1965)
Vehicle layout Front-engine, RWD, 2-pass, 2-door convertible
Engine 4.7L/271-hp/314-lb-ft OHV 16-valve V-8
Transmission 3-speed automatic
Curb weight 2400 lb
Wheelbase 90.0 in
Length x width x height 151.5 x 61.0 x 49.0 in
0-60 mph 5.8 sec*
Quarter mile 13.8 sec @ 104 mph*
Braking, 60-0 mph 128 ft*

Motor Trend, September 1964, 4-speed manual test car

CARROLL

Nevertheless, we trailered up CSX2589 as quick as we could and headed to the Auto Club Raceway in Pomona, California. The dragstrip is on the Pomona Fairplex grounds, once home to SCCA races, where a Cobra scored one of its early victories in 1963.

When we first view the CSX2589 in the dimly lit garage space of Shelby's Gardena, California, shop, it looks old and tired. But as the Cobra rolls off its enclosed trailer, the sun glinting off its blue and gold paint, it suddenly seems reinvigorated, full of life. McCluskey's restoration has survived well these past decades–the paint is still shiny and the interior is patina'ed, but not worn out. The wooden steering wheel's varnish is worn; the brightwork isn't as shiny as it might have once been; and the driver-side windwing is cracked near its hinge. Other than that, the car is hard to fault. Dash plaques bear testament to Shelby's ownership and McCluskey's restoration work. Look closely and you'll still see the rollbar mounting points located behind the seats.

The biggest question on everyone's mind: Will it start? We've been assured it will. A gallon of premium

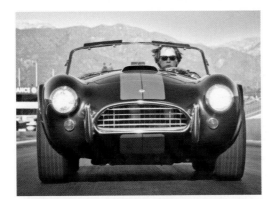

is carefully funneled into the aluminum fuel filler aft of the Cobra's cabin, and the lid is latched closed with a metallic clink! We're ready for ignition.

We flick the dash-mounted switch to engage the fuel pump, hold the throttle to the floor, twist the rather short key, and the Cobra fires into life with a growl, then settles into a lumpy 2500-rpm idle, as indicated on the Smiths tachometer (the speedo is also a British Smiths unit, but the rest of the gauges are American Stewart Warner equipment). Slipping the automatic gearshift (man, this is strange!) through reverse, neutral, then drive brings a lurch and a chirp from the rear tires. Best to keep the brake firmly engaged until you're really ready to go. This snake is rearing to strike.

Moving off, the steering is initially heavy, but lightens up by 20 mph, around the speed where the Cobra decides to shift into second gear with another lurching chirp, despite accelerating gently. Having just driven a modern CSX8000 continuation car with a five-speed, it seems strange not to be reaching for the notchy shift lever and stabbing at a clutch pedal that feels like a piece of gym equipment. There's a definite transformation in feel from would-be canyon racer to boulevard cruiser or, even better, Saturday night Stoplight Grand Prix champion. That's not a bad thing, just different. Still, the question remains. Why the automatic? McCluskey offers his interpretation.

"Shelby was always a fan of automatics. A Cobra with an automatic isn't really what you think of today, but he was sort of pushing for that. He built a few 427s that way also."

Hey, if a slushbox was good enough for Carroll, it's good enough for us.

51

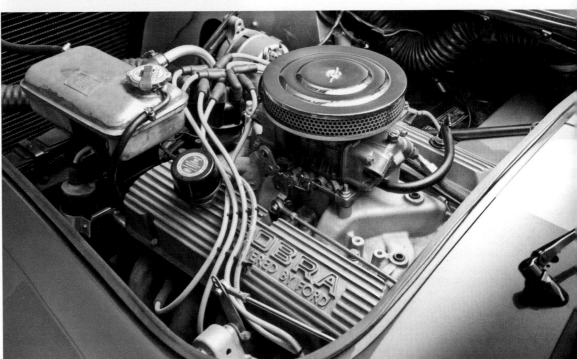

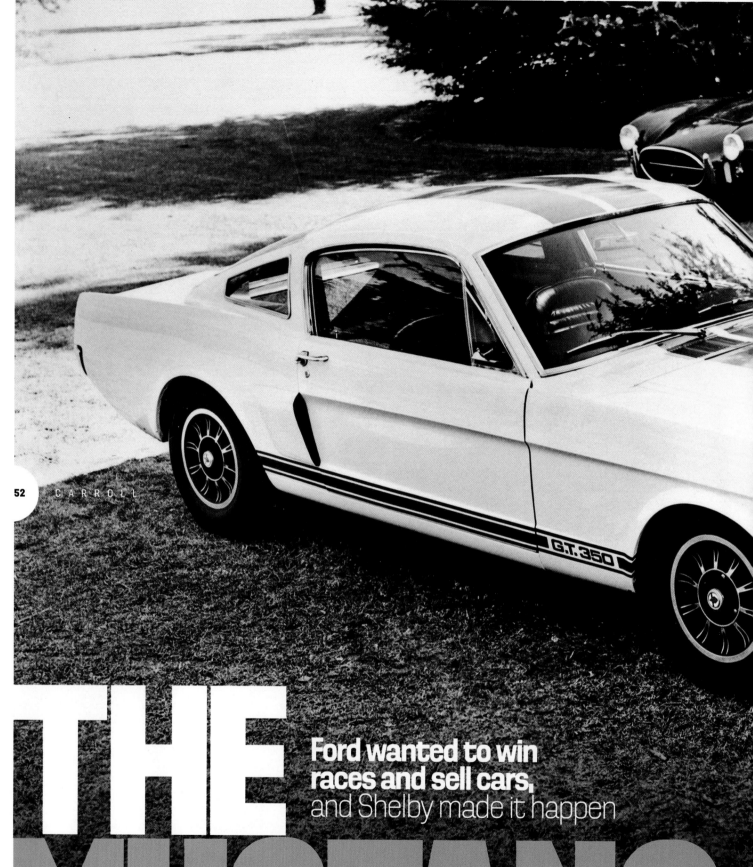

52 CARROLL

THE MUSTANG

Ford wanted to win races and sell cars, and Shelby made it happen

ERA

WORDS TOM CORCORAN

By mid-1964, Lee Iacocca was on his way to quadrupling Ford's sales projections for the popular new Mustang. Yet Ford needed more. While horsepower and ponycar styling were paying off in sales, the $6000 Cobras were out of the average buyer's range, and the Mustang lacked muscle and the image to go with it. Pontiac's Tempest had a 389 V-8 with three two-barrel carburetors. Chevy fit a 327 into its "Corvette-powered" Chevelles and Chevy IIs. Buick, Plymouth, and Dodge all offered huge V-8s.

Ford also wanted to compete against the Corvette, but the SCCA did not consider the Mustang a "sports car" because it wasn't a two-seater. In August 1964, Ford turned to Shelby for a solution.

He was a busy man. Shelby's projects included phasing out the 289 Cobra, starting to build 427 Cobras, racing the Cobra-based Daytona Coupes, and rebuilding and racing the GTs Ford wanted him to turn into world-beaters. Turning the Mustang into a street success and race winner would require moving his workshop from Venice, California, to a larger plant adjacent to Los Angeles International Airport.

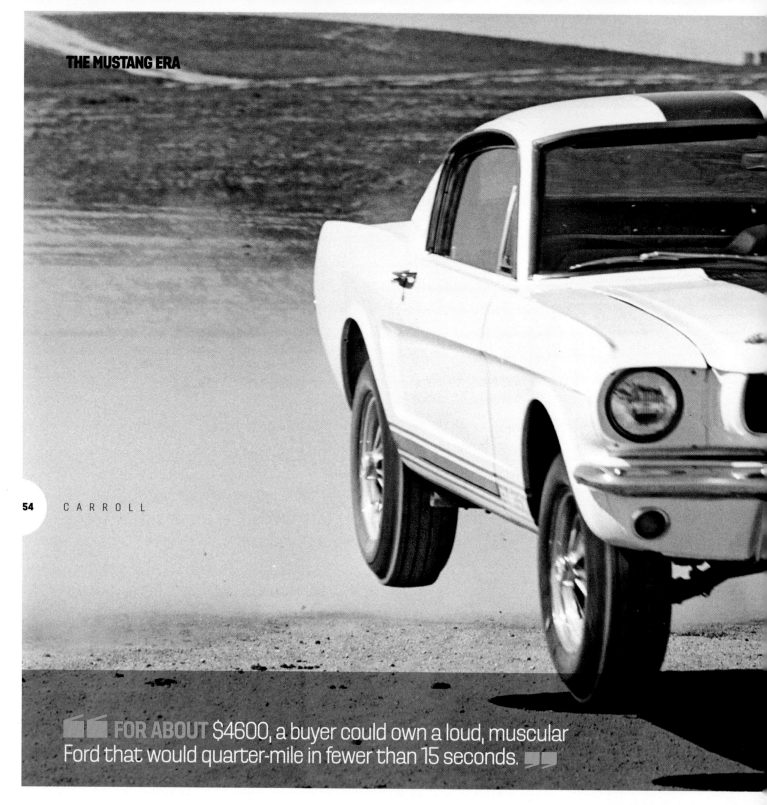

CARROLL

FOR ABOUT $4600, a buyer could own a loud, muscular Ford that would quarter-mile in fewer than 15 seconds.

Shelby met with his production bosses, and then conferred with John Bishop at the SCCA. He found that the Mustang fastback could qualify for racing if the street version had no rear seat and was upgraded either under the hood or in the suspension, but not both. Shelby chose to keep the Hi-Po 289 from the street versions and add racing suspension and brakes.

With SCCA approval, Shelby received Ford input and financial backing. He assembled a group to

plan the conversion of 271-hp Mustang fastbacks into street and race cars. Ray Geddes and Sam Smith, from Ford's Special Vehicle Department, and Klaus Arning, Ford's chief suspension engineer, coordinated with drivers Bob Bondurant and Ken Miles. They took two Hi-Po Mustang notchbacks to Willow Springs Raceway and tested shocks, springs, anti-roll bars, and alignments to perfect a performance suspension. Pete Brock designed badging, striping, and scoops. Chuck Cantwell was

For 1965, Carroll Shelby was flying high with the '65 GT350, his "sports car" version of Ford's new Mustang fastback.

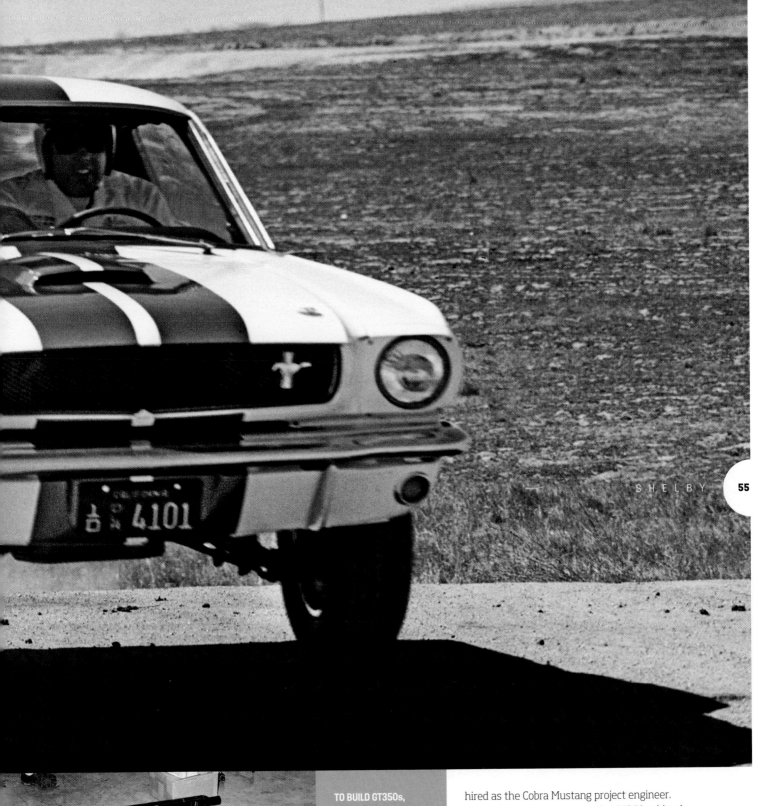

TO BUILD GT350s, Shelby American bolted on aftermarket speed parts like headers, an aluminum intake with a Holley four-barrel carburetor, traction bars, and Koni shocks.

PHOTOGRAPHS: MOTOR TREND ARCHIVE

hired as the Cobra Mustang project engineer.

What came together was the GT350, a blend of special brakes, underhood braces, and a Borg-Warner T-10 transmission, along with wheels, a fiberglass hood, competition seatbelts, and assorted speed parts from Southern California aftermarket shops. For about $4600, a buyer could own a loud, muscular Ford that would cut a quarter mile in fewer than 15 seconds, kick butt at a racetrack with corners, and say "Shelby" on the build plate.

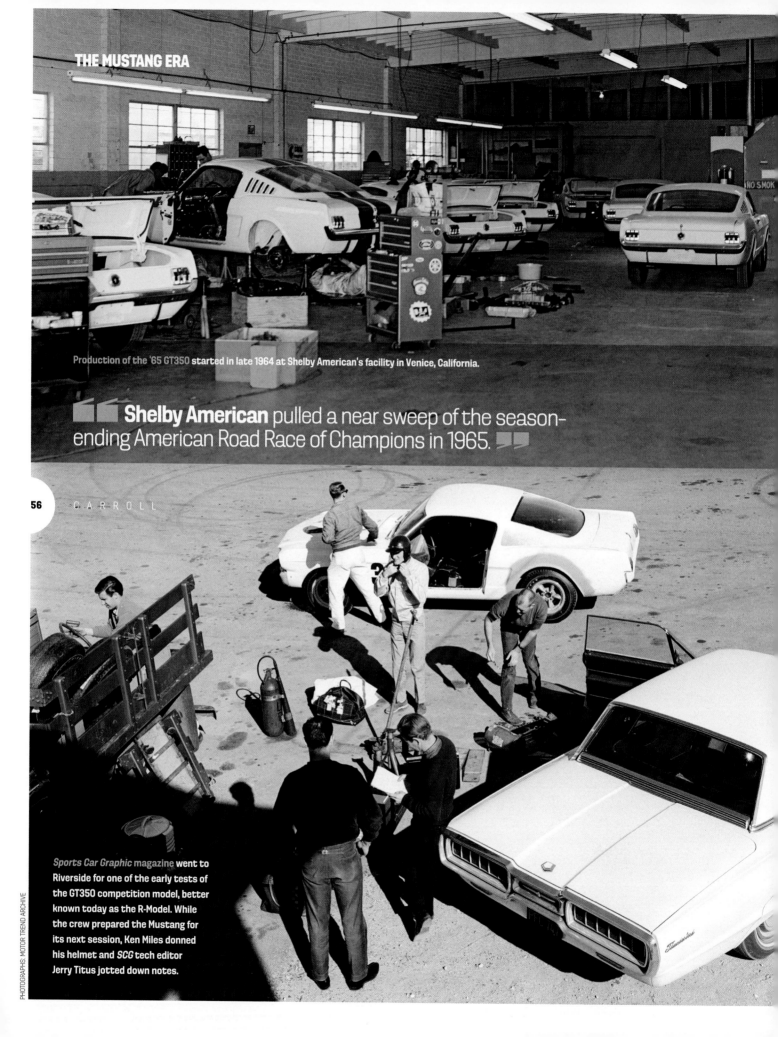

Production of the '65 GT350 **started in late 1964 at Shelby American's facility in Venice, California.**

> **Shelby American** pulled a near sweep of the season-ending American Road Race of Champions in 1965.

C A R R O L L

Sports Car Graphic **magazine** went to Riverside for one of the early tests of the GT350 competition model, better known today as the R-Model. While the crew prepared the Mustang for its next session, Ken Miles donned his helmet and *SCG* tech editor Jerry Titus jotted down notes.

The next step was to "invent" the competition, or R, version. Cobra racing engines were installed in two Mustang fastbacks. The bumpers, badges, headliner, upholstery and insulation, dash pad, hood and trunk latches, sound deadener, seam sealer and undercoating, carpet, and heater-defroster unit were removed. The rear window went away, replaced by Plexiglas slotted at the top for ventilation. A fiberglass apron replaced the front valence, and aluminum panels covered the holes left by removing the C-pillar vents. These changes took off almost 500 pounds.

The team added a 7-quart oil pan, a thicker front anti-roll bar, reworked cylinder heads, an oversized radiator, an oil cooler, a high-rise aluminum intake manifold under a 715cfm Holley, brake cooling ducts, a 34-gallon fuel tank with a quick-release filler cap, a rollbar, a fire extinguisher, and klik-pin closures for hood and trunk.

Raced first by Ken Miles in mid-February 1965, then by Jerry Titus in March, the "mule" taught the team how to make the GT350 a winner. Titus drove a second prototype to win that year's SCCA B/Production championship, and Shelby American pulled a near sweep of the season-ending American Road Race of Champions.

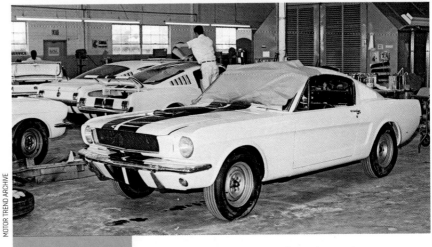

MOTOR TREND ARCHIVE

(Above) A couple of GT350s get their over-the-top Le Mans stripes.

With the GT350 added to Shelby American's production schedule, Carroll Shelby moved his growing company to larger facilities at the Los Angeles International Airport in March 1965.

The automotive press went berserk over the GT350. Carroll Shelby sold 562 street versions for 1965–a huge nine-month run for a specialty shop.

Again, Shelby had delivered. Ford was elated.

Only one problem: Ford had subsidized Shelby's Mustang conversions and lost money on each one sold. With GT350 production about to enter a new model year, Dearborn decided to advise Shelby American on how to cut its losses and boost sales.

Ford dealers and many buyers weren't overjoyed with Detroit Locker differentials, no back seats, no automatic transmissions, and one color choice. Dearborn wanted to "refine" the '66 GT350

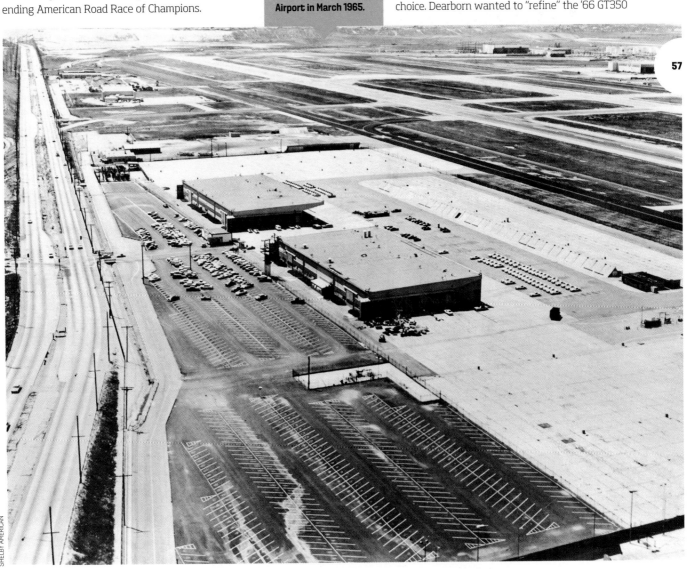

SHELBY AMERICAN

for a broader sales appeal. Shelby went along. He had a huge operation in a new building and employees dependent on salaries. Base priced at $4428, the '66 models could be ordered with automatic transmission, air-conditioning, Paxton superchargers, and four available colors with white stripes, plus Wimbledon White with blue stripes.

In September 1965, Peyton Cramer, Shelby American's general manager, suggested to Hertz that the company add a few GT350s to its Sports Car Club fleet–performance rental cars for "mature" customers. In November, Hertz shocked Cramer with a commitment for 200 cars. They'd be black with gold striping, chrome Magnum 500 wheels, and GT350H side striping.

Elated, Shelby planned that all 200 cars would be delivered to Hertz by February. Ford suggested a joint Shelby-Hertz ad campaign to promote the rentals and it got a green light. Then, on December 21, Cramer received a revised order: Hertz would need 1000 cars. Merry Christmas, Carroll.

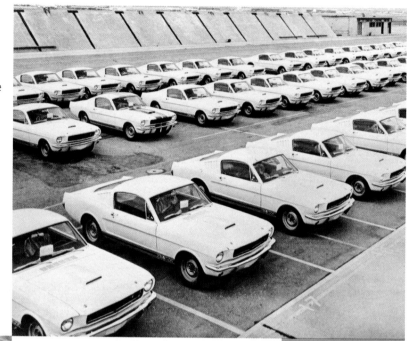

In His Own Words

"I remember when Iacocca wanted us to build the GT350. We had five or six meetings. A planeload of people came from Detroit trying to decide what to call it. And after about the third meeting, I said, 'If Nissan can have Ladybird as the name of their sport car, a name doesn't make a car. A car makes a name.'

So and I said to one of our guys, 'How far is it to that building over there?'
"And he said, 'What the hell you talking about?'
"And I said, 'Step it off.'
"He came back and said 'It's 348 paces.'
"I said, 'We're going to call it the GT350, and you guys can go back to Detroit.'"

The joint ad campaign gave the GT350 national exposure through TV, magazine ads, movie cameos, and airport and auto show displays. Non-Hertz GT350s, with their "refinements," sold twice the '65 output. But all this ushered in a new era. Ford's involvement in the design and creation of its headline-getters would increase over the next three years, not always to Shelby's liking. Also, the Mustang became larger in 1967 and again in 1969, a factor Shelby could not control. The road-thumping thriller of the first GT350s would evolve into a cushy "road cruiser" by 1969 and 1970.

But let's not forget that Shelby started this whole enterprise because he wanted to go racing.

Completed GT350s were staged behind the Shelby American buildings to await shipment to Ford dealers. Note the plain steel wheels (optional Shelby/Cragar wheels were shipped separately for installation by dealers) and the lone car with Le Mans stripes.

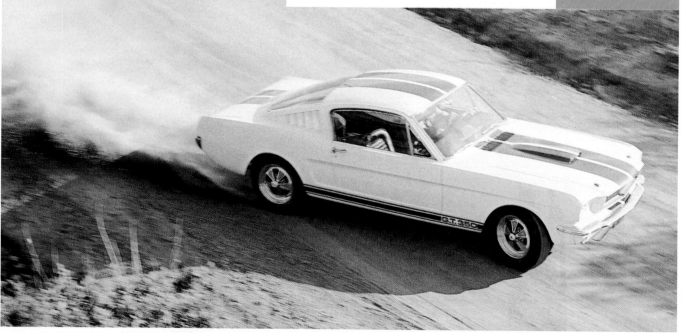

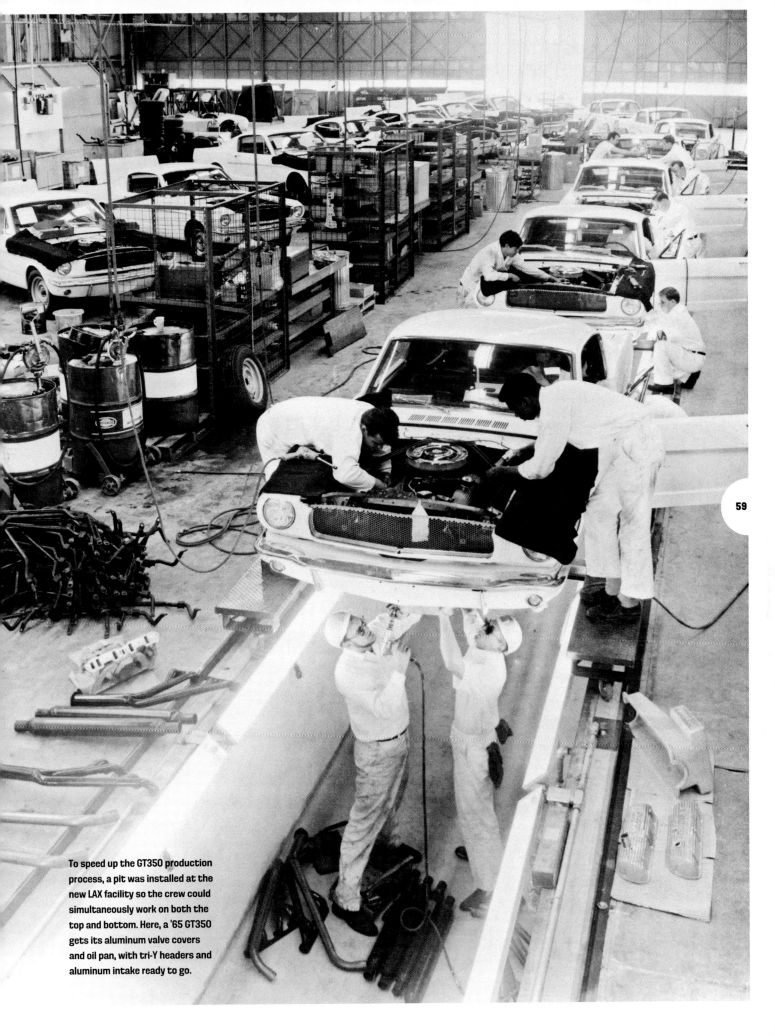

To speed up the GT350 production process, a pit was installed at the new LAX facility so the crew could simultaneously work on both the top and bottom. Here, a '65 GT350 gets its aluminum valve covers and oil pan, with tri-Y headers and aluminum intake ready to go.

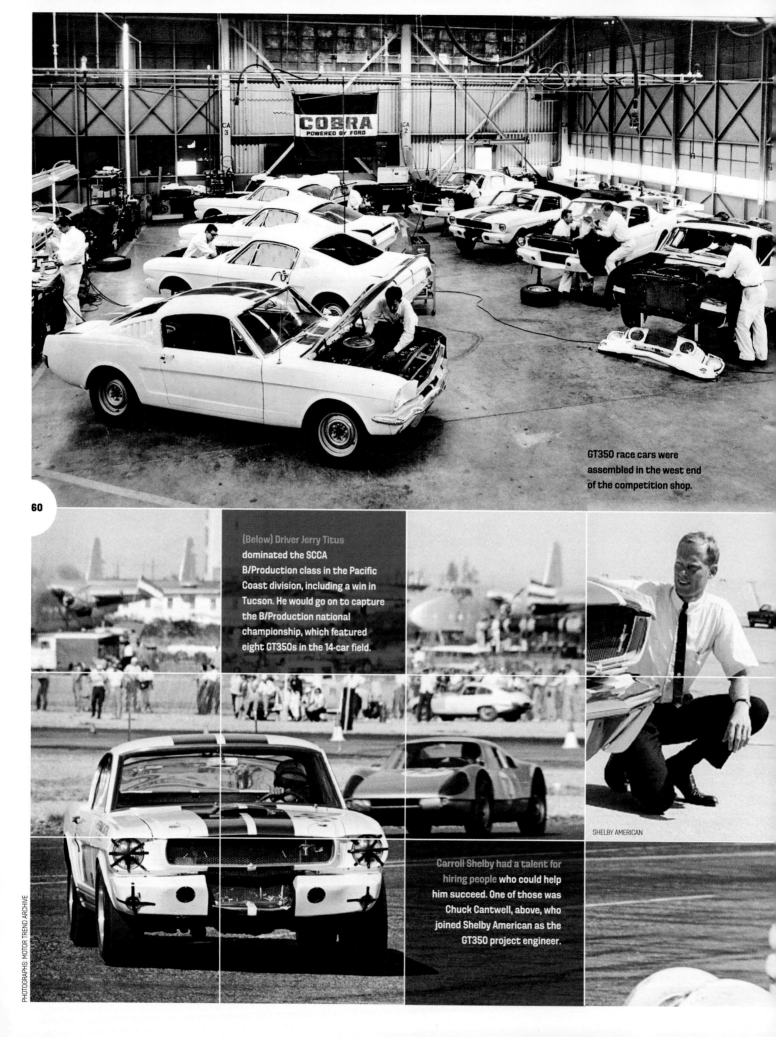

GT350 race cars were assembled in the west end of the competition shop.

(Below) Driver Jerry Titus dominated the SCCA B/Production class in the Pacific Coast division, including a win in Tucson. He would go on to capture the B/Production national championship, which featured eight GT350s in the 14-car field.

SHELBY AMERICAN

Carroll Shelby had a talent for hiring people who could help him succeed. One of those was Chuck Cantwell, above, who joined Shelby American as the GT350 project engineer.

An order for 200 GT350H models for Hertz expanded to 1000 cars when the '66 Shelby was added to the Hertz Sports Car Club rental offerings. Most were Hertz colors— black with gold stripes— although other exterior colors were available.

In getting permission to build GT350s—which was Ford's idea in the first place—Shelby got to extend the fun far beyond Cobras. For the next five years, Shelby-blessed Mustangs would rule B/Production and Trans-Am racing.

For 1967, the GT350 and new big-block GT500 were promoted as the "Road Cars." Ads in late 1966 pushed the Shelby racing heritage, but performance upgrades were "safety" improvements. This was no longer a race car made street legal, but the larger Mustang still had plenty of grit. Instead of accepting Ford's new 390 engine, Shelby dropped a dual-quad 428 in the new GT500 for only $200 extra at retail. The fiberglass hood was 4 inches longer than a Mustang's. It had grille-mounted headlights, a rear spoiler, side scoops on the C-pillars and rear quarters, wide Cougar taillights, and a rollbar. Then came the comfort: power steering, automatic transmissions, deluxe interior, and air-conditioning. Obviously, Ford wanted to sell cars.

Carroll Shelby was hooked on racing. He still wanted to build cars to support his habit, and he wanted Ford's support. Building the bigger cars was a way to maintain cash flow and stay tight with Ford. He'd learned to be a juggler as well as a competitor—especially since Ford proved its hunches with sales. If you discounted the huge Hertz order, 1967's total build-out tripled that of 1966.

That fact guaranteed that the '68 Shelby would be sold as a status symbol. Changes that year included the front and rear Shelby redesign. The aggressive grille opening and wide '65 Thunderbird taillights allowed the Shelby to stand out. Was there a downside? The 302-4V in place of the race-proven Hi-Po 289. An upside? The 428 Cobra Jet in what was designated the GT500KR, a genuine performer, introduced late in the model year.

But the huge change, due mainly to logistics, was the split of Shelby American into three separate companies. The manufacturing sector, renamed

For 1966, Ford influenced Shelby to open up the GT350 to more potential customers by offering a choice of colors, automatic transmission, air-conditioning, and a full back seat. Side scoops and quarter-windows in place of the fastback's factory vents were model year upgrades.

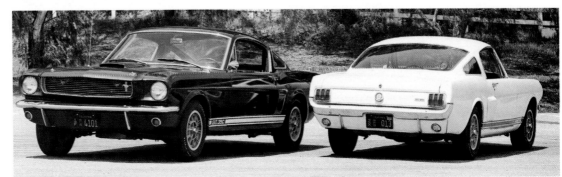

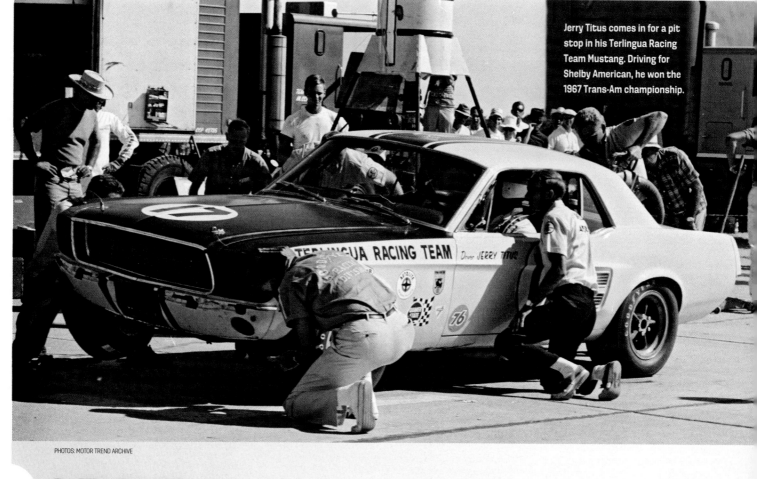

Jerry Titus comes in for a pit stop in his Terlingua Racing Team Mustang. Driving for Shelby American, he won the 1967 Trans-Am championship.

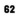

In His Own Words

"Did you ever know where the KR name came from? Lee Iacocca had an assistant named Hank Carlini that kept an eye on what Chrysler and General Motors were doing. And he said, 'Did you know that Corvette is coming out with King of the Road? They're fixed to announce it in two weeks, and here's the brochure.'

"So I called my trade-dress lawyer in Washington–it was about 3 o'clock in the afternoon–and said, 'I want to know if King of the Road has been copyrighted.' He said he'd find out in the morning. So I said, 'I'll have another trade-dress lawyer by in the morning. I want to know now.' He called me back in about an hour and said it wasn't taken. I said, 'You better be there at 8 o'clock in the morning to take it.' He did. I called 3M to make the decals, GT500KR. We could move fast. If that had been back at Ford, it would have been 12 committee meetings."

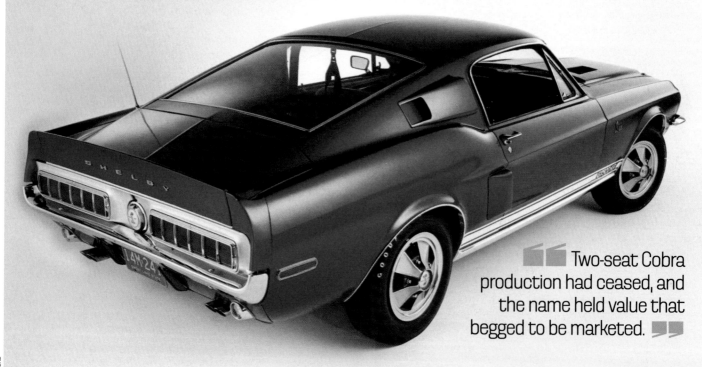

❝ Two-seat Cobra production had ceased, and the name held value that begged to be marketed. ❞

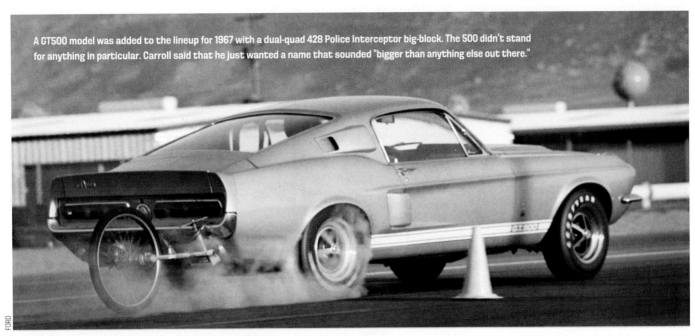

A GT500 model was added to the lineup for 1967 with a dual-quad 428 Police Interceptor big-block. The 500 didn't stand for anything in particular. Carroll said that he just wanted a name that sounded "bigger than anything else out there."

Shelby Automotive, Inc., went to Michigan, with the A.O. Smith Company in Ionia handling '68 production. The Shelby Parts Company, in Torrance, California, handled aftermarket component sales; it later moved to Michigan and was renamed Shelby Autosports. And Shelby formed the new Shelby Racing Company, also in Torrance. This facility would build and race-prep '68 Mustangs for the SCCA Trans-Am series, as well as several other race cars.

Why Michigan? The lease had run out for Shelby's

In addition to GT350s for SCCA racing, Shelby was enlisted to help with the Mustang's first foray into Trans-Am competition by preparing the Group II Mustang hardtops. With Mustang leading the points chase with one race to go, Shelby tapped Jerry Titus to drive. Titus nailed down the first Trans-Am championship for Mustang.

large building near the Los Angeles airport. That was just as well. The plant had looked huge in 1965; by late 1967, Shelby had outgrown it. Also, Ford felt the San Jose assembly plant could no longer provide base Mustangs without diminishing its production for the Western states. Even Dearborn couldn't meet projected needs. Mustangs destined to be Shelbys were made in Metuchen, New Jersey, and shipped by rail to Ionia for completion. The cars would be Shelby Cobras rather than just Shelbys. Two-seater Cobra production had ceased, and the name held value that begged to be marketed. It also offered a tie-in to aftermarket parts sales and, in late spring, the Cobra Jet era.

Shelby's reaction to all this? He posed for Ford's photographers next to the new models. Pictures of a smiling Shelby casually leaning against '68 Shelby Mustangs were included in full-page ads destined for

63

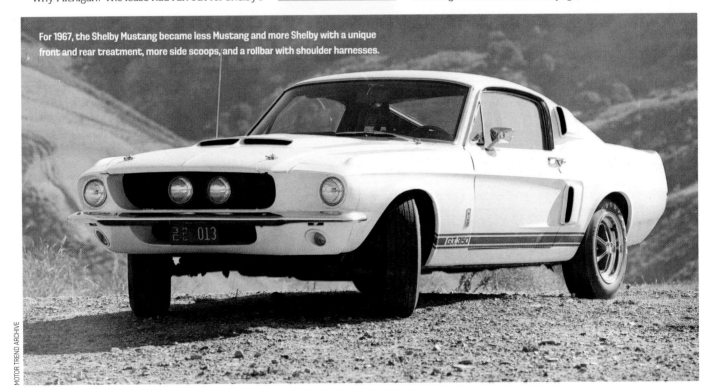

For 1967, the Shelby Mustang became less Mustang and more Shelby with a unique front and rear treatment, more side scoops, and a rollbar with shoulder harnesses.

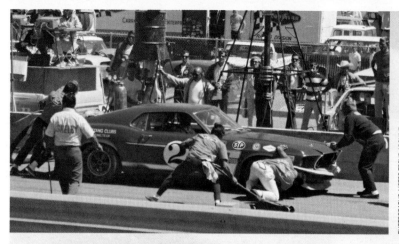

Shelby's racing exploits with Ford came to an end after the 1969 Trans-Am season. Shelby Racing fielded two Boss 302 Mustangs as part of Ford's two-team (with Bud Moore) effort.

Ford built the production Shelby Mustangs for 1968; Carroll Shelby preferred to stay closer to racing. Here, Shelby (right) discusses strategy with team manager Lew Spencer and driver Jerry Titus.

When Ford introduced the 428 Cobra Jet engine in mid-1968, the Shelby GT500 switched to the new, more powerful big-block and became the GT500KR. In its November 1968 issue, *Hot Rod* magazine tested a pair of GT500KRs–this fastback and a convertible. The lighter four-speed fastback ran a 14.04-second quarter mile at 102.73 mph; the heavier automatic convertible managed 14.57 seconds at 97.71 mph.

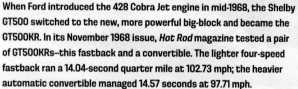

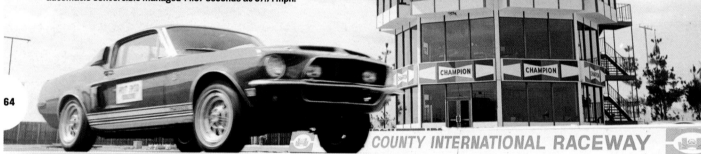

64

Ford designers influenced the '68 Shelby and a convertible was offered for the first time. Although the '68s were built by A.O. Smith in Michigan, Shelby didn't mind posing for promotional photos.

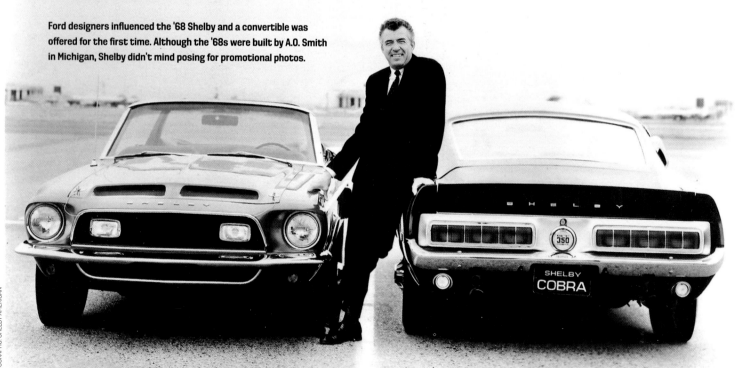

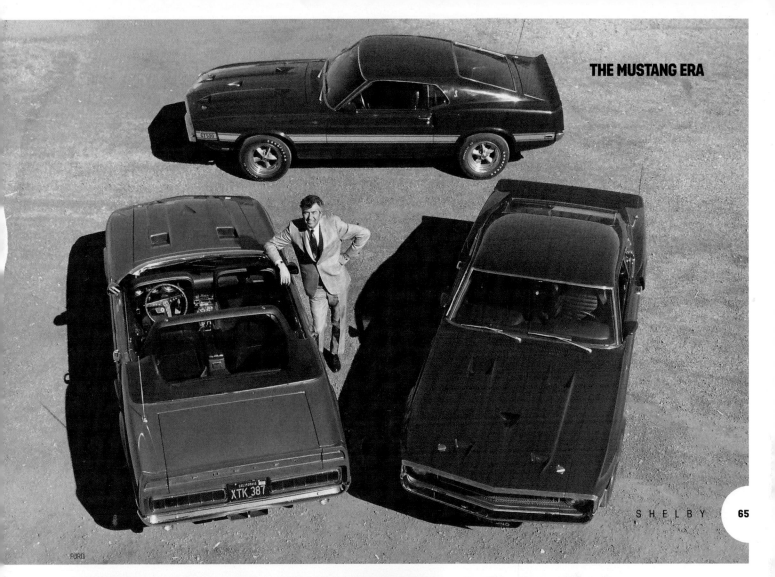

FORD

SHELBY 65

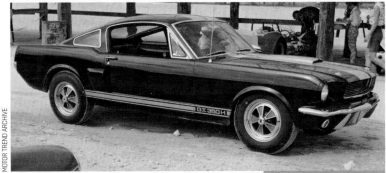

MOTOR TREND ARCHIVE

In His Own Words

"It wasn't that Hertz had people taking them [GT350H Mustangs] out to the racetrack and dragstrip. [Renters] would take them out there and race them, then they'd take the engine out of 'em and put their little 289 two-barrel out of their Mustang in the Hertz. Then they'd take it back to Hertz with the two-barrel in 'em."

For what they were, the '69-'70 models turned out well. The GT350 was upgraded to Ford's new 351 Windsor, and all GT500s were equipped with the torque-strong Cobra Jet 428. Both models were capable of 15-second or quicker quarter miles. The new design stood out from its Mustang brethren with fiberglass fenders, an extended and scooped fiberglass hood, a unique front bumper, and twin Lucas driving lights under the bumper. The reflective side stripe, moved to mid-door level, was available in four colors to offset the exterior paint. The most distinctive touch at the rear was the center-positioned rectangular outlet for the dual exhausts.

Shelby's admirable finale turned out 1281 small-block cars and 1869 big-block cars in nine months of production. He and Ford agreed to close their Mustang collaboration after the final car sold.

broad-circulation magazines, and in press releases and brochures. Why? There was no question that he would earn royalties on cars produced.

The '69 and '70 model years marked a grand finale. Corporate planners had once again expanded the Mustang—longer, wider, and heavier by 400 pounds—and they had created their own performance cars: the Mach 1, Boss 302, and Boss 429. The GT350s and GT500s were in direct competition with Ford's new Mustang roster, and the Shelbys were miles away from what Carroll had envisioned in 1964 when he'd first agreed to convert Mustangs into gnarly competitors.

By 1969, the Shelby Mustang was more luxury car than sports car, plus Shelbys were competing against Ford's Mach 1 and Boss Mustangs. Carroll ended the Shelby Mustang program in 1969, although a few leftovers were converted into 1970 models.

10,000 MILE ROAD TEST:
SHELBY MUSTANG 350 GT

The editors of the June 1965 issue of *Sports Car Graphic* performed the first-ever extended road test–9000 miles in three weeks, for a total of 10,000 miles. Easy to understand their choice of vehicle, isn't it?

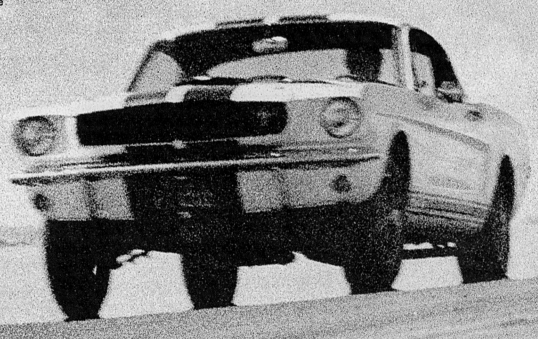

ROAD TEST 11/65: *Through 20 States with a fish-eating horse.*

THIS REPORT MARKS A FIRST in magazine road tests. We've long felt that while our usual test procedures were more than adequate for cars that have been in production for some time, they really are not of sufficient duration to catch all the attributes and faults of a completely new car or one that has been changed substantially from previous models.

It isn't easy to get a manufacturer to turn loose a car for the sort of extensive testing we had in mind, but two have done it so far. One was Carroll Shelby whose Mustang 350 GT is the subject of this report; the other was Alfa Romeo with a 2600, the report on which will follow in a subsequent issue. The procedures varied somewhat but the results were the same. In one case we lived with the car for some months; in this case we did an extensive track test, made a shake-down trip from Los Angeles to San Francisco and back and then did a mad, three-week dash that covered 9,000 miles, 20 states and virtually every sort of weather from 110-degree heat through a dust storm to a mountain blizzard. It is easy to grow to hate a car when one is cooped up in the thing for 12 hours a day over a three-week period under these conditions. One can also fall in love with a machine in the same circumstances. We fell in love with the Shelby Mustang 350 GT.

The Shelby Mustang is something of a brute but a totally attractive one. At first blush it looks just about like the standard fastback that has become virtually ubiquitous all over the country, but at first look only. A second glance (and it draws double-takes without fail) shows there is something more, a purposeful, hulking look about the car that insists on further inspection. We have a strong suspicion, based on experience, that one could park one of these things in the middle of the Mojave desert and draw a crowd in something short of five minutes.

What is this car? It is, basically a three-way crossbreed comprised of Mustang two-plus-two, Cobra and

Galaxie, with an extra couple of touches that are pure Shelby-out-of-Ken Miles (the organization's talented competitions manager).

Semi-complete Mustangs, less hood, are delivered from San Jose to Shelby American's new El Segundo plant where the cross-breeding takes place. Engines fitted are the 306 bhp "street snake" variety, mated to the Cobra close ratio gearbox. This power unit started life as a 271 bhp Fairlane "High Performance" plant, but has been equipped with a high-rise manifold and larger four-barrel Holley carburetor with equal-sized venturis (1.7 inches), headers and the Cobra cam, all of which combine to produce the 306 horses that make the difference between this and the ordinary breed of Mustang in terms of performance. The close ratios of the all-synchro gearbox make this explosive combination very easy to deal with, even in 15 mph school zones, as long as one remembers that shifting is what a gearbox is for. From the gearbox on back, everything is heavy-duty Galaxie and the differential is equipped with a very positive limited slip unit that lets one know in no uncertain terms when it locks and unlocks — one staff member thought he had broken an axle the first time he felt it unlock! Rear drum brakes are chosen from the scad of options originally built for the rally Falcon Sprints, and are equipped with competition shoes. All this metal is held in place by a very hefty pair of radius arms that ride above the springs and locate *inside* the body. This caused a problem on the very early versions in that fumes from the side exhausts were sucked into the slots for these arms and thence into the interior of the car. This has since been cured on subsequent models, and even on the prototypes and pre-production models, by a very neat rubber boot and fiberglass housing that not only seals everything tightly but stops most of the noise from the positively located rear axles which tended to clunk when the limited slip locked or unlocked. All this beef means unsprung weight which is held in check by

Photos: CHARLENE MEGOWAN

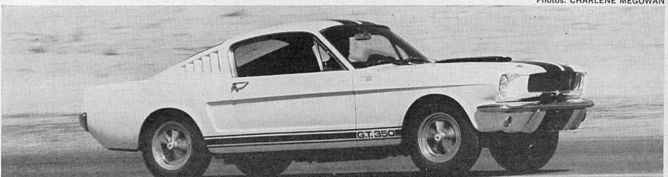

Under heavy acceleration the Shelby Mustang shows slight weight shift to the rear, increasing the bite. Jump is sudden but the tires can be broken loose at half throttle.
Right — Braking is sure and smooth from any speed. As can be seen there is little or no apparent nose drive or rear end lift. In acceleration, braking and flat out the car is totally stable and sure on the road.

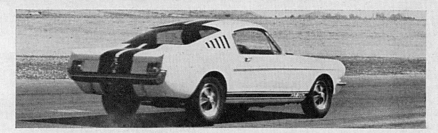

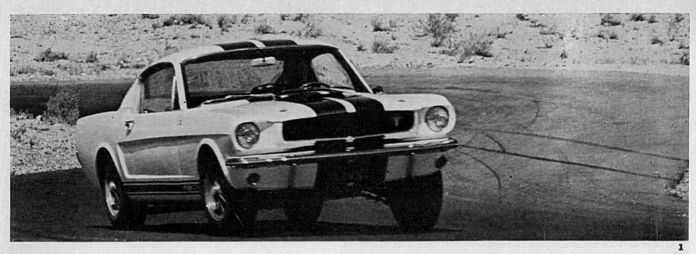

1

MUSTANG 350 GT

heavy-duty Koni shock absorbers that can be set from moderately soft to dead hard. The only time this unsprung weight gets noticeable is on washboard streets when acceleration is wanted. The resulting hopping and skipping is controllable but surprising. The only place we found it really aggravating was New York City, but then that's a place where the only suitable vehicle is a Checker cab anyway — preferably driven by somebody else.

The front end is where the Miles treatment is noticeable. It has been erroneously reported to be decambered but the reworking is much more sophisticated than that. The upper A-arms are relocated downward at their inner pivots, changing the roll center completely. Further changing the roll center is a VERY heavy-duty anti-sway bar. Again all this beef is held in check by Konis. Steering arms and idler arms have been lengthened to increase the steering speed significantly. Brakes on the front are Kelsey-Hayes discs, equipped with very hard pads. Pedal pressure requirements are high but stopping is smooth and firm, with no tendency to lock. The remainder of the handling package comes in the form of Kelsey-Hayes mag-centered, steel rimmed wheels, six inches wide with 7.75 x 15 Goodyear Blue-Streak street tires. The result of these changes is handling that is lighter than the original, far faster, and a change from strong to very light understeer that goes neutral at speed.

At first it seems to want more than a bit of muscle but as one learns to drive the 350 GT this requirement gets to be less and less. For instance we found that while it could be hauled into an early apex in a corner safely, the choosing of a late apex in the same corner made things much easier, faster and smoother. On our test car the ride was, by request, on the hard side but it can be adjusted, as we found when we tried another one with softer settings which would probably be more suitable for the Northeast part of the country. When pressed the Shelby Mustang uses up quite a bit of road, but it is completely predictable, and once one gets the feel of the car this gets to be fun and is easily brought under control. At one point in the track testing we had the car at Riverside and in completely street trim were able to bomb through certain parts of the course including the esses at speeds higher than many all-out racing cars can be run through. At another point during the trip back from New York, in one of the western states, we were able to maintain an average of between 90 and 100 mph over a mountain road for nearly an hour with no strain on driver, passenger or car. It was quite obvious that this car is easily the equal of anything that

Europe has to offer in the GT category, even at three times the price.

Inside the car is comfort and space the equal of any two seater Grand Tourer. The seats are of semi-bucket design standard in the tamer Mustangs but are equipped with wide competition-type seat-belts that hold one firmly in place at all speeds. The wheel, a Cobra unit, is flat as opposed to the dished standard item, and therefore sits at a proper distance inviting the "arms out" driving position. An additional instrument group consisting of a tachometer and oil pressure gauge has been placed in the center of the dash cowl, augmenting the rather sparse standard instrumentation. To the rear, the seats have been removed and replaced with a flat fiberglass shelf which holds the spare tire and all sorts of luggage, groceries, equipment and other impedimenta except passengers. As a matter of fact the

(Continued on page 67)

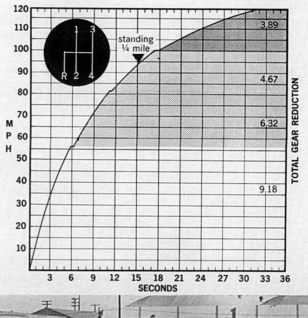

6

2

4

5

1. Upper left — Under hard cornering, even downhill, the GT 350 exhibits little tendency to lean but it does use up road, predictably.
2. Engine in the 350 bristles with Cobra bits and pieces is equipped with high rise manifold and large Holley 4-barrel carburetion.
3. Large sump virtually doubles oil capacity and doubles as an oil cooler, which is needed.
4. End of radius rod comes through flooring and attaches inside car. Note large slot.
5. Slot is sealed by a rubber boot and by fiberglass box to keep out water and fumes.
6. Below — Scotch one canard. The 350 GT is definitely in production, by the yardfull.
7. Right — Here's how it looks from the seat. We suggest that you try it for yourself now!

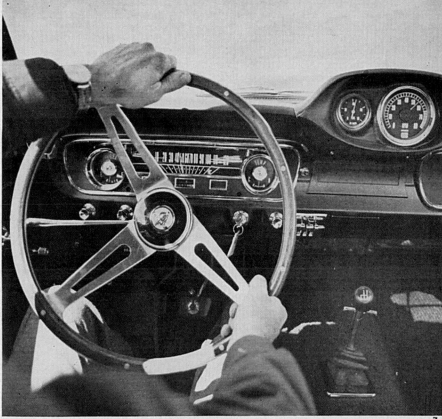

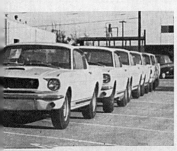

7

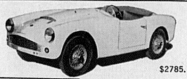
MUSTANG

continued from page 51

luggage space, including the trunk, will hold enough luggage and gear for two people to cover a month's worth of grand touring in the grand manner.

As we said, the 350 GT will draw a crowd anywhere, any time. Part of this crowd appeal is due to the exhaust system which emerges just in front of each rear wheel and announces the presence of the wild oats in rather insistent terms, especially when warming up in the morning. One passenger made the comment that it felt at first as though the pipes came in at each window and plugged in, stethoscope style, at each ear. This is a bit exaggerated but the noise level *is* on the high side until the car gets up to about 70, when the Cobra-like roar turns into a steady buzz for some reason or other, possibly due to distributor advance reaching peak. It was noticed by *Motor Trend's* test crew that their car became noisy when the ignition points closed up, retarding the spark.

All in all, the Shelby Mustang proved to be one of the most reliable sports cars we have ever tested. It went through every conceivable kind of weather, over every conceivable kind of road, with absolutely no trouble of any kind and it is, purely and simply, a sports car in every sense of the word. No car is perfect, at least not in pre-production form (ours was number seven) and the 350 GT was no exception. Most of the faults were of a niggling nature having to do with convenience rather than actual operation. The most glaring was the lack of ability of the windshield wipers to cope with the speeds with which the car can be driven in the wet. At anything over 60 mph the wipers skipped abominably, though the car was stable and secure at far higher velocities on wet pavement. However, how the car behaved under various conditions is the subject of the following episode, as are the adventures of those who would take what could be aptly termed an irresistible hazard into all parts of the country. Next month we'll tell you about that— fuzz, rain, wind, snow, thieves, idiots and all. Don't miss the next episode of the fish-eating horse. —*John Christy*

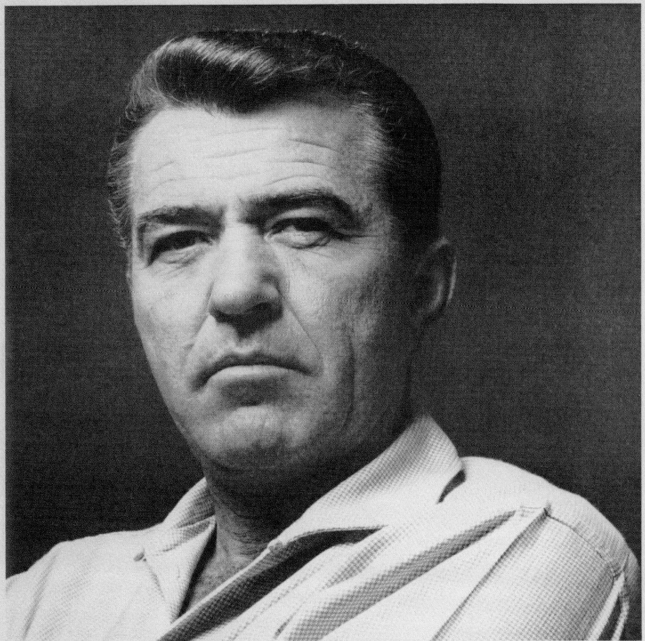

Carroll Shelby, LeMans winner and SCCA national champion, uses Dep for Men

Carroll Shelby just had his hair styled. Any comments?

One comment. If you think that makes him anything but rugged, you're out of your head.

Shelby's a lot like those GT 350's and 500's he builds out at Shelby American. And that's plenty rugged. So how come the hair stylist? Simple.

Shelby's got a head of hair that's as tough and wiry as he is. And no time to fool around, trying to make it look neat. So once every three weeks he saves time by getting a professional styling job.

His stylist cuts his hair wet. And cuts it in the direction it grows, so every hair stays where it belongs, even while it's growing out. That's what hair styling is all about.

Then he sets and grooms it with a clear, non-greasy gel called Dep for Men, finishes off with some Dep for Men Hair Spray, and Carroll looks like a million.

All Shelby has to do to keep on looking like a million is use a little Dep for Men each morning. It's non-alcoholic and won't dry his hair out.

If you'd like to look like a million, get your hair styled. And don't forget the Dep for Men.

Dep for Men Gel in Regular or new Dry Hair formulas

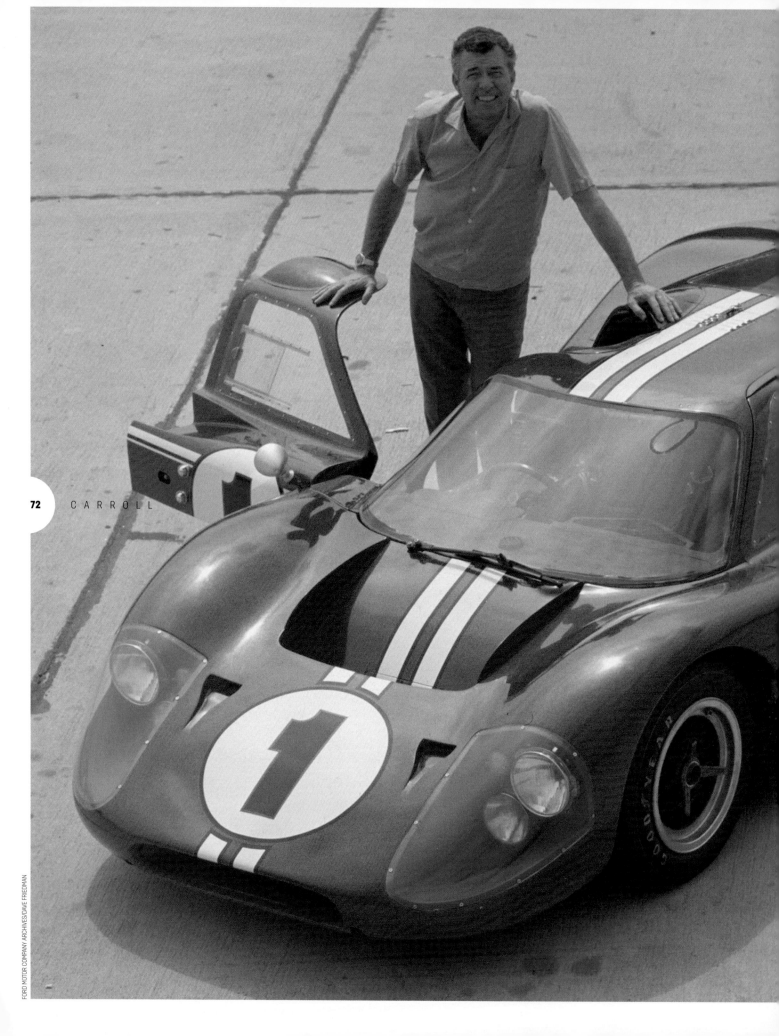

72 CARROLL

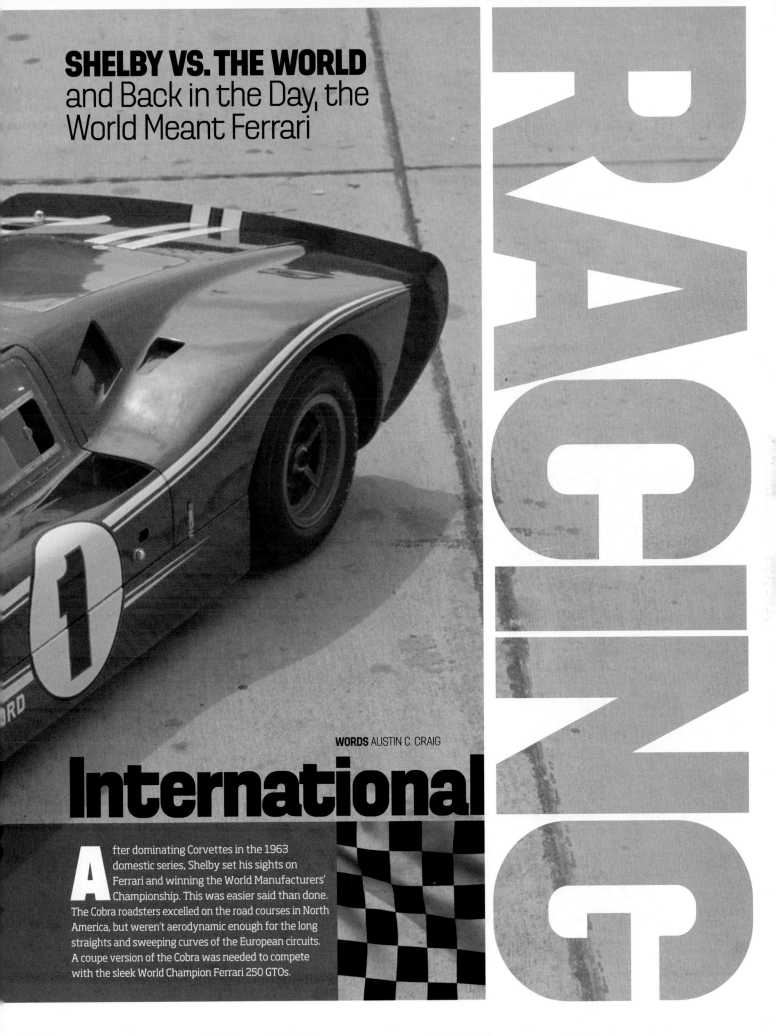

RACING

International

SHELBY VS. THE WORLD
and Back in the Day, the
World Meant Ferrari

WORDS AUSTIN C. CRAIG

After dominating Corvettes in the 1963
domestic series, Shelby set his sights on
Ferrari and winning the World Manufacturers'
Championship. This was easier said than done.
The Cobra roadsters excelled on the road courses in North
America, but weren't aerodynamic enough for the long
straights and sweeping curves of the European circuits.
A coupe version of the Cobra was needed to compete
with the sleek World Champion Ferrari 250 GTOs.

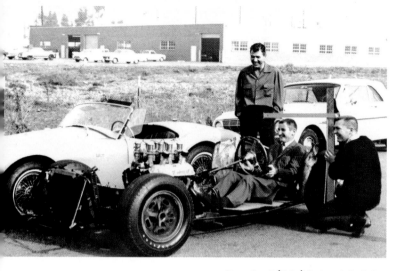

Peter Brock (right) designed the Cobra Daytona Coupe. Here, he checks the seating position for driver Ken Miles as Carroll Shelby, standing, looks on.

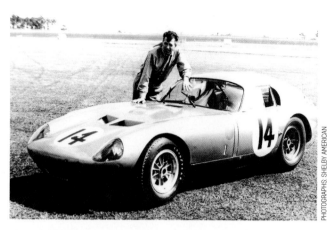

Above, Carroll Shelby poses with the new Cobra Daytona Coupe at Daytona in February 1964. The coupe was the Cobra body style needed to beat Ferrari on the fast European race circuits.

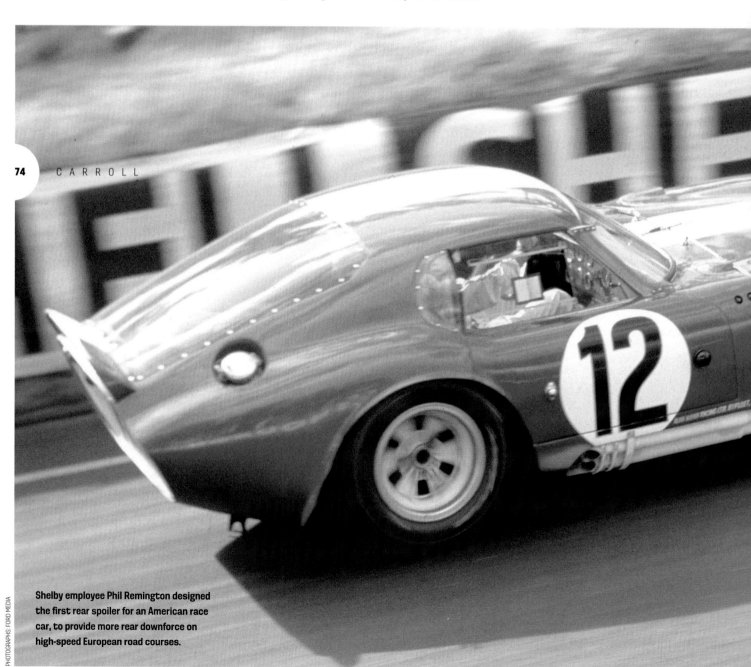

Shelby employee Phil Remington designed the first rear spoiler for an American race car, to provide more rear downforce on high-speed European road courses.

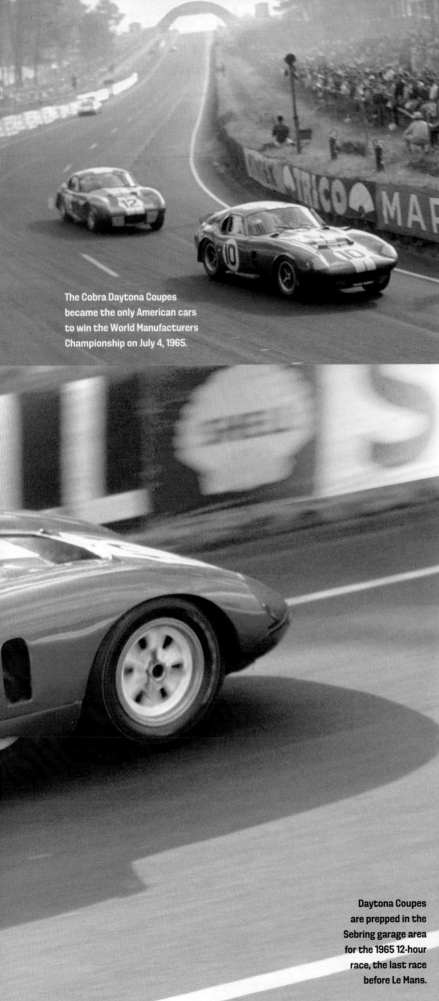

The Cobra Daytona Coupes became the only American cars to win the World Manufacturers Championship on July 4, 1965.

Daytona Coupes are prepped in the Sebring garage area for the 1965 12-hour race, the last race before Le Mans.

Of all the projects undertaken at Shelby American, the creation of the Cobra Coupe was one of the most challenging. Starting in October 1963, the company had 90 days to design, engineer, build, and test the coupe prior to Daytona in February 1964.

Peter Brock led the project, and of all his accomplishments at Shelby American, his crowning achievement was the design—from scratch—of the Cobra Coupe, working with Ken Miles, who reengineered the suspension. The Coupe was almost 20 mph faster than the Cobra roadsters, plus it got 25 percent better fuel economy.

The Cobra Coupe made a sensational debut at Daytona, and henceforth was known as the Cobra Daytona Coupe. Driven by Dave MacDonald and Bob Holbert, the car led the race and set numerous lap records until a freak pit fire sidelined it. A month later, the Cobra Daytona Coupe placed first in the GT Class and fourth overall at the Sebring 12 Hours of Endurance. The Daytona Coupe was the class of the GT field.

After Sebring, the Daytona Coupe and roadsters were shipped to Europe to compete with Ferrari. At Spa, the rear end of the Daytona Coupe lifted at high speeds, so Phil Remington designed and fabricated a rear spoiler, the first ever for an American race car.

At the 24 Hours of Le Mans, the Bob Bondurant/ Dan Gurney Daytona Coupe finished first in class and fourth overall behind three prototypes. The Cobra was timed at an incredible 199 mph down the Mulsanne Straight.

In the World Championship events in Europe, the Shelby American team was primed to win the World Championship when Enzo Ferrari pulled a fast one by having the last race of the year canceled. Without the race, Ferrari won the GT World Championship by a couple of points. When asked how he felt about the cancellation, Carroll Shelby remarked, "Next year, Ferrari's ass is mine!"

The string of 1965 Cobra victories began at the first race at Daytona, where the Daytona Coupe finished second overall and first in GT. At Sebring, the Daytona Coupe won the GT class and finished fourth overall. On July 4, 1965, Shelby American became the first and last American manufacturer to win the World Championship.

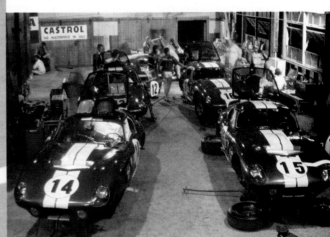

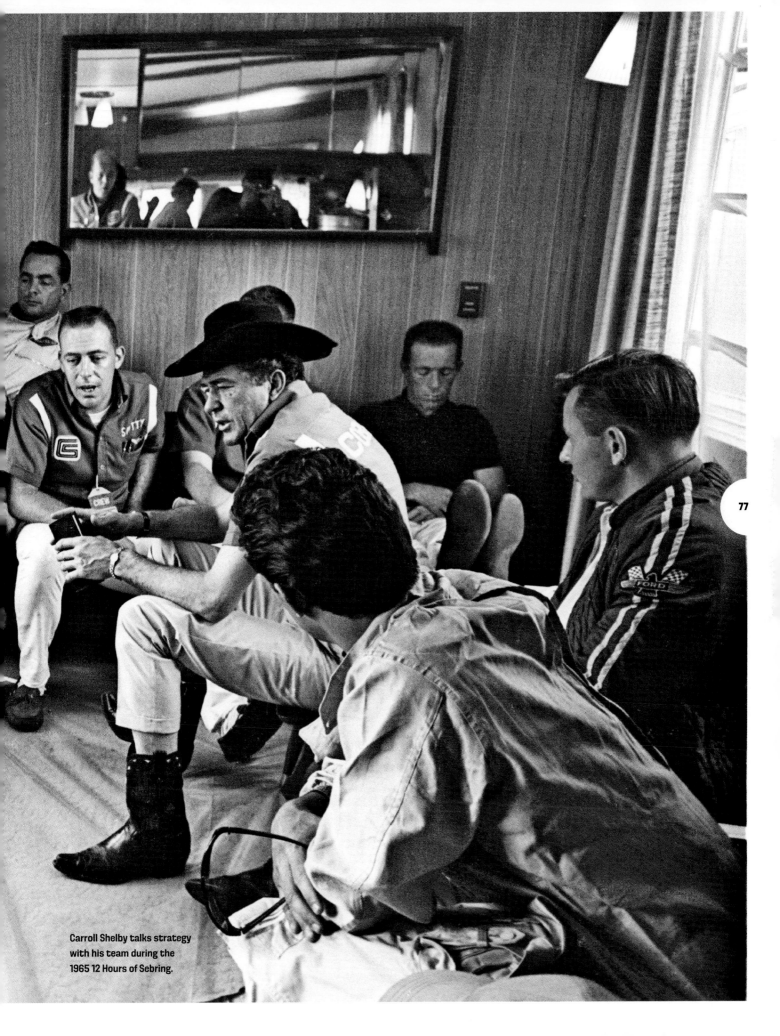

Carroll Shelby talks strategy
with his team during the
1965 12 Hours of Sebring.

FORD GT PROGRAM

The Ford GT Program was conceived after Ford Motor Company's offer to buy Ferrari was rebuffed by Enzo Ferrari. Henry Ford II said, "If we can't buy Ferrari, we will beat them." That was no easy task, as Ferrari had years of international competition experience and always built the finest race cars.

In 1964, Ford gave the assignment of building and campaigning Ford GTs to Ford Advanced Vehicles in Great Britain. The cars did not win or even finish a race all year. With its corporate image on the line, Ford turned to Shelby American.

The two well-worn Ford GTs arrived at Shelby American in mid-December 1964, less than eight weeks before the start of the 1965 racing season at Daytona. Here was the pride of Ford

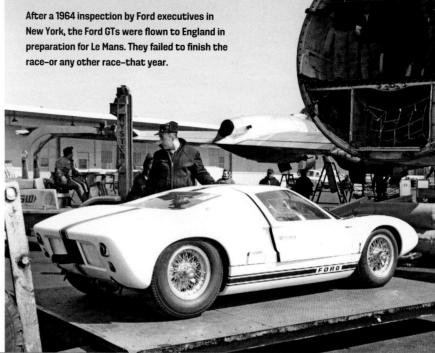

After a 1964 inspection by Ford executives in New York, the Ford GTs were flown to England in preparation for Le Mans. They failed to finish the race—or any other race—that year.

78 C A R R O L L

Officially, it was the Ford GT, but the Europeans dubbed it the "GT40" because the car was only 40 inches tall. This comparison with a Ford station wagon illustrates the height difference.

Motor Company's international racing effort, in need of a complete rebirth. Already overloaded with race and production programs, the Venice facility bulged at the seams. "Adapt, improvise, and overcome" was the motto.

The Shelby crew totally reengineered the cars. Team manager Carroll Smith summed up the situation: "We were not afraid to cut, hack, and experiment. The English were."

After an exhaustive two months of rebuilding, modifying, and testing, the cars were ready for

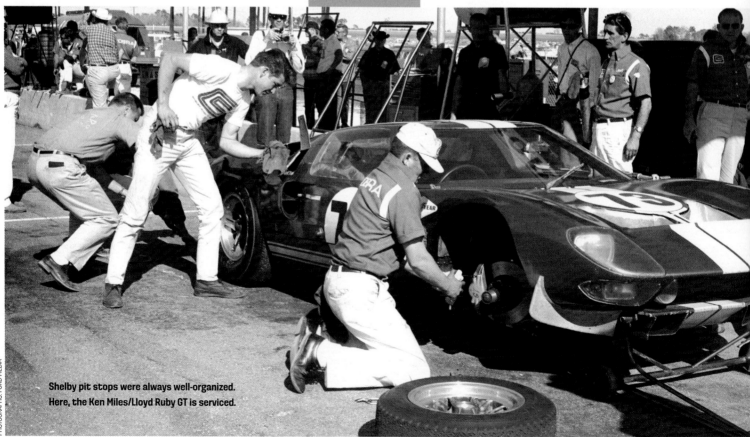

Shelby pit stops were always well-organized. Here, the Ken Miles/Lloyd Ruby GT is serviced.

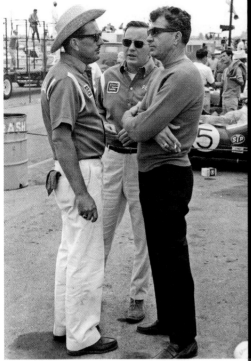

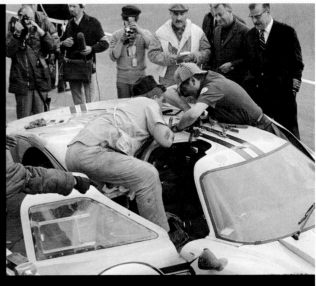

Bill Eaton (right) and Dennis Gragg attempt to repair the rear decklid on the Bruce McLaren/Mark Donohue Mk IV. Eaton eventually asked Shelby for his belt, which he used for a tie-down.

Daytona. The finicky English overhead-cam engines had been replaced by competition-proven Ford 289s. The engine and brake cooling and the suspension were improved and updated to handle the new power. The cars were race-worthy, but the Daytona Continental would be the ultimate test. Sporting new Guardsman Blue paint with white racing stripes, both Ford GTs qualified well and the Ken Miles/Lloyd Ruby car won the race. In its first outing, Shelby American had developed the cars from losers into winners.

SHELBY AMERICAN

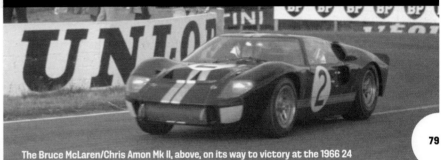

The Bruce McLaren/Chris Amon Mk II, above, on its way to victory at the 1966 24 Hours of Le Mans. Fords finished 1-2-3, led by the Shelby American entries.

Shelby American returned to Le Mans in 1967 with Ford GT Mk IVs. Dan Gurney and AJ Foyt would drive car No. 1.

PHOTOGRAPHS: FORD MEDIA

After winning the prototype class at Sebring, the Ford GTs went to Europe, where, after several races, it was decided that an additional 40-50 hp, a five-speed gearbox, and a lighter car were needed to be competitive with the Ferrari 330 P2. The result was the new Mk II, powered by a 427-cubic-inch Ford engine. With 485 hp, it was the most powerful engine ever run at Le Mans. Although the race results were less than satisfactory–the GTs were DNF'd at the 1965 Le Mans–Phil Hill reached a top speed of 213 mph, easily the fastest car ever seen on the circuit.

By February 1966, the Ford Mk II was a well-tested, very fast, and reliable race car. During the Daytona 24-hour race, the Fords reached 196 mph on the banking. Ken Miles/Lloyd Ruby led the entire race, and won the event for the second year in a row. In March, the Miles/Ruby Mk II roadster won

In His Own Words

"This is Henry Ford II with his new wife, Christina, and his son, Edsel, right behind him at Le Mans in 1965, when all the cars blew up. Edsel's fixing to be 60 years old [in 2008], so he was 17 or 18 years old when this picture was taken."

(Left) After winning Le Mans, Carroll Shelby used his success with the Ford GT to promote other Shelby American activities, including performance parts sales at the first SEMA Show in 1967.

its second straight Sebring race. The next stop would be France and the 24 Hours of Le Mans.

Shelby American built five new Mk II proto-types for the assault on Le Mans. In addition to Shelby American, Fords also were entered by Holman Moody, Ford of France, Alan Mann, and Scuderia Filipinetti. But the main competition would come from the Ferrari 330 P3. Ford won the 1966 24 Hours of Le Mans with the famously controversial 1-2-3 finish. The first two Mk IIs were Shelby American entries of Bruce McLaren/Chris Amon, with the Ken Miles/Denis Hulme car second. The Holman Moody Mk II driven by Dick Hutcherson/Ronnie Bucknum was third. In just three years, Ford Motor Company, led by Shelby American, had won the world's most presti-gious endurance race in a convincing manner.

For the 1967 season, the Ford GTs were updated with more horsepower, plus aero and suspension modifications. At Le Mans, Dan Gurney and AJ Foyt drove their red Mk IV to victory, setting records for overall speed and distance traveled during the 24-hour race.

Once Shelby American took control of the Ford GT program, it was the only company to win races for Ford. Carroll Shelby had taken a major corporate embarrassment and turned it into a world-class racing effort.

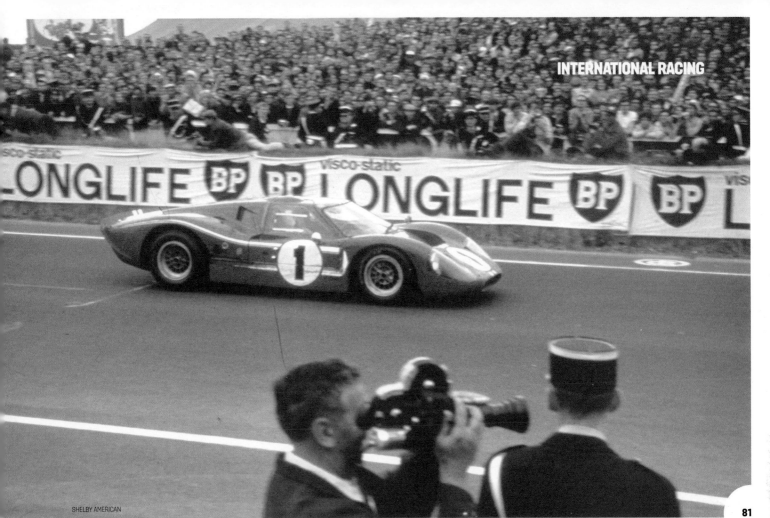

SHELBY AMERICAN

In His Own Words

"Wow, ol' No. 1. That brings back so many memories because of Henry Ford's directive in 1965– after so many of their race cars had blown up because of cylinder head bolt problems. You will never see another program [like the one Ford created to win Le Mans]. Henry got us together in 1965: Ray Geddes, Leo Beebe, Don Frey, and I. Henry had put together name tags that said, 'Ford Wins Le Mans in 1966.' Well, you saw four people with dysentery from that.

"To win Le Mans was not that easy. I remember the Ford chief financial officer called me about three months into the program and said, 'Carroll, we've spent $200 million on this program so far. I'm afraid it's going to bankrupt the company.' I said, 'You better talk to Mr. Ford about that. He told us to win Le Mans.'"

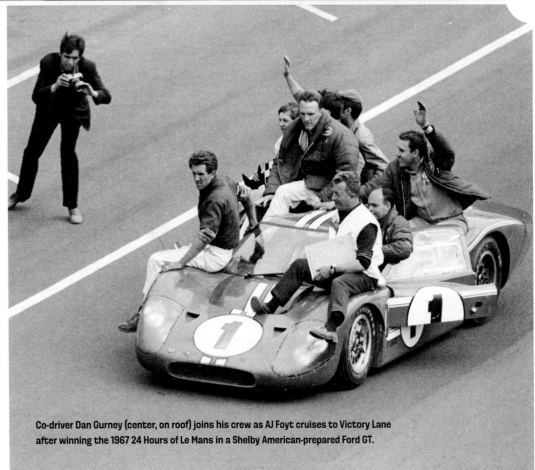

Co-driver Dan Gurney (center, on roof) joins his crew as AJ Foyt cruises to Victory Lane after winning the 1967 24 Hours of Le Mans in a Shelby American-prepared Ford GT.

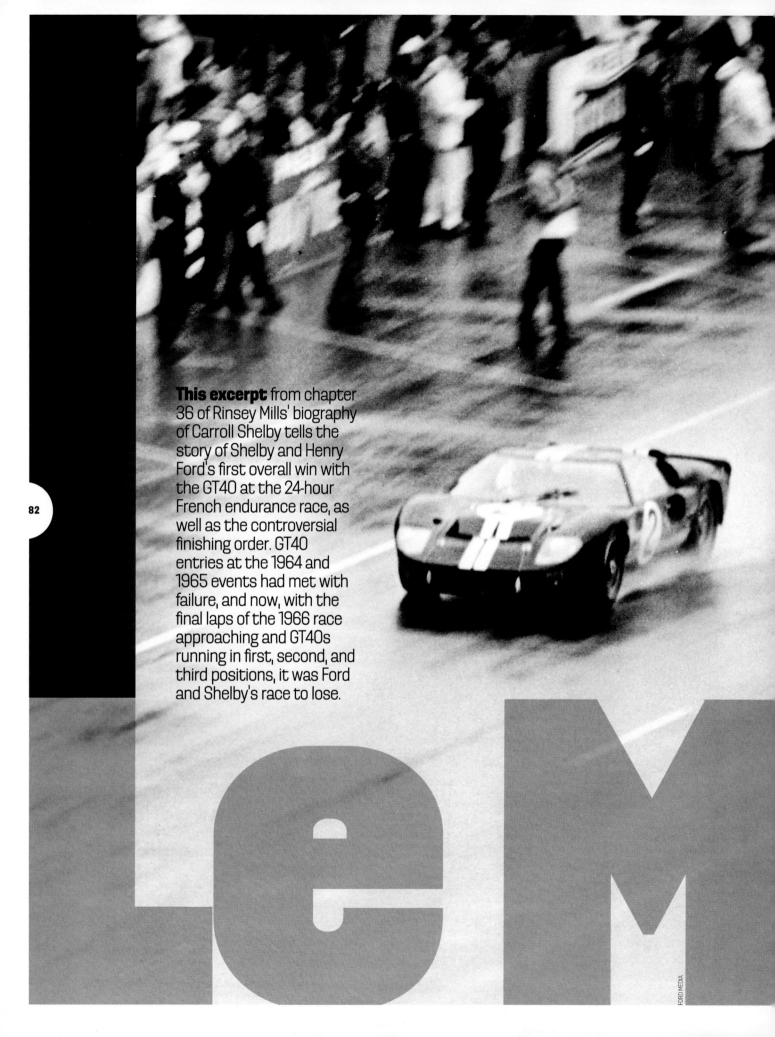

This excerpt from chapter 36 of Rinsey Mills' biography of Carroll Shelby tells the story of Shelby and Henry Ford's first overall win with the GT40 at the 24-hour French endurance race, as well as the controversial finishing order. GT40 entries at the 1964 and 1965 events had met with failure, and now, with the final laps of the 1966 race approaching and GT40s running in first, second, and third positions, it was Ford and Shelby's race to lose.

Le M

FORD MEDIA

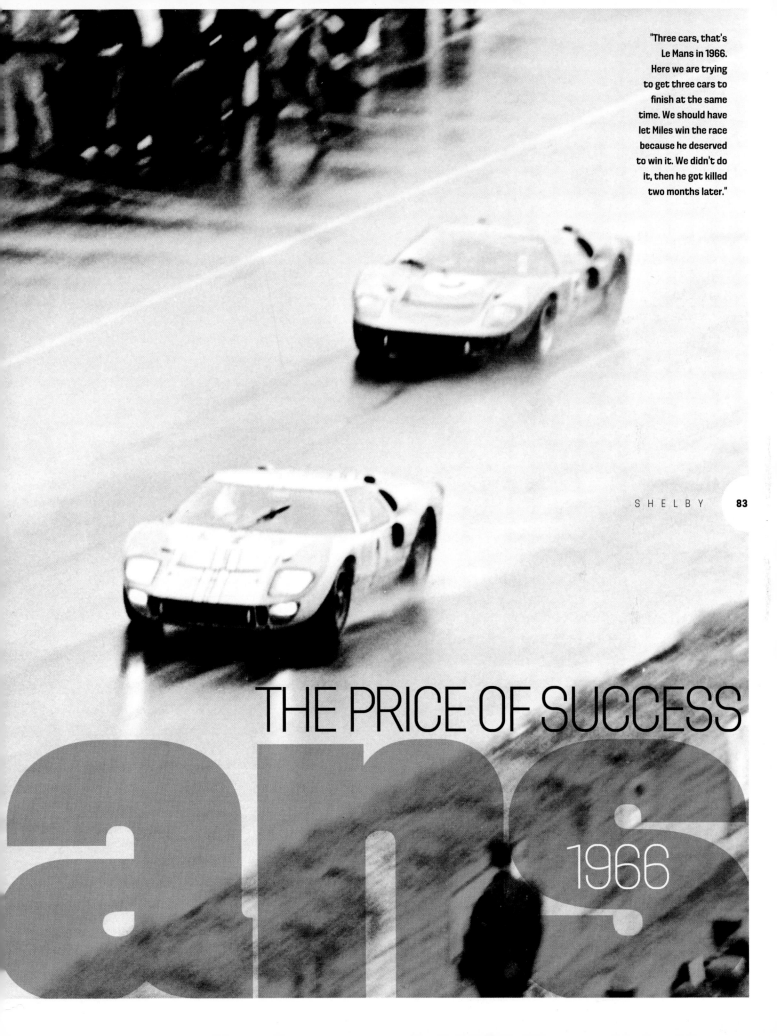

"Three cars, that's Le Mans in 1966. Here we are trying to get three cars to finish at the same time. We should have let Miles win the race because he deserved to win it. We didn't do it, then he got killed two months later."

THE PRICE OF SUCCESS

1966

For one or both to finish was all that mattered.

By this time, the two remaining Shelby cars were several laps ahead of Ronnie Bucknum and Dick Hutcherson, who were still in there with their Holman Moody car, but with all their direct opposition gone, none had any reason to hurry. For one or more to reach the finish at their present rate of progress was enough to win, as well as to break the distance record; but even with victory now finally in sight it could all so easily go wrong, as the recent expiry of the Gurney/Grant MkII had demonstrated.

Not too far behind the third-place car the three Porsche Carrera 6 prototypes were still furiously battling for the 2-liter honors, and it only needed one untoward pit stop for one or more of them to overtake it—then it would be solely down to the Shelby American entries to fulfill Henry's dream, as Carroll considered it had been from the start. With this very much in mind the Ford pit area was cleared of all unnecessary onlookers and media people who might get in the way, or in some way compromise the final outcome.

With both cars crewed by highly competitive drivers who no longer had anyone to race against except themselves, it was most important that they didn't—for one or both to reach the finish was all that mattered, and each was expected to put any personal ambition out of their mind. Easier said than done when the opposition has ceased to exist and there are several hours to go at reduced speed under strict team orders with the knowledge that only one car/driver combination can emerge as the winner.

It was then that, presuming that both cars made it to the finish, the idea to stage a dead heat was put forward, and upon checking with the race officials that this was allowable it seemed the ideal solution—one that would mollify the drivers and could well net Ford even more publicity. When Carroll broke the news to Ken Miles that this was what they would be aiming for, however, the latter's emotions briefly got the better of him before he icily continued to do the job he had begun at 4 p.m. the previous day. Bruce McLaren for his part was reportedly at one point overhead saying to Chris Amon something to the effect, "I don't know about this but I'm not going to lose."

Whatever the drivers thought and said, they did as they were asked and with four hours to go the New Zealanders' black car is recorded as having led from the light blue one shared by Miles and Hulme. Two hours later the rain had returned, and almost everyone, from the leaders down to the little Mini-Marcos that was last of the 16 cars still running, cautiously made their way around the soaking track—any heroics were over, to finish was all that mattered.

The Shelby cars were coming in neck and neck.

Around this time the two Shelby cars made their last fuel stops and Bruce McLaren and Ken Miles took over to go through to the end, whereupon Ken found himself out in front once more. These positions were maintained until the last few laps, by which time the rain had intensified, especially in the environs of the Mulsanne corner, and it was there, with the clock back at the pits fast approaching 4:00, that the two cars were seen to have closed up.

At the start of what was going to be their last lap they cruised through the grandstand and pit area, with Miles still in front—the tracks they left on the streaming wet tarmac fast disappearing as their roostertails settled and the gold Holman Moody car followed in their wake—a hundred miles behind on the road but running third. To their left the thousands of spectators' cheers mingled with catcalls directed at the lines of assembled gendarmes, whilst to their right in the pits the majority of the key figures involved with Ford's Le Mans program—including Henry Ford himself, who had returned to the circuit to witness the final hours and what was finally going to be his triumph.

With Shelby American's win at Le Mans, Henry Ford II finally got his victory over Ferrari. Here, Ford (center) celebrates on the podium with winners Bruce McLaren and Chris Amon.

84

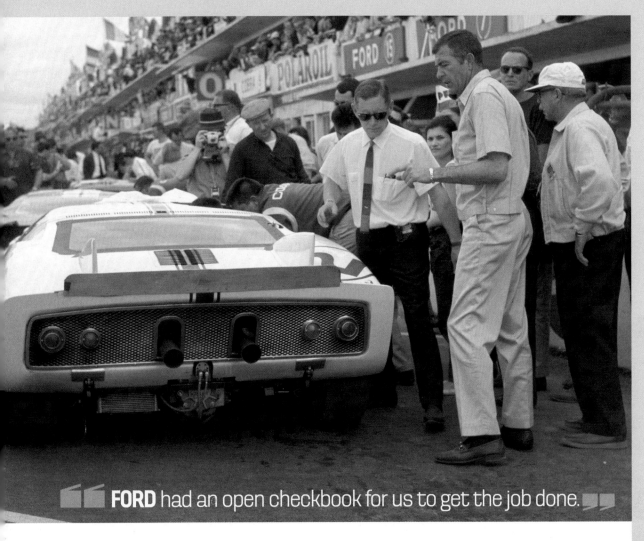

> **FORD** had an open checkbook for us to get the job done.

Minutes later all eyes were focused towards White House, straining to catch the first glimpse of the leader, as two sets of lights appeared–the Shelby cars were coming in neck and neck with the other Ford now just behind them. It looked like it was going to be the dead heat that had been planned–but those who had organized it already knew it wasn't going to happen.

As they approached the checkered flag the black car driven by Bruce McLaren surged ahead–thus to onlookers and cameras that focused on the moment it was in front; but the electronic timing was situated at the start of the pits, where the two cars had been level.

As soon as the drivers brought them to a halt their waiting co-drivers climbed aboard and they then slowly continued through the milling crowd; but just as Miles and Hulme's crew headed by Charlie Agapiou

were about to maneuver the car into position they were told to make way for the other, as it had won.

Thus a slightly bemused Bruce McLaren and Chris Amon mounted the stand to be presented with large sprays of flowers by a beaming Henry Ford and his wife, Christina, before taking their bow as the winners along with a discreet glass of champagne–unlike Carroll, who'd necked a good part of a bottle seven years earlier immediately after his victory. A haunted-looking Ken Miles, who had donned his old duffel coat to ward off the now light rain, mingled with the onlookers until he and Hulme were persuaded up on to the rostrum to join their teammates and drivers of the 2-liter class-winning Porsche, Jo Siffert and Colin Davis. He never told anyone exactly how he felt–he didn't have to. Those who mattered to him knew.

Shelby with the Hill/Amon MkII prototype before the start of Le Mans 1965. Both GT40s retired from the race with mechanical issues.

85

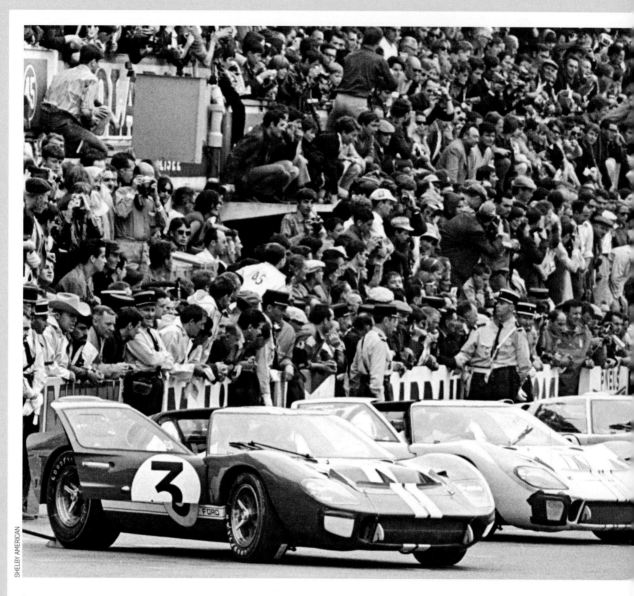

SHELBY AMERICAN

Let me tell you what happened

When Carroll and I were discussing the writing of this book something he very much wanted included was the truth about the circumstances surrounding the finish of the 1966 Le Mans 24-hours. "Aha!" I thought to myself, "he knows more than has previously been disclosed!" After all, the controversy surrounding the result of that race remains one of motor racing's enigmas, and if anyone could throw some light on it, surely it would be him.

Several months later, Carroll and I were driving to meet some people when the subject came up again—I was very careful not to prompt his memory in any way.

"Let me tell you what happened at Le Mans in '66," he said. "Leo Beebe, Henry Ford and I were standing there and all three cars were leading the race and he decided it would be nice if they came across the finish line at the same time. When this decision was made Miles was way ahead and leading the race. He had already won Daytona and Sebring and his ambition was to win all three of them.

"I've regretted it ever since, but I went along with what they wanted. The way it was put to me right off, or how I saw it, was that what cars we had left running at the finish would close up and go across together. Then when I realized what they were really trying for I did

LeMans1966

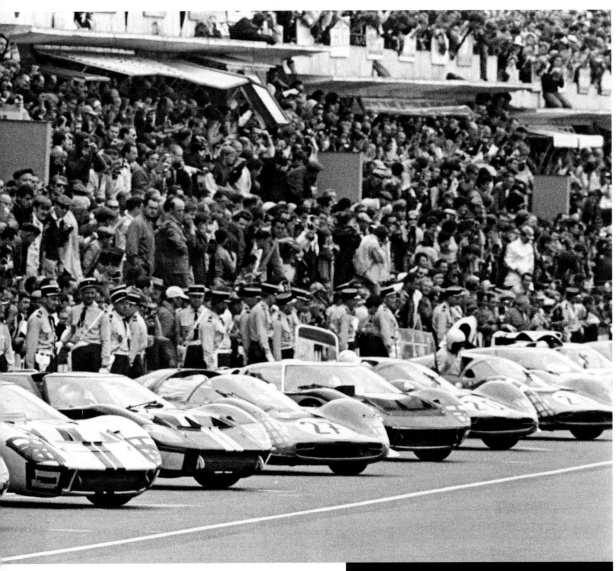

nothing. I didn't defend Ken's position, even when they came out with that stupid crap about him starting in front, which they said meant he'd have to be that way at the finish–and he was my friend. I still think to this day he may have been a whole lap ahead and I tried to prove it at the time but couldn't–the Le Mans people ended up by telling me they'd lost our lap records.

"I suppose while the race was still running I was happy to have our cars in front and went along with that idea to please old Henry, who'd paid for the whole thing, never thinking it would turn out how it did, and when it did it was too late."–**Rinsey Mills**

Those wishing for the full story on Le Mans and Shelby's life won't be disappointed by Rinsey Mills' "Carroll Shelby: The Authorized Biography" (Motorbooks, $35). Mills delves into the events that defined the life of a masterful businessman, race car driver, and automotive engineer, with insight from the man himself. Shelby's anecdotes alone are worth the price. Available at amazon.com and motorbooks.com.

 I've regretted it ever since, but I went along with what they wanted.

TERLINGUA
RACING TEAM
and Chili Cook-Offs

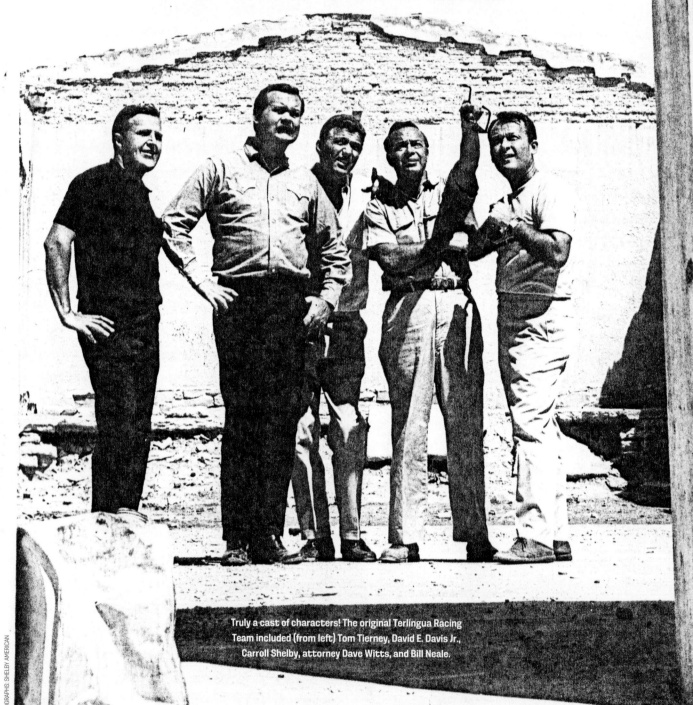

Truly a cast of characters! The original Terlingua Racing Team included (from left) Tom Tierney, David E. Davis Jr., Carroll Shelby, attorney Dave Witts, and Bill Neale.

Tom Tierney D.E. Davis Jr. Shelby Dave Witts B. Neale 1965

The Most Famous Racing Team You've Never Heard of...

WORDS SUE ELLIOTT **PHOTOGRAPHS** BILL NEALE

Many of the most famous cars in the history of racing have worn Terlingua Racing Team colors–some intentionally, some not. Jerry Titus won the 1967 Trans-Am series behind the wheel of the first "official" Terlingua Racing Team ride. And hundreds–perhaps even thousands–of drivers in all forms of motorsport have stuck the now-famous, yellow-and-black decal on their cars.

Then there are the cars that wore Terlingua team colors unwittingly. "One year, Carroll Shelby and I were in Indianapolis," says longtime Shelby friend Bill Neale, one of the Terlingua Racing Team founders. "I think this was in 1965 or 1966, and Shel said, 'Let's go down and put one of these decals on every car.' We got one on every car except one, and that's the car that won the race."

Neale adds, "That kind of describes our race team. Over the years, it has operated on frivolity, graft, corruption, and partying."

Bill Neale applies the first Terlingua Racing Team decal to the first GT350 ever to race. Ken Miles piloted the car at right to victory at Green Valley Raceway that day, February 14, 1965.

How did a serious racer like Carroll Shelby come to be associated with a racing team that has been called a "spoof," among other less flattering things?

It all started with a ranch in southwest Texas. Dave Witts bought the 200,000-plus-acre parcel, then persuaded his old pal Shelby to buy a big chunk of it in the early '60s. The rugged, dry, hot, and inhospitable area was largely uninhabited.

It also happened to be home to a ghost town on the Rio Grande River called Terlingua. During its peak as a mercury mining center in the late 1800s, perhaps 5000 people lived there. The town had played host to three different American Indian tribes: the Kiowa, the Apaches, and the Comanches. "That's how it got its name," says Neale. " 'Terlingua' means three languages."

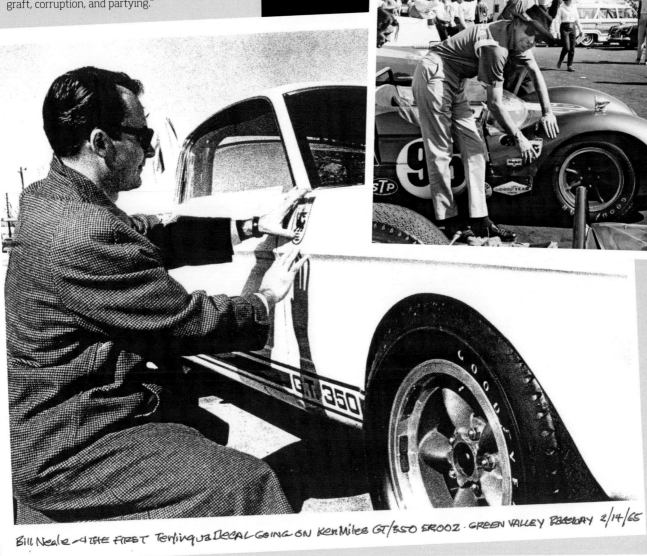

Bill Neale - The First Terlingua Decal going on Ken Miles GT/350 5R002 · Green Valley Raceway 2/14/65

89

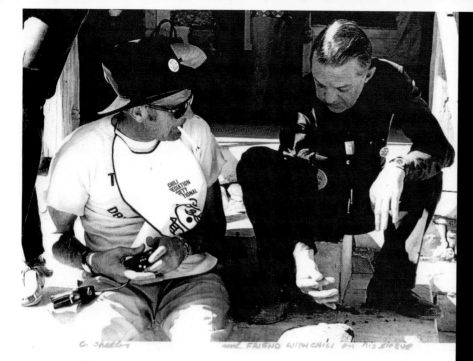

C. Shelby and FRIEND WITH CHILI on his sleeve

Faking History

At one point, Shelby wanted to build a school in Terlingua for underprivileged boys. So Neale designed a logo–a coat of arms, actually–for the school.

Neale explains the significance of its now iconic symbols: "The rabbit is one of the few things that can live in the Big Bend–rabbits, panthers, rattlesnakes, and coyotes. The rabbit is holding up his paw to say, 'Don't put any more peppers in the chili.'"

"There are three Indian feathers on the logo, and that stands for the three Indian tribes. Of course, it's got the sun in it because that area gets very hot in the summertime. It's not unusual for the temperature to get up to 115, 120 degrees.

"And then up in the left-hand corner is the number 1860. Shelby asked me, 'What's 1860 for?'

"And I said, 'That's the first year they had a race in Terlingua. It was with the ore wagons, pulling cinnabar, which is what you make mercury out of. They had 18 wheels put on each ore wagon.'

"And he said, 'Damn, Neale, that's interesting. Where did you find that information?'

"And I said, 'I made it up.'"

Shelby and Witts got a real kick out of owning their own ghost town, and they soon started tapping friends for membership on the Terlingua City Council and to fill other important civic roles. "I was the director of the Terlingua Museum of Modern Art, of which there was none," says Neale. "It was a two-hole wooden privy over a mine shaft behind the Chisos Saloon, and it had a sign above the door: Terlingua Museum of Modern Art. Shelby was chairman of the social committee. We had a district attorney and a leading TV personality on the

During the second chili cook-off at Terlingua, in November 1968, Shelby and a friend wearing some of the hot stuff on his sleeve–and, from the look of things, wiping it on his pants–took a break on the front porch of the Chisos Saloon.

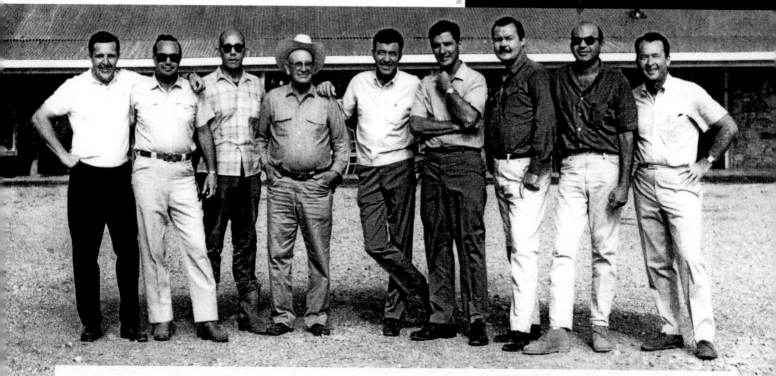

Plenty of friends came to Terlingua to hang out. Here (from left), Tom Tierney, Dave Witts, Dave Clelland, Harold Wynne, Carroll Shelby, a Goodyear executive, David E. Davis Jr., a friend from Ford Motor Company, and Bill Neale kick back at the Terlingua Ranch House in 1965.

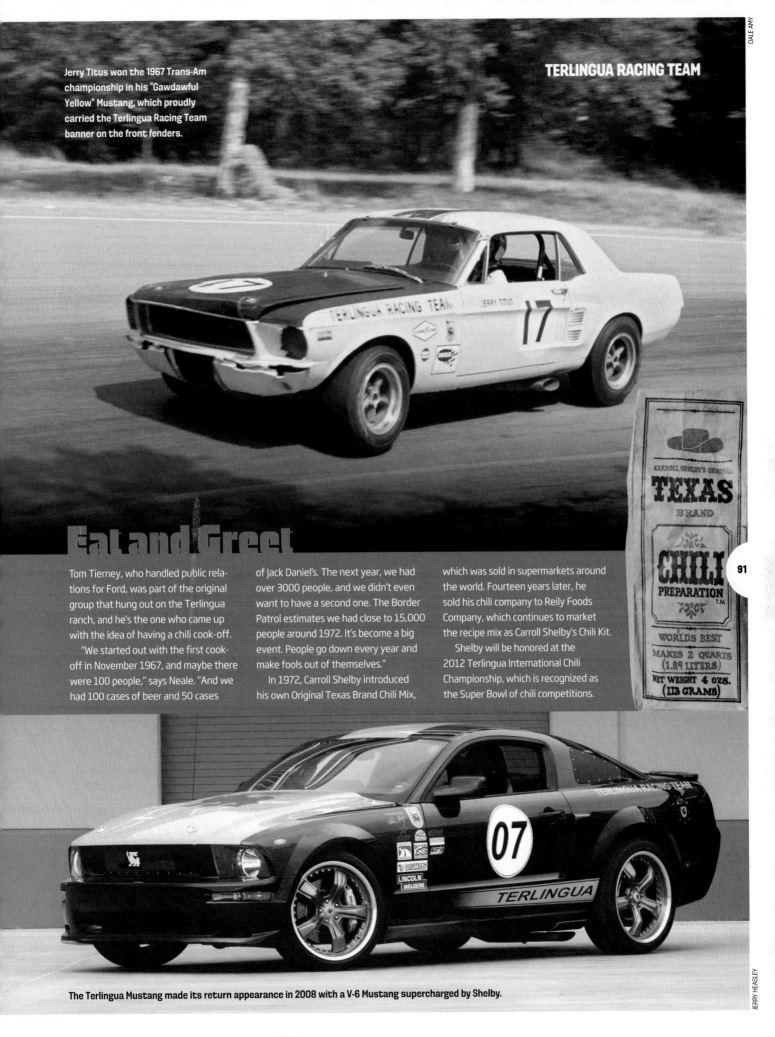

Jerry Titus won the 1967 Trans-Am championship in his "Gawdawful Yellow" Mustang, which proudly carried the Terlingua Racing Team banner on the front fenders.

Eat and Greet

Tom Tierney, who handled public relations for Ford, was part of the original group that hung out on the Terlingua ranch, and he's the one who came up with the idea of having a chili cook-off.

"We started out with the first cook-off in November 1967, and maybe there were 100 people," says Neale. "And we had 100 cases of beer and 50 cases of Jack Daniel's. The next year, we had over 3000 people, and we didn't even want to have a second one. The Border Patrol estimates we had close to 15,000 people around 1972. It's become a big event. People go down every year and make fools out of themselves."

In 1972, Carroll Shelby introduced his own Original Texas Brand Chili Mix, which was sold in supermarkets around the world. Fourteen years later, he sold his chili company to Reily Foods Company, which continues to market the recipe mix as Carroll Shelby's Chili Kit.

Shelby will be honored at the 2012 Terlingua International Chili Championship, which is recognized as the Super Bowl of chili competitions.

CARROLL SHELBY'S ORIGINAL

TEXAS
BRAND T.M.

CHILI
PREPARATION T.M.

WORLDS BEST
MAKES 2 QUARTS
(1.89 LITERS)
NET WEIGHT 4 OZS.
(113 GRAMS)

91

The Terlingua Mustang made its return appearance in 2008 with a V-6 Mustang supercharged by Shelby.

92

CARROLL

TERLINGUA RACING TEAM

In His Own Words

"My friend Bill Neale. Looks like Willow Springs around 1967, and that looks like Ray Crawford's Mexican Road Race Lincoln, built by Stroppe, in the background. Bill's about 40 years older now. He needs a face-lift now. Everybody knows about the Terlingua Racing Team we had. We're building more cars again [2008]."

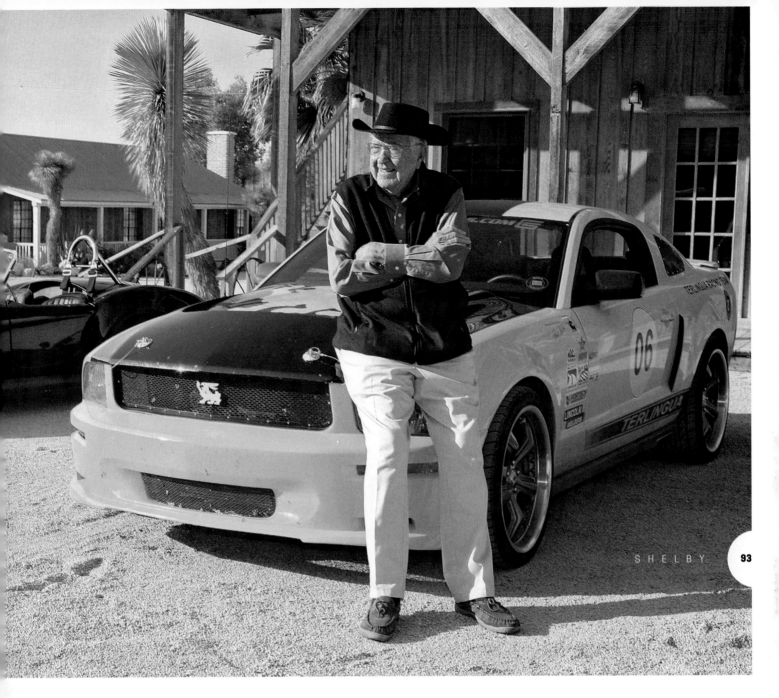

council. We had one of the top judges in the state. We gave him a job as office boy."

These people didn't just hold honorary positions, either. They went to Terlingua to hang out with Shelby and "let their hair down," as Neale puts it. Terlingua was a place to party far away from prying eyes. It was a great escape.

The idea for a Terlingua Racing Team came later. Since every race team needs a logo, Shelby asked Neale to come up with something (see sidebar), and the first decals were printed up.

"Some of the greatest racers in the world competed in Terlingua Shelby Mustangs," Shelby recalled. "Ken Miles was the first to put the 'prancing rabbit' in the winner's circle when he won at Green Valley Raceway in 1965. Then things really broke loose when he introduced Jerry Titus to the team."

Titus is likely the most famous official Terlingua racer, and he also drove the first official Terlingua Racing Team car. Not only did he rack up four wins for the team in a Shelby Mustang during the 1967 Trans-Am series, but he also nabbed the championship.

Neale says, "Shelby wanted his car to really show up on the grid. So I designed the paint scheme for the car using the yellow from the logo with a black hood. And Shelby, when he first looked at my design, referred to it as 'Gawdawful Yellow.'"

While the team was never an official Ford effort, the company didn't exactly frown on it. Quite the contrary. Says Neale, "Shel would slap Terlingua decals on the cars at Le Mans, and [the folks from] Ford would look at 'em and just smile."

Carroll at the 2008 Shelby Bullrun Challenge. To the left of the 2008 Terlingua is a 427 Terlingua Cobra, owned at the time by Bill Neale.

THE DODGE YEARS

CARROLL

Throughout the 1970s and early 1980s, Carroll Shelby was no longer racing or building cars. He caught his breath, spent time in Africa, began to make chili mix, and kept his hand in the car business with the Shelby American Automobile Club (SAAC). He appreciated the group because it encouraged members to keep driving and racing 10-year-old Cobras and GT350s. But it took a phone call from Chrysler in 1982 to reboot the Shelby machine and inspire it to action.

Lee Iacocca was in a tight spot. He had taken over Chrysler in 1978 to save it from itself and a roster of boring sedans. Part of his plan to accommodate emissions and economy rules–and make money– was to start building front-drive compact cars. But the buying public was underwhelmed by the boxy Chrysler lineup. Always the salesman, Iacocca knew his vehicles lacked flash, and sought something to inspire excitement. That certain something was his old friend Carroll. Lee had supported Shelby back when it counted. It was time to call in a favor.

Iacocca Calls in a Favor
and Changes Shelby's Path Forever

WORDS TOM CORCORAN

BOSCH
PILOT

THE DODGE YEARS

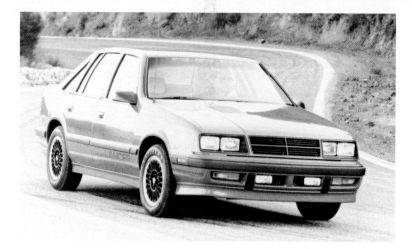

"I got into this deal because Lee's my buddy, and he was in trouble. He needed a performance image. And my ego wanted to see if I could build a car the kids would buy," Shelby told the Austin American-Statesman in 1983.

The Chrysler/Shelby Performance Center, in Santa Fe Springs, California, opened in December 1982. Chrysler engineers and Shelby used the facility to plan strategies for upgrading a special generation of Chrysler products. Much of the initial work would amount to typical California custom and hot-rod tweaks: boosting compression, changing the final drive ratio, stiffening the suspension, then adding quick-ratio steering, wheels and tires, badges, stripes, and Shelby's name.

The Center's first project was the Charger coupe, a lightweight hatchback that already was the sportiest Dodge available. Its 2.2-liter, four-cylinder engine produced 94 horsepower before it got the Shelby touch, which boosted it to 107 horses. Introduced halfway through the 1983 model year, the Dodge Shelby Charger would sell more than 30,000 units in its 5-year run. *Motor Trend* said of the car: "We'll venture a bet that no other Shelby street car on street tires ever...had more sheer cornering force."

Shelby became a performance spokesman for Chrysler Corporation, with his photo on the cover of its Direct Connection catalog of racing and performance parts. He also appeared in mid-1980s Dodge advertising. All this, however, was for mass-produced cars.

That changed when Shelby sold his chili operation to Reily Foods and opened his own workshop, Shelby Automobiles, in Whittier, California. Between 1986 and 1989, the facility created limited-edition Chrysler-based cars that went well beyond factory limitations.

Dodge marketed hundreds of Shelby Chargers and Daytonas. For its part, Shelby Automobiles' first creation was the 1986 Omni GLHS; only 500 were built. Special intake manifolds and intercoolers boosted the horsepower in Chrysler's turbocharged 2.2 engine from 146 to 175. Next, Shelby built 1000 Charger GLH-S models with black paint and silver

Utilizing the turbocharged 175-hp, 2.2-liter from the Omni GLHS, the '87 Shelby Lancer was designed to compete with European sport sedans.

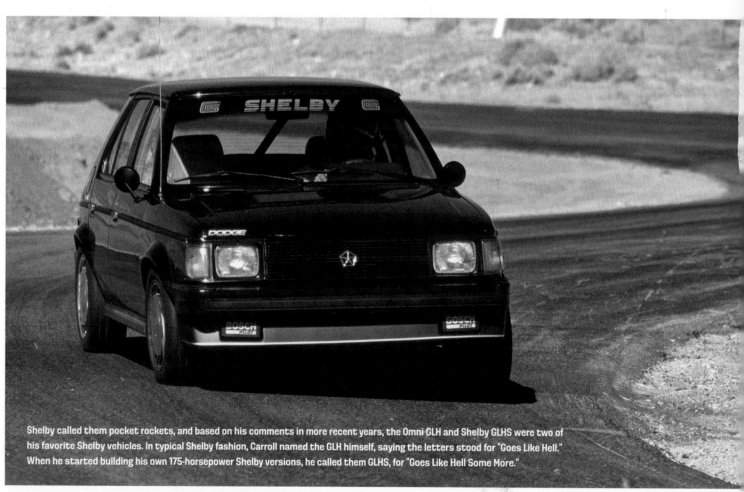

Shelby called them pocket rockets, and based on his comments in more recent years, the Omni GLH and Shelby GLHS were two of his favorite Shelby vehicles. In typical Shelby fashion, Carroll named the GLH himself, saying the letters stood for "Goes Like Hell." When he started building his own 175-horsepower Shelby versions, he called them GLHS, for "Goes Like Hell Some More."

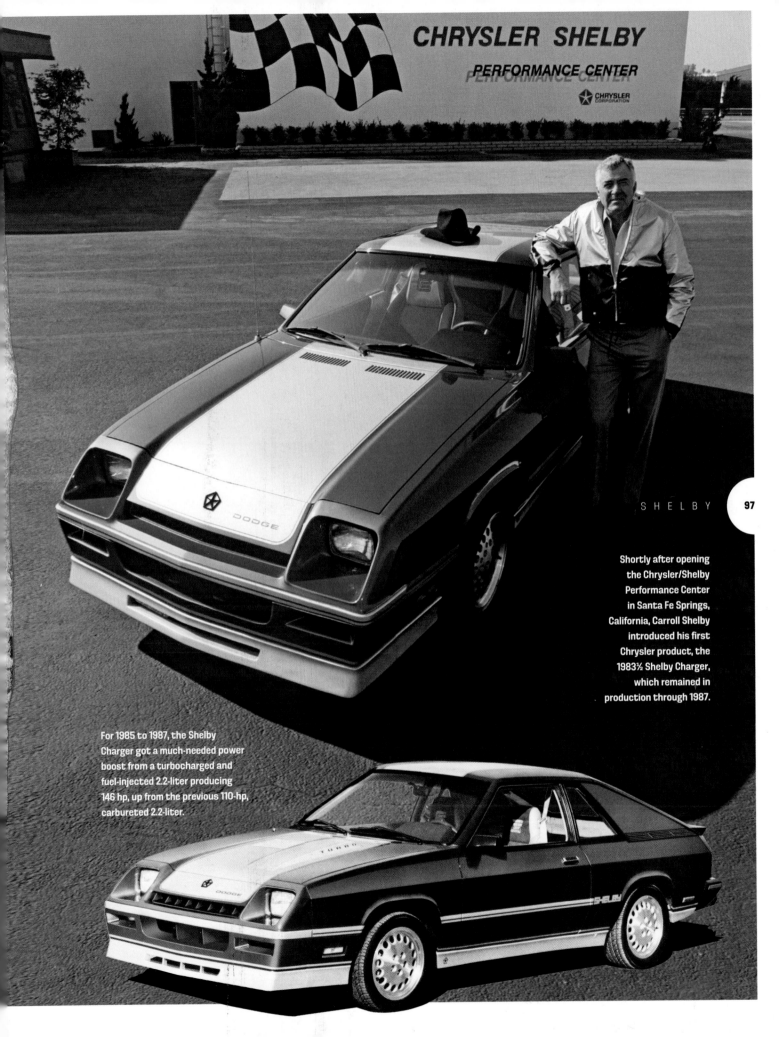

CHRYSLER SHELBY
PERFORMANCE CENTER

Shortly after opening
the Chrysler/Shelby
Performance Center
in Santa Fe Springs,
California, Carroll Shelby
introduced his first
Chrysler product, the
1983½ Shelby Charger,
which remained in
production through 1987.

For 1985 to 1987, the Shelby
Charger got a much-needed power
boost from a turbocharged and
fuel-injected 2.2-liter producing
146 hp, up from the previous 110-hp,
carbureted 2.2-liter.

In His Own Words

"I got so much shit building those little hot rods–Chargers, GLHs, and all that. I got so much crap in the press, saying 'Shelby's lost it, he's crazy.' I had more fun doing that. We wound up with 750 horsepower in our little GLH drag car, out of a 2.2-liter engine. That little GLH, I've got one with 425 horsepower that I still enjoy driving. So it doesn't bother me very much if the press kicks the shit out of me, because I'm probably going back and build more pocket rockets with Ford."

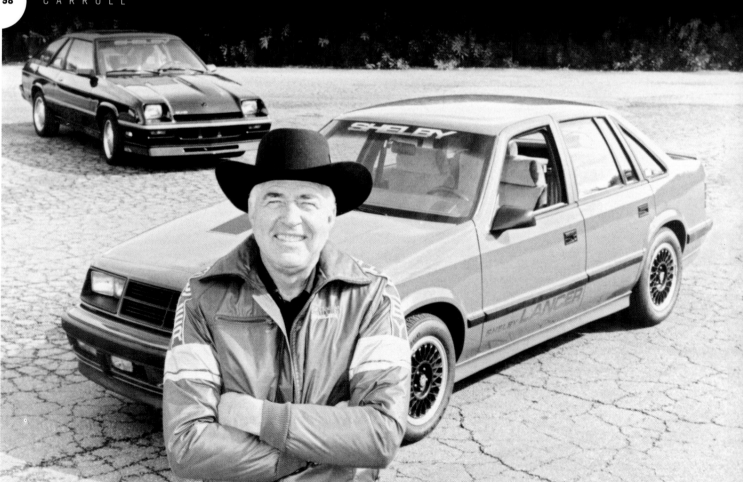

From 1987 to 1989, Shelby transformed the Dodge Shadow Turbo into several variations of the Shelby CSX, including a CSX-T for Thrifty Rental Car.

lettering, followed by the Lancer and Shadow CSX in 1987, and a CSX-T for the Thrifty rental car chain in 1988. Sound familiar? A Shelby Dakota V-8 and a CSX with Variable-Nozzle Turbocharging appeared in 1989. Production slowed at that point, but Shelby consulted for Chrysler on the creation of the Viper and helped develop a Shelby Durango SUV.

In 1990, Carroll Shelby received a heart transplant, which profoundly altered his life. But his love of speed and fast cars was unchanged. Only months after surgery, Shelby drove the all-new Dodge Viper pace car at the 1991 Indianapolis 500–talk about an image-builder for both car and

man. A year later, Shelby was inducted into the Automotive Hall of Fame, years ahead of a few automotive stars you might recognize: Ferrari, Bugatti, Peugeot, and Granatelli.

Few can argue that Iacocca's plea to Shelby for assistance launched a whole new era of Shelby performance. In years to follow, the motorsport world would welcome SCCA Shelby Can Am spec racers, "continuation" Cobras, Shelby Concept vehicles–even boats and motorcycles. Shelby subsequently reunited with Ford to produce the 2007 GT500 and built other new creations from his Las Vegas, Nevada, headquarters.

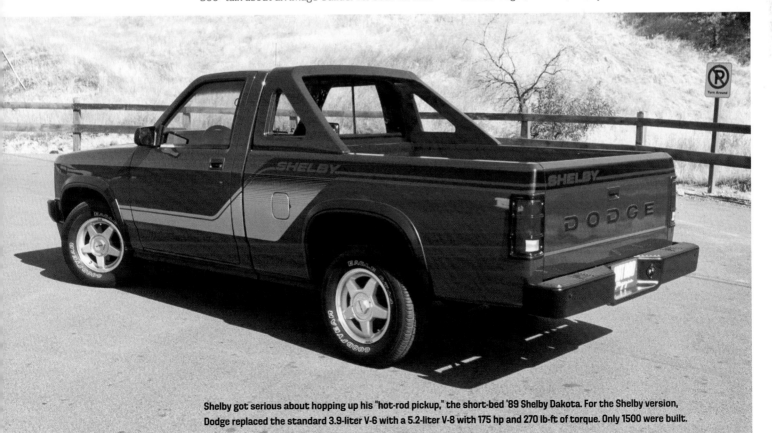

Shelby got serious about hopping up his "hot-rod pickup," the short-bed '89 Shelby Dakota. For the Shelby version, Dodge replaced the standard 3.9-liter V-6 with a 5.2-liter V-8 with 175 hp and 270 lb-ft of torque. Only 1500 were built.

Shelby boasted that his little pocket rocket GLHS could "blow the doors off of cars that cost four or five times as much," so *Hot Rod* brought along a Shelby GT350 to prove him wrong. The result was surprising.

SHELBY

THE GLHS SURPASSES THE LEGEND

By Rick Titus

So you thought Carroll Shelby was out of it, reduced to the second-fiddle role of keeping all the performance car promises Lee Iaccoca was making about Chrysler products. Perhaps you even figured the Ol' Master was talking out of the side of his mouth when he spoke (HRM June '85) of low-cost, four-cylinder, front-wheel-drive mini cars that can go out and beat up on the big stuff. Well, don't feel bad, so did we. Till now.

Carroll Shelby is back, and he's just fired the first bullet in his battle with the performance car world—the Shelby GLHS. Seems Shelby is setting up shop again. It's back in the trenches for the man who's been busy consulting with Chrysler Corporation for the past three years. Though his plans haven't changed on that score, he'll still be developing hardware for the "Dodge Boys,"

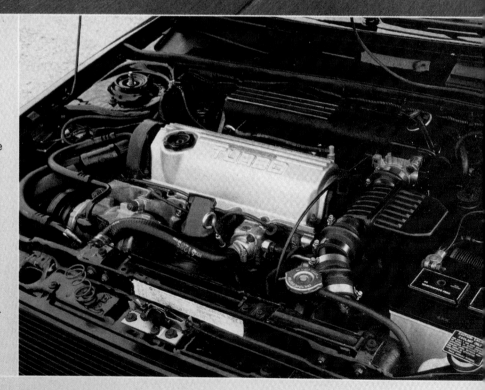

Photography: Bob D'Olivo, PPC Photographic

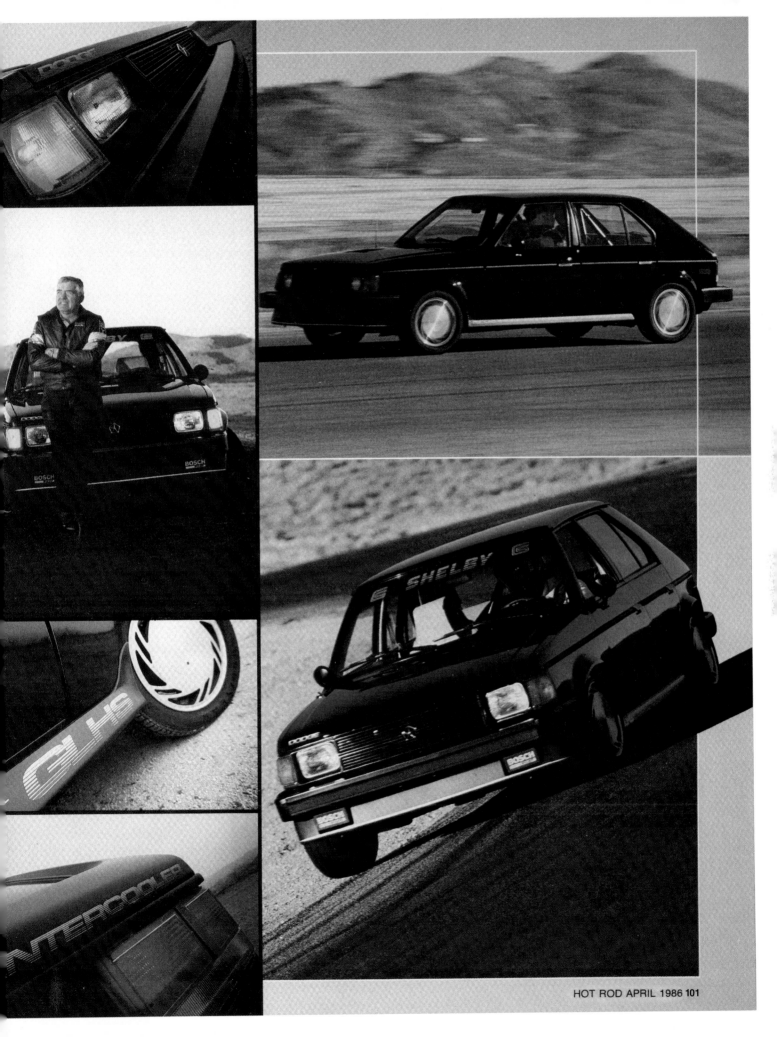

SPEC SHEET	FORD SHELBY GT350	DODGE SHELBY GLHS
WEIGHT	3000 pounds	2300 pounds
HORSEPOWER	306 hp	175 hp
TORQUE	329 ft.-lbs. @ 4200	175 @ 4600 rpm
ENGINE TYPE	V8	4 Inline
DISPLACEMENT	289-cid	134-cid
INDUCTION	1 4-barrel carb.	Fuel-injected/Turbo-charged/Intercooled
TRANSMISSION	4-speed/manual	5-speed/manual
BRAKES	Disc—Front Drum—Rear 60-0—140 ft.*	Disc—Front Drum—Rear 60-0—121 ft.
PERFORMANCE 0-60 mph: ¼-mile: Skidpad:	7.0* 15.7 @ 91 mph* .76	6.7 14.7 @ 94 mph .88
WILLOW SPRINGS INTERNATIONAL RACEWAY Lap Time:	1:45	1:43

Motor Trend, May 1965 tests.

Standard Omni Turbo GLH interior receives minor dress-up items on GLHS model—Shelby logos, leather-wrapped wheel, and optional rollbar, to name a few.

and now he intends to build the cars the bean counters won't let Iacocca make.

If there's one question Shelby dislikes hearing about his new activity, it's: "Will it be like the good old days?" Without our ever asking, Shelby made it perfectly clear that the new Shelby Automobiles, Inc. won't be building any 427 Cobras, GT350's, or GT500 Mustangs. "We'll be building today's cars...you boys had better learn to deal with that fact." And just to prove it, we let Shelby lead us like sheep to slaughter at a track test set up to preview the new Shelby-version Omni Turbo GLHS.

Using Willow Springs International Raceway as their introduction location, the Shelby group put the automotive press in a standard 1986 Omni GLH Turbo for a comparison baseline. Content to be impressed with the car's lap times (the current model is not weak-wristed), we took the bait—hook, line, and sinker.

The mile-wide grins dominating the faces of the Shelby PR people should have told us something as they strapped us in the shiny black GLHS. By the end of the pit straight, the gig was up. By the entrance to Turn One, so was our heart rate. Quicker? Quicker doesn't even come close. By Turn Two (a sweeping, slightly uphill right-hander), a corner we had been entering flat-out in the standard GLH, we now arrived going so much quicker we had to lift and tap the brakes. Yes folks, this puppy is definitely quicker. Lots quicker.

And it's quicker everywhere! On the straights, in the turns, everywhere. It took us three laps just to catch up to the thing, but by three more we were comfortable and having at it. The car pulls down the straight like a strong V8, and it works in a corner like some

of the best set-up, conventional rear-drive performance platforms. If it showed us any weakness, it was the brakes. The darn thing can just plain be driven harder than its brakes can stop it. One of our return trips to the pits was made all the more spectacular by a front-disc brake fire. A point was made in the GHLS' favor, given that the stock pads were brand-new and not properly burnished for this kind of use. But who could resist driving the little monster this hard? Not us.

After the initial shock wore off we started to better appreciate just what a watershed car this is. For starters, it was all the things Shelby had been telling us it could be—a low-cost (about $11,000), front-wheel-drive (because that's what Chrysler is manufacturing today), four-cylinder (mileage and economy still call the shots), turbocharged (because some folks still want to enjoy driving a car) little car (because today it's required to make better use of space and materials). In short, it has all the earmarks of a "today" car, not those of the mid-Sixties.

To further prove the point, we pitted the Shelby of "today" against the Shelby of "the good old days." We brought to the test a 1965 Shelby GT350 Mustang. A watershed car in its own time,

it would now stand toe-to-toe with the future and slug it out; a no-holds-barred contest for technical supremacy. A fair fight? Not really. By our perspective the GT350 was playing with a stacked deck, but what better way to make Shelby prove his point?

The car we used belongs to Shelby American Automobile Club member Phil Schmit. Schmit's not a rookie to Shelby products. He not only restored his own GT350, but his 427 Cobra as well, both of which he drives in SAAC track events. Considered by his fellow club members to be a quick Shelby driver, Schmit was chosen to champion "the good ol' days."

The two cars took to the track looking as mis-matched as David and Goliath. It was a growling V8 against a muffled, straight four—a fat-rubbered, rear-drive, 3000-pound musclecar versus a gumballed, front-drive, 2300-pound shoebox. Surely Shelby was starting to sweat. The contest came to speed in a hurry, as the GLHS took off in an effort to stretch an advantage, with the GT350 in hot pursuit. The gap opened to about 10 car lengths, where it remained for three rapid laps. Much to our amazement, the GT350 showed no significant advantage anywhere on the course. It reeled in a few car

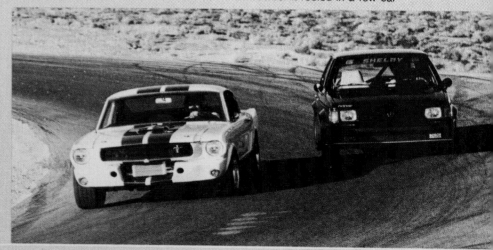

lengths at the exit of the low-speed corners, but was held at bay down the remaining straights. The GLHS had slightly higher corner entrance speeds and was able to pull out a few lengths in the really tight stuff.

The cornering performance of the GLHS surprised us, and why not? The GT350 Shelby Mustang had won on race courses over the country in the mid-Sixties (we might add, against Corvettes, Cobras, and Jags), yet the way the GLHS held the Mustang off down the long straights really blew our minds. Both cars recorded 125 mph at the exit of the back straight.

Feeling a wealth of confidence, we backed off the throttle in the GLHS, letting it charge about 10 car lengths ahead. With both cars back up to speed, another three-lap ding-dong developed: this time the GLHS closed up. By mid-point of the second lap the GLHS was on the trunk of the GT350. To pass it would serve no point. The cars returned to the pits together. Shelby beamed.

On paper this whipping should not have happened. The GT350—with Schmit's admittedly "smiled on" motor putting out about 350 horsepower, its high-powered cornering ability, its large disc brakes and Detroit locker rear-end—should have put it to the shoebox with shark's teeth.

Bewildered, Schmit, along with the rest of us, put the obvious question to Shelby. How? He calmly explained that it was a matter of ". . . efficiency. For three years now my guys have been playing with engines. You know, heads, pistons, turbos, superchargers, the whole range, just looking for ways to make that 2.2-liter engine think it's a 5-liter V8. Turbos, which I've been telling you guys for years, are the only way to go in a small-displacement vehicle."

Shelby GT350 interior differed little from production-line Mustangs. Shelby items include add-on tach/gauge panel and a wood-grained steering wheel. Bucket seats offer no lateral support.

Shelby goes on: "Scott Harvey heads our engineering team, and he's had Neil Hannemann developing the chassis, while the engine team—Jerry Mallicoat and Jim Broske—worked with our electronics engineer, Alex Koral, to really make the power we needed. Engine detail changes for the GLHS include an air-to-air intercooler that cools the compressed turbo air by as much as 100 degrees F, allowing more of it to be forced into the combustion chamber. As a result, the turbocharger's boost can be bumped up to 12 psi, as compared to the standard GLH's maximum of 9 psi. A tuned multi-point fuel-injection manifold, with longer intake runners, help improve the distribution of the fuel/air mixture. All this adds up to a 30-horsepower increase and a broader powerband to 175 ft.-lbs. at 4600 rpm. The durability homework was done the Powerplant Engineering group and the Special Vehicles team back in Highland Park, Michigan."

Shelby brags that the car was designed as a package. "Steve Hope, who, like Harvey, has been a racer for years, put it all together. Chassis, engine, electronics, everything. To make this little monster effective, as a real-world car, we had to plan ahead. I wanted a car that a young couple could afford to buy, but would enjoy gettin' out in. Turned out it could blow the doors off cars that cost four or five times as much."

Its quarter-mile times do nothing to discount Shelby's statement. Passes at 14.7 @ 94 mph make the GLHS one of the 10 fastest production turbo cars in the world. Its 0 to 50 time of 4.57 seconds makes it a real stoplight racer and puts nearly every other car in danger of a short-race whipping. On the skidpad, where the car's lateral acceleration is measured, it pulled an amazing .88g. It's a fighter of the pocket-rocket variety, no doubt about it.

As for progress, Shelby's benchmark of 20 years ago ran 15.7 @ 91 mph in the quarter, with 0 to 60 times of 7.0

seconds (see *Motor Trend* and *Sports Car Graphic*, May '65)—in its day a very hot machine. But Shelby is quick to add, "I would have been sorely disappointed if I hadn't been able to build a faster, more efficient car today. It's a sign of the times." Shelby goes on to say, "It's a lot of little car for the money. We're given it Koni adjustable gas shocks, our new 15x6 Centurion cast wheels with Goodyear 205/50VR Eagle Gatorbacks, a 175-hp turbocharged, intercooled engine, a special gauge group with some real information in it, and rollbar and oil cooler option for the guys who might want to go race the damn thing."

Current production plans call for only 500 of the black demons to be built. Assigned a Shelby serial number, they shouldn't be in the dealer's showroom for long. First production versions are due to roll off the new Shelby Automobile Inc. assembly lines in mid-March. When pressed about expanding the production numbers, Shelby replied that "If the demand is that great, we'd take a look at it."

Shelby Automobiles, Inc. is going to be a small production car group building specialty cars aimed at a narrow market segment. Shelby's goal is to build cars that will focus on the current technology and take advantage of the engineering breakthroughs that continue to take place. "We'll be able to respond quickly to the latest thinking," says Shelby. "Our group is already developing hardware for the Lancer and Daytona. We've got some slick stuff coming down the pike for you."

Seems the Ol' Master wasn't talking out the side of his mouth these last few years. Shelby has made his point, and he plans to keep on making it. It might not be like the good old days, but it's sure to be as interesting. **HR**

High-output 289 made 306 horsepower and featured a host of aftermarket speed equipment carefully engineered into the Shelby package. Front chassis stiffness was aided by crossbar ahead of shocks.

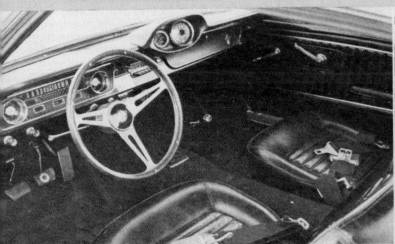

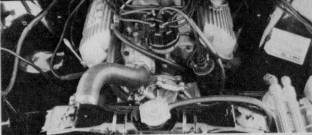

SERIES 1

CARROLL

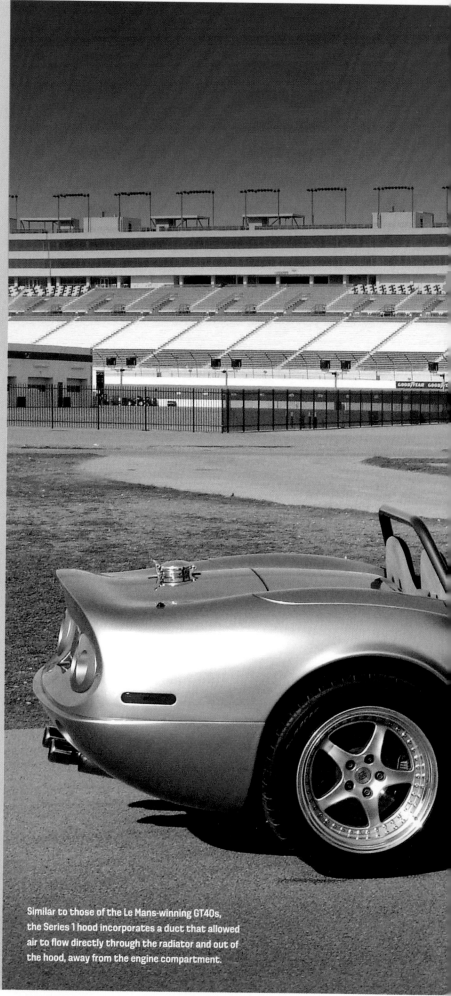

It never surprised anyone that Carroll Shelby was full of surprises. He shocked the automotive and racing worlds with his Cobras and Mustangs in the 1960s, only to drop it all to go hunting in Africa in the 1970s. When he returned to building cars in the 1980s, it wasn't with Ford; it was with Chrysler to build "pocket rockets" like the Dodge Omni GLH. So no one was surprised when Carroll announced a new sports car venture in the 1990s that aligned him with the Oldsmobile division of General Motors.

That car was the Shelby Series 1, a throwback to his Cobra roots, but a much more modern two-seat sports car. When it was unveiled in 1997, the car was a concept and a long way from production. Shelby told the assembled media, "Don't ask me how much horsepower it's got or how fast it'll go from zero to 60, because we don't know yet."

Similar to those of the Le Mans-winning GT40s, the Series 1 hood incorporates a duct that allowed air to flow directly through the radiator and out of the hood, away from the engine compartment.

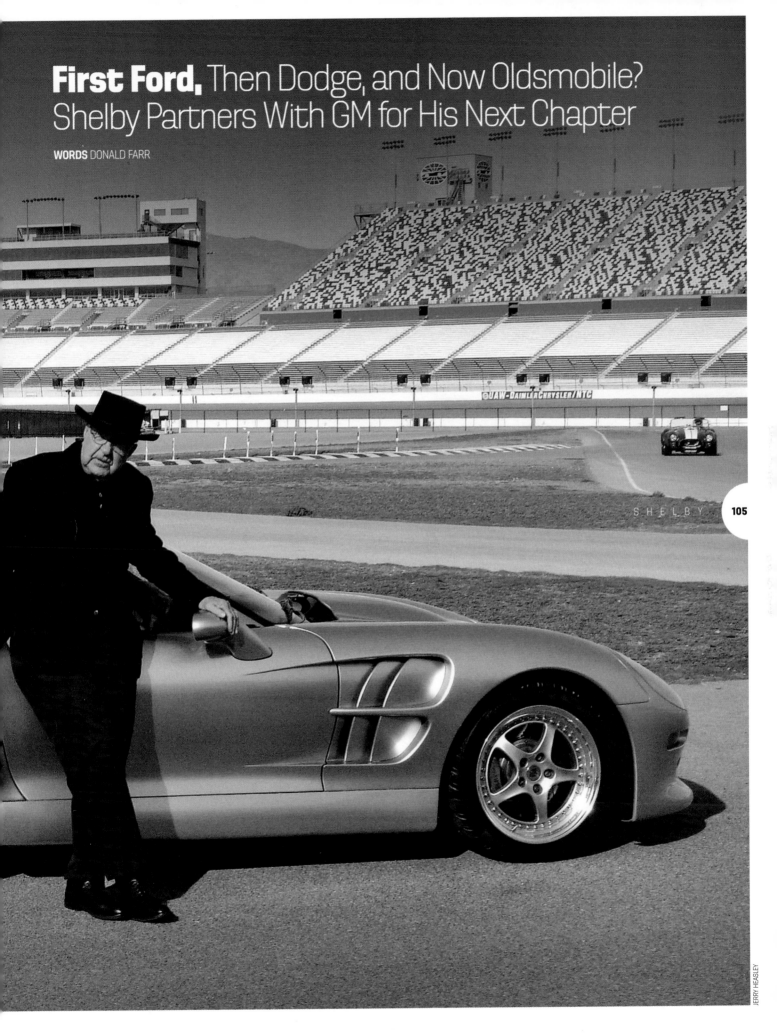

First Ford, Then Dodge, and Now Oldsmobile?
Shelby Partners With GM for His Next Chapter

WORDS DONALD FARR

SHELBY

105

JERRY HEASLEY

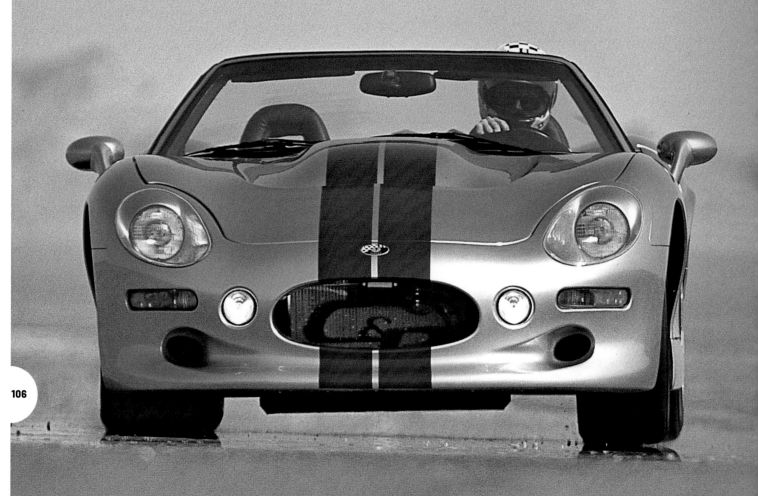

> **The Series 1** would be built as a brand-new Shelby design, instead of a car built by someone else and modified by Shelby.

You'll always find a Series 1 among the Mustangs and Cobras in the Shelby American Museum in Las Vegas.

Carroll Puts the Pressure on His Lustworthy Asp-Kicker

From the November 2000 *Motor Trend* cover story, "High-Speed Shoot-Out!"

Blast through the closely spaced gears with your right foot planted, and it feels for all the world like there's way more than 4.0L under the Shelby's hood. No peaks. No valleys. Just one awesome plateau of power that stretches from horizon to horizon. Still in rough developmental trim—and sniffing a bit of octane booster—when we drove it, the supercharged Shelby takes the dyno curve of the Oldsmobile Aurora-derived DOHC V-8 powerplant and puts it on stilts. Horsepower jumps from 320 to an estimated 450, and torque swells from 290 to about 400 lb-ft.

But the blown Series 1 isn't just for straightline glory dashes; its monumentally ridged tubular aluminum chassis has a high level of at-the-limit predictability and ultimate grip. Think "race car." True, the Shelby will tolerate easy cruising, but it punishes you with a heavy clutch, stiff shifter, and foot pedals positioned far, far to the left to make room for the practically mid-mounted "front" engine. And there's no trunk. At all. You'll whine loudly about the ergonomic and practical shortcomings only until the next full-throttle blast, at which point all will be forgiven. **Jeff Karr**

Shelby Series 1 Supercharged

BASE PRICE	$174,975
VEHICLE LAYOUT	Front-engine, RWD, 2-pass conv
ENGINE	90-deg V-8, DOHC, 32-valve
DISPLACEMENT	244 cu-in/3995cc
HORSEPOWER (SAE NET)	450 hp @ 6800 rpm (est)
TORQUE (SAE NET)	400 lb-ft @ 5300 rpm (est)
TRANSMISSION	6-speed manual
SUSPENSION, FRONT; REAR	control arms, coil springs, anti-roll bar; control arms, coil springs, anti-roll bar
BRAKES, F;R	13.0-in vented disc; 12.0-in vented disc
WHEELS, F;R	10.0 x 18-in; 12.0 x 18-in, cast aluminum
TIRES, F;R	265/40ZR18; P315/40ZR18 Goodyear Eagle F1 Supercar
WHEELBASE	96.2 in
CURB WEIGHT	2950 lb
PRICE AS TESTED	$195,000 (est)
EPA CITY/HWY ECON	12/20 mpg (est)

WHAT'S HOT Massive cachet, snakey styling, irresistible thrust **WHAT'S NOT** Sidesaddle driving position, parts-bin gauges, balky shifter

What Shelby did know was that the Series 1 would be a brand-new Shelby design, instead of a car built by someone else and then modified by Shelby. Its aluminum spaceframe, reinforced by aluminum honeycomb panels, weighed only 270 pounds. Carbon-fiber body panels helped, but the 2500-pound target weight was missed by about 450 pounds.

Instead of a Ford or Chrysler powerplant, Shelby used a General Motors engine for his new sports car. In standard form, the Oldsmobile 4.0-liter Aurora DOHC V-8 developed 320 hp. Not surprisingly, Shelby offered a supercharger to increase output to 450 hp.

The first prototypes were built at Shelby's facility in Gardena, California. For production and assembly, Shelby American moved into a new 100,000-square-foot facility at Las Vegas Motor Speedway. The first production versions reached consumers in 1999.

The Shelby Series 1 is truly notable because it's the only car Carroll Shelby produced from a clean sheet of paper. And it led Shelby American to its current facility in Las Vegas.

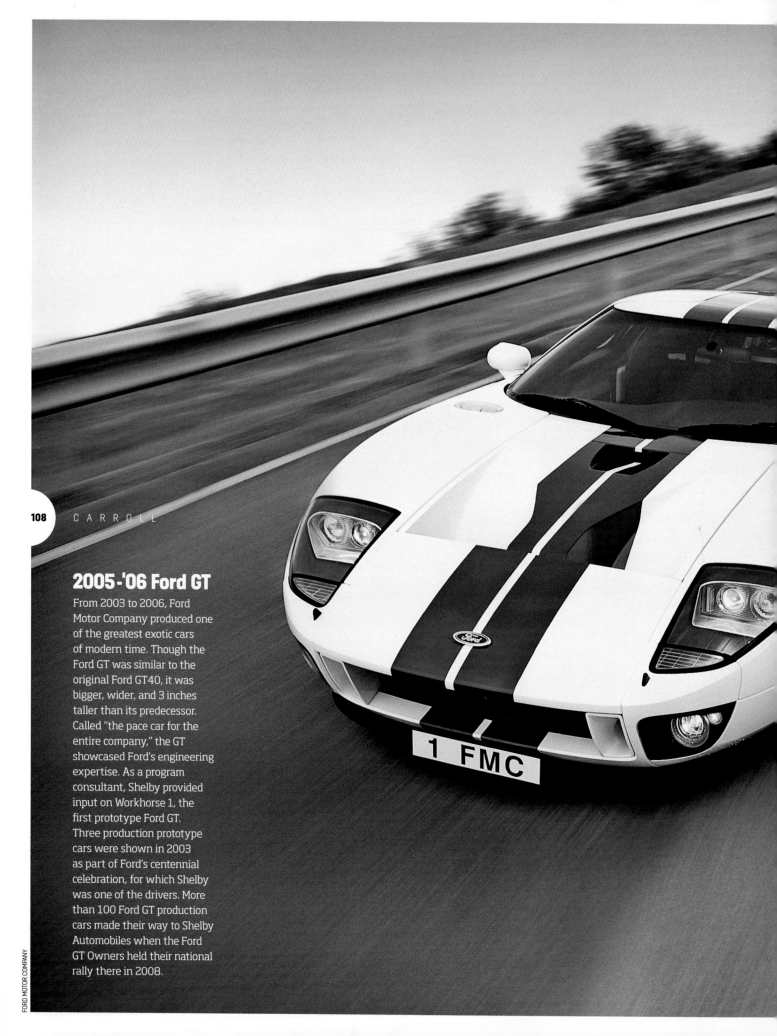

2005-'06 Ford GT

From 2003 to 2006, Ford Motor Company produced one of the greatest exotic cars of modern time. Though the Ford GT was similar to the original Ford GT40, it was bigger, wider, and 3 inches taller than its predecessor. Called "the pace car for the entire company," the GT showcased Ford's engineering expertise. As a program consultant, Shelby provided input on Workhorse 1, the first prototype Ford GT. Three production prototype cars were shown in 2003 as part of Ford's centennial celebration, for which Shelby was one of the drivers. More than 100 Ford GT production cars made their way to Shelby Automobiles when the Ford GT Owners held their national rally there in 2008.

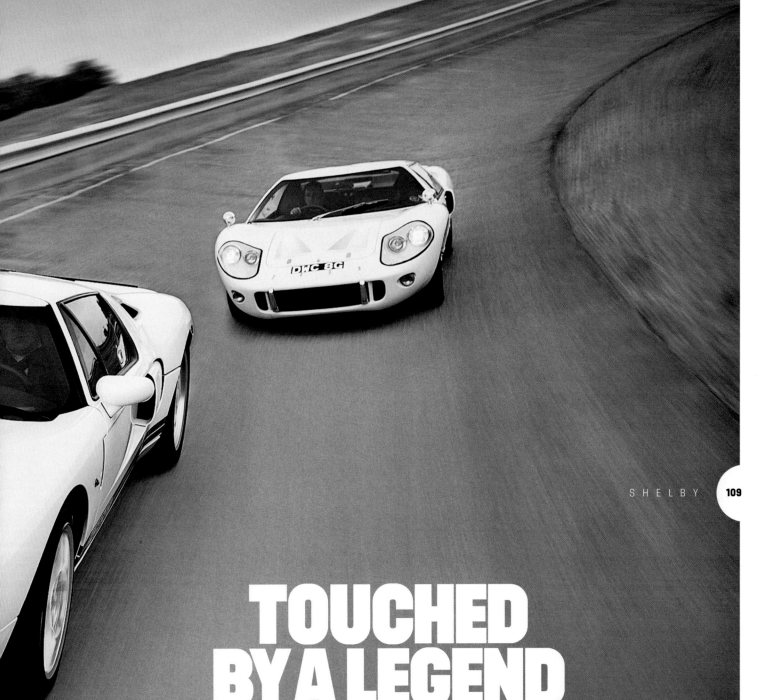

TOUCHED BY A LEGEND

WORDS SCOTT BLACK

Beginning in 1962, Carroll Shelby was involved with performance vehicles from every major American automaker, as well as cars from Europe and Asia. While he's most revered for the cars he built—the Cobra, GT350, GT500, and GT40—his contributions to some of the world's most iconic cars are often overlooked.

S H E L B Y **111**

1. '59 SCAGLIETTI CORVETTE

In the late 1950s, Carroll Shelby co-owned a Dallas sports car dealership with Jim Hall. As Shelby's driving career began to wind down, the two men and Chevy dealer Gary Laughlin decided to build a car that would beat the Europeans by combining American reliability with European expertise and flash. The trio leveraged their connections with Chevrolet to buy three Corvette chassis with the fuel-injected 283 that they sent to Carrozzeria Scaglietti, Ferrari's in-house fabricator, to be rebodied in aluminum. GM vice president Harley Earl and chief engineer Ed Cole approved the idea, but Chevrolet management did not, and called off the Scaglietti Corvette project. The idea was resurrected a few years later as the Cobra.

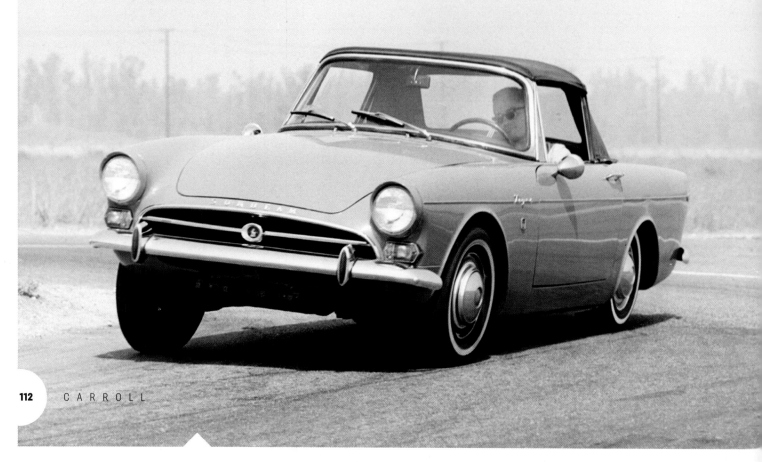

2. '64-'67 SUNBEAM TIGER

Often called the "poor man's Cobra," the Tiger packed a mean Shelby punch. Seeking to juice up Alpine's image with some V-8 magic, Sunbeam asked Shelby to build a functional prototype of a car that followed the same formula as the Cobra. Shelby's prototype came with Ford's new 260-cubic-inch V-8, a four-speed transmission, and suspension mods. From 1964 to 1967, 7085 Sunbeam Tigers were built in three distinct series, known as MK I, MK IA, and MK II. The last was powered by Ford's 289-cubic-inch V-8 even after Chrysler bought Rootes, Sunbeam's parent company, as Chrysler's 318 didn't fit.

3. '67-'69 DETOMASO MANGUSTA AND '71-'89 PANTERA

The DeTomaso Mangusta, nicknamed the Goose, was based on a stillborn Can-Am racing project intended as a collaboration between Shelby and DeTomaso. While DeTomaso was working on the front-engine chassis, changes in the Can-Am scene rendered the car irrelevant. When Shelby canceled the program instead of spending more money on the car, DeTomaso was furious. That chassis became the basis for a Ford-powered DeTomaso concept car. Later, it was incorporated into the 289-powered Mangusta–the Italian word for mongoose, which feasts on cobras.

As for the Pantera, there are a couple of connections. Shelby owned a Lincoln-Mercury dealership that sold some Panteras. Then there were Mopar-powered Pantera concepts in the 1980s. While Shelby was working with Lee Iacocca at Chrysler, they brought in a handful of Panteras and stuffed small-block Mopar engines into the sports cars. During a conversation with Shelby in Texas a few years ago, he said the idea had been an exercise for the new Viper.

3

4

5

6

4. '68 SHELBY-TOYOTA 2000 GT

Though Shelby passed up the rights to the West Coast distribution for Toyota, he did accept a contract to turn the Toyota 2000 GT into a race car. Built in small numbers (337 total) between 1967 and 1970, the car was created to offset Toyota's stodgy, practical vehicles with a sports car to rival those from Europe. In summer 1967, Shelby received three chassis that had been prepared in Japan. During the 1968 season, the new 2000 GTs showed great potential in the SCCA C-Production class, earning a total of three 1-2 finishes. By season's end, the Shelby Toyotas captured four wins, eight second-place finishes, and six third-place finishes. The cars validated Toyota's reliability and Shelby American's developmental skills, and put the 2000 GT on par with Europe's best.

5. '89-'10 VIPER

Along with Bob Lutz, Tom Gale, and Francois Castaing, Shelby is considered one of the "four fathers" of the Viper. Lutz wanted a modern Cobra with current technology that could be offered for around $100,000. The Viper is one of the most outrageous American cars in postwar history. True to the spirit of the Cobra, the car was built for the hard-core enthusiast and continues to be one of most coveted sports cars on the road. In May 1991, Shelby paced the Indy 500 in a Viper with Gen. Norman Schwarzkopf riding shotgun.

6. PRUDHOMME SUPER SNAKE DRAGSTER

Although Shelby offered no design or engineering advice, his sponsorship put the Shelby name on the side of a Top Fuel dragster from 1967 to 1969. When drag racer Lou Baney acquired a factory deal from Ford to run the 427-cubic-inch SOHC engine in a new Top Fuel car, he hired Ed Pink to build and tune the big Fords, and asked Don Prudhomme to drive. Baney told Prudhomme it would be a good idea to get Shelby involved. Prudhomme recalls, "I was just a kid off the streets, and when we went over to Shelby's office I was scared to death. Shelby took a liking to me, and the deal was done. We were friends from then on." Shelby certainly did have a thing for snakes.

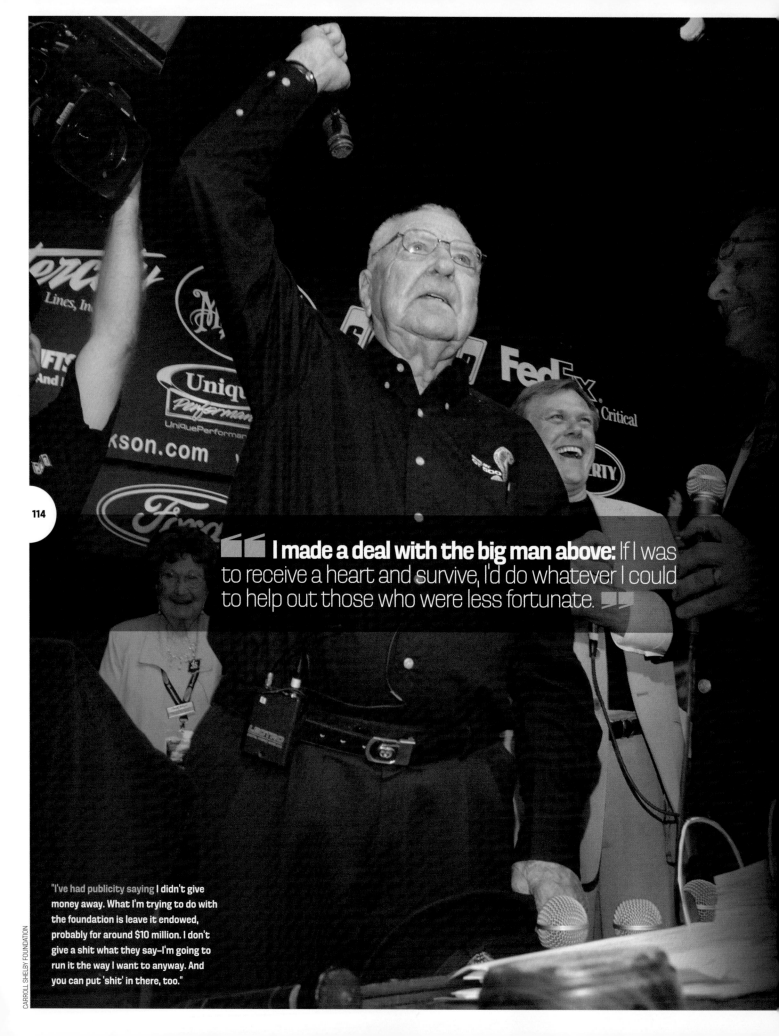

114

> ❝ **I made a deal with the big man above:** If I was to receive a heart and survive, I'd do whatever I could to help out those who were less fortunate. ❞

"I've had publicity saying I didn't give money away. What I'm trying to do with the foundation is leave it endowed, probably for around $10 million. I don't give a shit what they say–I'm going to run it the way I want to anyway. And you can put 'shit' in there, too."

WORDS SCOTT BLACK

Carroll Shelby Foundation

Few people cheat death as often—or live life as fully—as Carroll Shelby did. He spent much of World War II test-flying aircraft that had been grounded for mechanical trouble and then fixed. It was a very risky job. And even though he suffered from the same congenital heart defect that took his father's life, Shelby still jumped into the dangerous world of auto racing.

That heart ailment spelled the end of his racing career.

"It just wasn't safe for me to keep racing," Shelby said. "I was taking a couple of nitro pills during each race just to make it through."

Eventually, doctors determined Shelby needed a new heart. He was days from dying in 1990 when a gambler keeled over at a craps table in Las Vegas. Shelby was rushed to the operating table and his new "aftermarket" part was installed.

"When I was lying there in the hospital awaiting a heart, I noticed so many kids needed critical care," said Shelby. "So I made a deal with the big man above: If I was to receive a heart and survive, I'd do whatever I could to help out those who were less fortunate."

Shelby kept his word by establishing the nonprofit Carroll Shelby Children's Foundation to provide financial assistance to children in need of acute coronary and kidney care. The name has since been changed to the Carroll Shelby Foundation to reflect its expanded mission, which includes continuing education for young people. It also donates funds to organizations conducting research in coronary and organ transplant management and promotes organ and tissue donation.

To donate, or for more information, visit www.carrollshelbyfoundation.com.

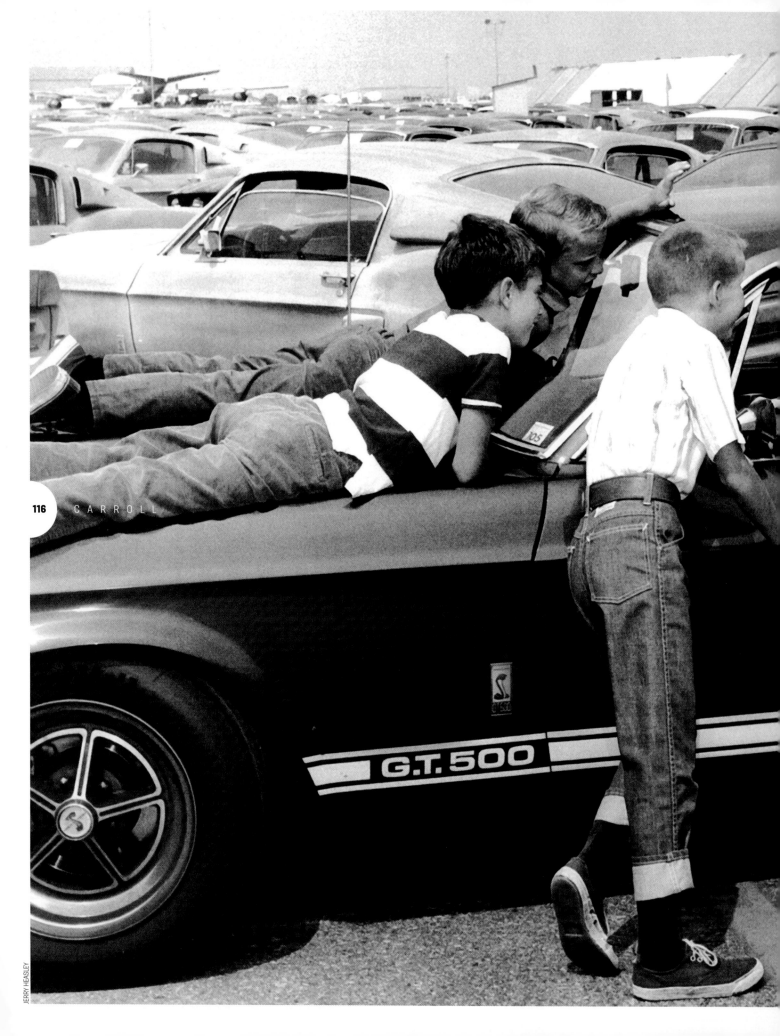

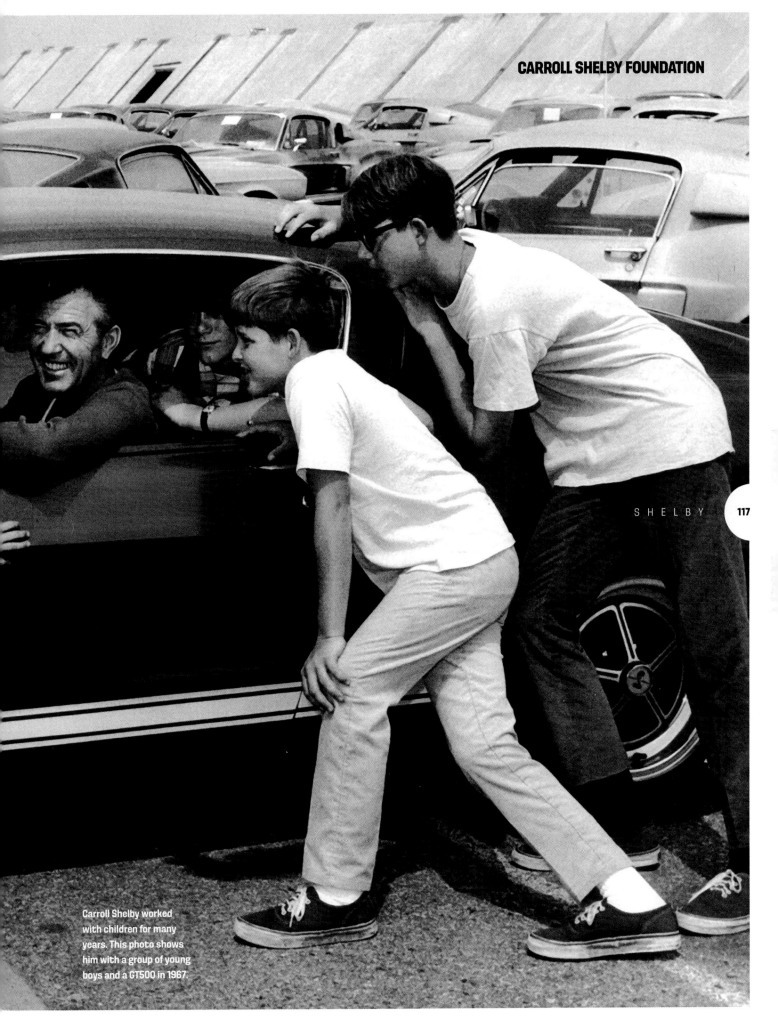

SHELBY 117

Carroll Shelby worked with children for many years. This photo shows him with a group of young boys and a GT500 in 1967.

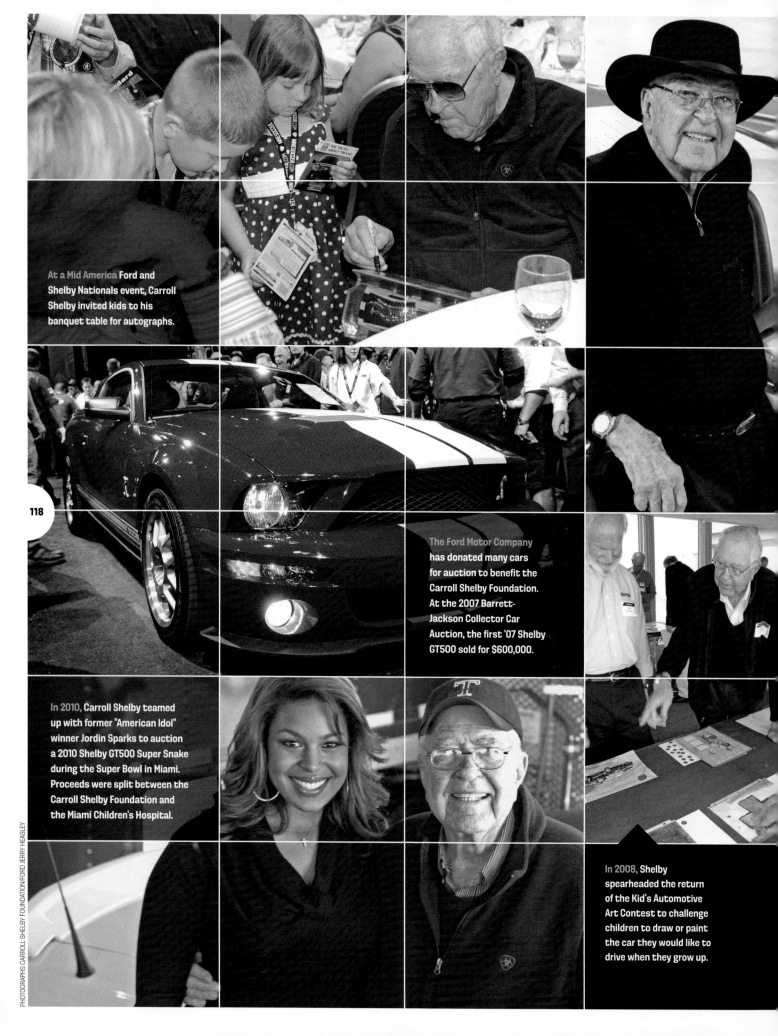

At a Mid America Ford and Shelby Nationals event, Carroll Shelby invited kids to his banquet table for autographs.

The Ford Motor Company has donated many cars for auction to benefit the Carroll Shelby Foundation. At the 2007 Barrett-Jackson Collector Car Auction, the first '07 Shelby GT500 sold for $600,000.

In 2010, Carroll Shelby teamed up with former "American Idol" winner Jordin Sparks to auction a 2010 Shelby GT500 Super Snake during the Super Bowl in Miami. Proceeds were split between the Carroll Shelby Foundation and the Miami Children's Hospital.

In 2008, Shelby spearheaded the return of the Kid's Automotive Art Contest to challenge children to draw or paint the car they would like to drive when they grow up.

118

Jenni Shreeves, **executive director of the Carroll Shelby Foundation.**

The Carroll Shelby Foundation contributes **to other organizations that help children, such as the Children's Medical Center in Dallas.**

A heart full of memories

I have had the honor of calling Mr. Shelby my friend for 21 years, but I don't remember actually meeting him because I was only five months old. What brought us together, however, was not what he was most known for. We shared something else in common besides cars: a second chance at life. Like Mr. Shelby, I, too, had a heart transplant. Mine was in April 1991, 10 months after his. I was only 11 days old. I was born with hypoplastic left heart syndrome—I had no left ventricle. My only chance at survival was a heart transplant. I was very blessed to have gotten my heart so quickly. My family is from Auburn, Indiana, and my grandfather, John Martin Smith, was one of the founders of the Auburn Cord Duesenberg museum. My parents organized the fund-raiser to help cover the costs of my transplant during the Auburn Cord Duesenberg festival, Labor Day weekend of 1991. Mr. Shelby was there as grand marshal of the festival parade. We had attended the same press conference together and were nearly inseparable the rest of the weekend. Mr. Shelby took me to the parade, the festival and the classic car auction. He even put me up on the auction block for sale to help my family with the fund-raising efforts.

I will miss my conversations with Mr. Shelby. We talked on the phone often to check in with each other. He ended every phone call with an "I love you," and it meant so much. The legacy I am most glad to share with him is the formation of the Carroll Shelby Children's Foundation.

Leah Smith, **heart transplant recipient and the inspiration for the Carroll Shelby Children's Foundation.**

119

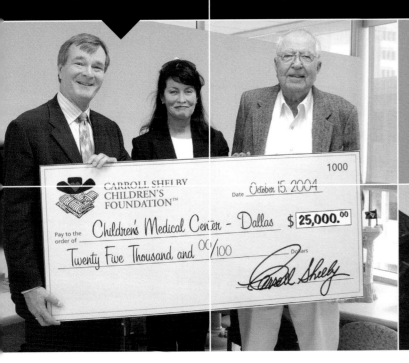

One of the fund-raising **methods for the Carroll Shelby Foundation is autographs. Shelby signed thousands of items for auction each year, from memorabilia to car parts.**

Shelby Returns to the Ford Family to Build a Modern GT

WORDS DONALD FARR

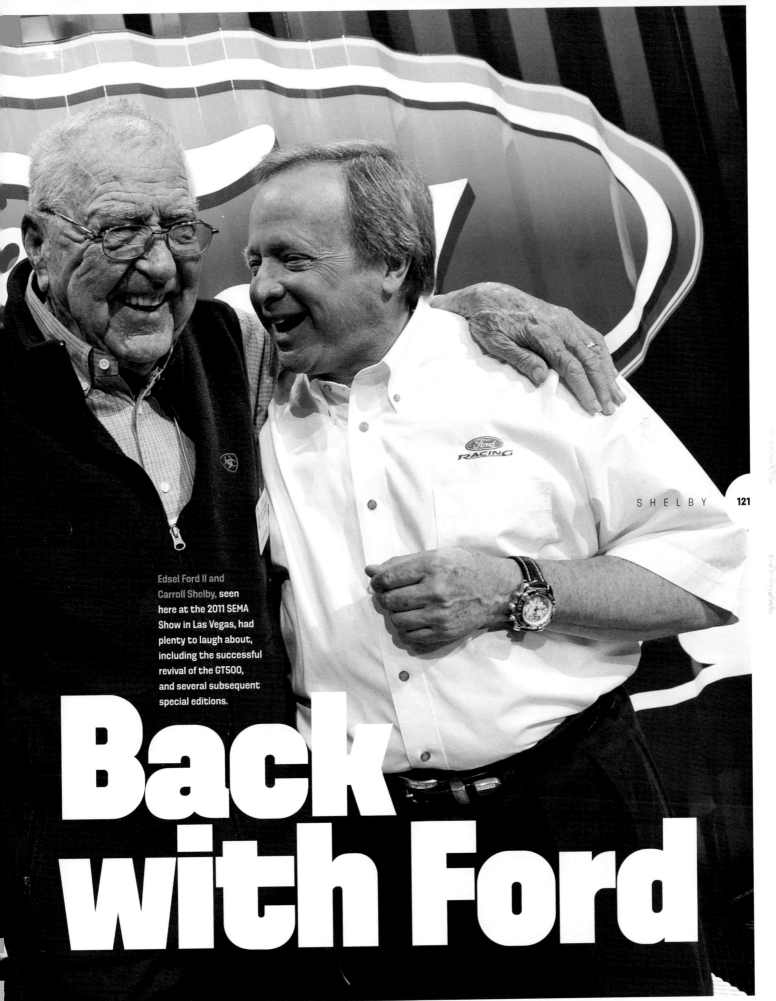

Edsel Ford II and Carroll Shelby, **seen here at the 2011 SEMA Show in Las Vegas, had plenty to laugh about, including the successful revival of the GT500, and several subsequent special editions.**

Back with Ford

BACK WITH FORD

For eight years in the 1960s, Carroll Shelby rode the wave of Ford's Total Performance campaign to create the Cobra; launch a Mustang performance car; and win numerous racing championships, including Le Mans, all with Ford backing. But in 1982, Shelby followed his pal Lee Iacocca to Chrysler, and suddenly his old friends at Ford were the competition. He even sued Ford over the use of the GT350 name for a 20th-anniversary Mustang in 1984. That created a lot of bad blood throughout the 1980s and 1990s.

Then, in the summer of 2001 at the Pebble Beach Concours, Shelby ran into Edsel Ford II. The two had been friends since the 1960s. Henry Ford II, Edsel's father, had sent him to Southern California to work for Shelby in summer 1968. In the midst of all the vintage cars at Pebble Beach, the two decided it was time to smooth over their differences. Edsel mentioned that Ford wanted to build a modern GT, and Shelby was game.

Soon, Shelby was back in Dearborn, meeting with Ford designers and engineers to build the 600-hp Ford Shelby Concept Cobra. He signed autographs with Edsel

With the introduction of the 2007 Shelby GT500 at the 2005 New York auto show, the Shelby name was back on a Mustang. During the presentation, Shelby shook hands with Phil Martens, Ford's group vice president for Product Creation.

(Right) In one of Shelby's last public appearances, he visited the SEMA Show in November 2011 to participate in Ford's 110 Years of Racing Celebration.

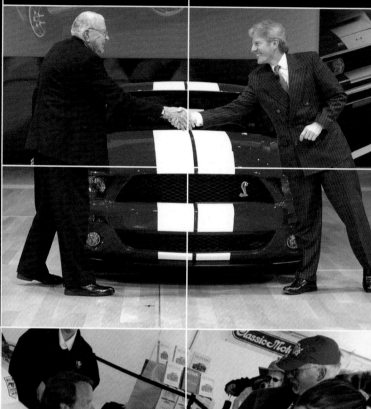

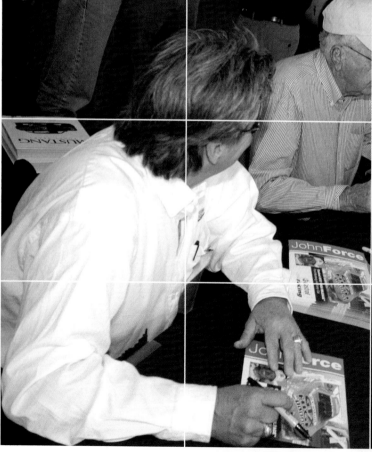

In 2003, during Ford's Centennial Celebration in Dearborn, Carroll Shelby and Edsel Ford were together again while signing autographs with drag racer John Force (foreground).

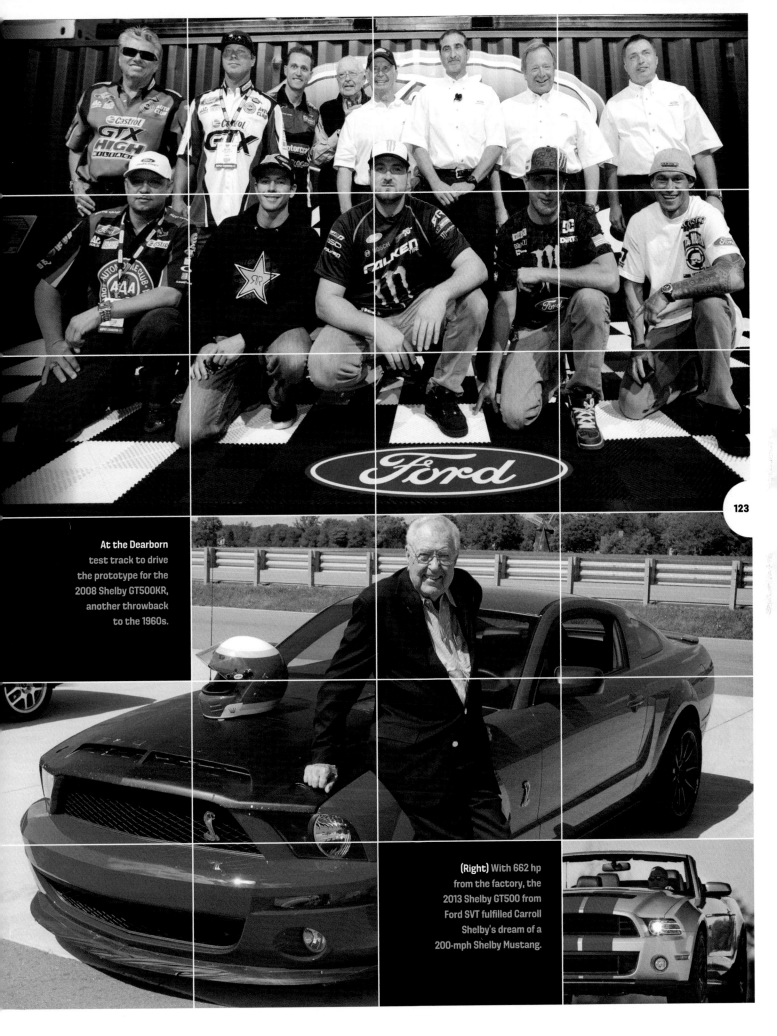

123

At the Dearborn test track to drive the prototype for the 2008 Shelby GT500KR, another throwback to the 1960s.

(Right) With 662 hp from the factory, the 2013 Shelby GT500 from Ford SVT fulfilled Carroll Shelby's dream of a 200-mph Shelby Mustang.

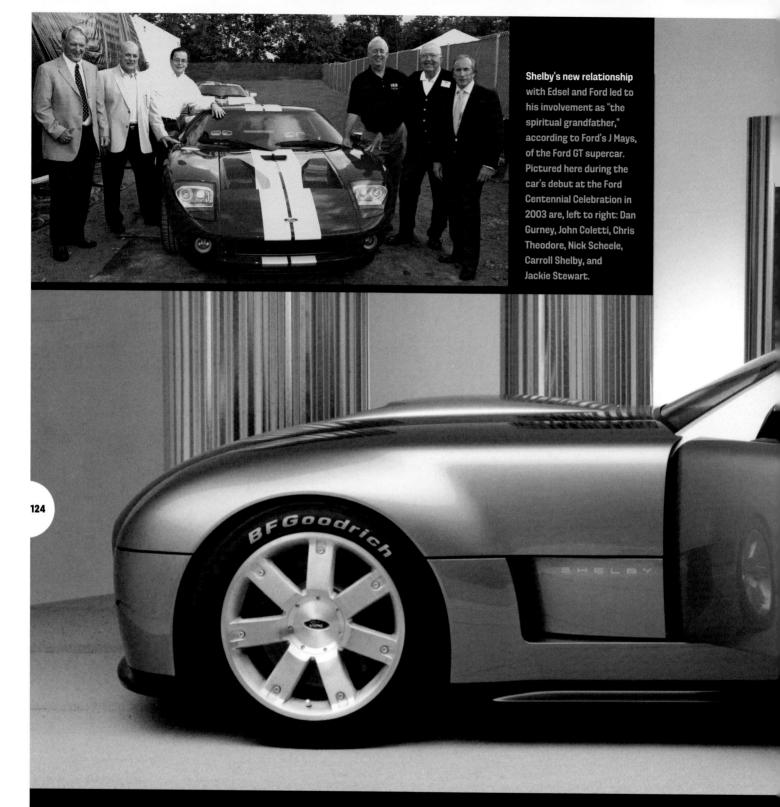

Shelby's new relationship with Edsel and Ford led to his involvement as "the spiritual grandfather," according to Ford's J Mays, of the Ford GT supercar. Pictured here during the car's debut at the Ford Centennial Celebration in 2003 are, left to right: Dan Gurney, John Coletti, Chris Theodore, Nick Scheele, Carroll Shelby, and Jackie Stewart.

at Ford's Centennial Celebration at World Headquarters, accepted an award for his contributions to Ford racing, and was even seen racing scooters with Edsel through the aisles of the SEMA Show at the Las Vegas Convention Center. Shelby was back with Ford–and he was having fun.

The partnership soon led down a familiar path to Mustangs. It wouldn't be long before the names from the past were back: GT500, Super Snake, Hertz, and even GT350.

"I plan to be with Ford when I go horizontal," Carroll was known to say. And he was.

Two years after reestablishing his friendship with Edsel Ford II, Shelby was back with Ford doing what he did best: building sports cars. The Shelby Cobra concept debuted at the 2003 Detroit auto show. It was the beginning of a new relationship between Shelby and Ford.

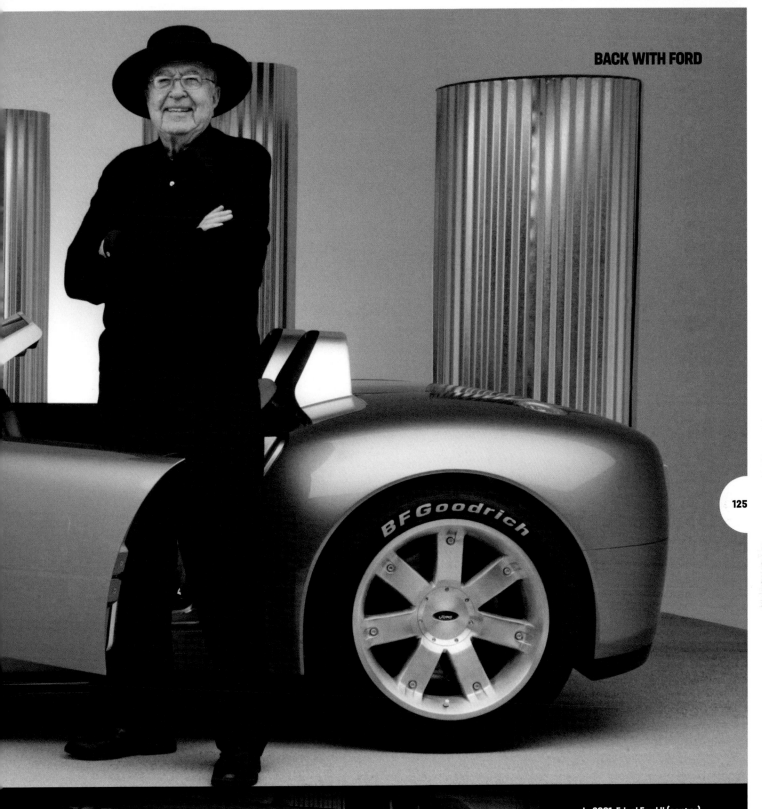

In 2001, Edsel Ford II (center) presented awards for achievement in contributions to Ford racing. Of course, Carroll Shelby was among the honorees. Left to right: George Follmer, Bob Glidden, Ned Jarrett, Dan Gurney, Junior Johnson, Don Nicholson, Lyn St. James, Tom Kendall, Parnelli Jones, Jackie Stewart, Carroll Shelby, Glen Wood, and Leonard Wood.

On Shelby's return to Ford...

"He lived 10 lives. Sometimes two or three at the same time. People are going to remember him for a long time, because to create a legend—and there's only a couple—first you have to be a good race driver, which he was. You have to design your own car and live everybody's dream, which he did. You have to have the balls to put your name on it, which he did. You have to be a larger-than-life character, which he was. And then you had to have longevity. If you think about it, everybody thinks everything stopped in 1967.

It didn't. I spent five years bringing him back into Ford, and a whole new generation learned what Shelby was. So now, you got teens that know the name Shelby—they don't really know what it means, but they know it's important, so when they're driving age, there's gonna be enthusiasts another 15, 20 years from now. It's a hell of a legacy."

Chris Theodore, *former vice president of Product Development, Ford Motor Company*

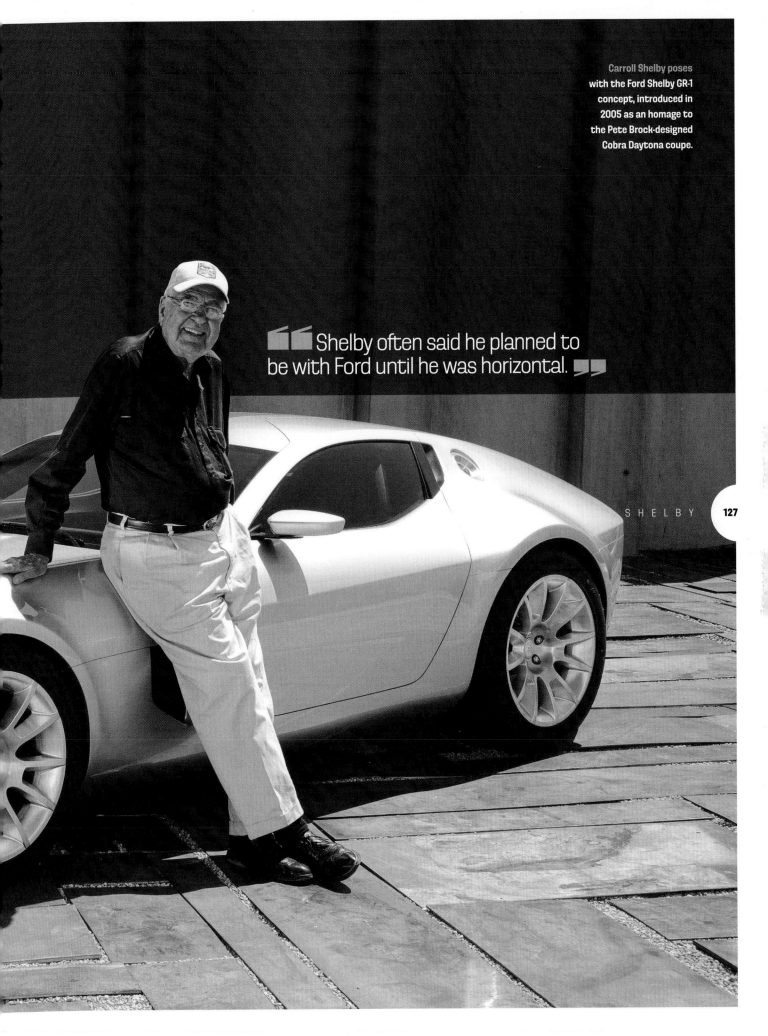

Carroll Shelby poses with the Ford Shelby GR-1 concept, introduced in 2005 as an homage to the Pete Brock-designed Cobra Daytona coupe.

"" Shelby often said he planned to be with Ford until he was horizontal. ""

SHELBY 127

Carroll Shelby passed away exactly one week before the official launch of the 2013 Shelby GT500. Our first review appeared in the August 2012 issue of *Motor Trend*, which had two commemorative covers.

PONY SHOW

WORDS SCOTT MORTARA, EDWARD LOH
PHOTOGRAPHS BRIAN VANCE

(More) Power to the People

The Great Ponycar War has been raging longer than many of us have been alive, with countless skirmishes between Chevrolet and Ford over the last 40-plus years. The latest battle began with the arrival of Chevy's new 580-hp Camaro ZL1. But Ford has quickly regained the high ground with its all-new 2013 Ford Shelby GT500. Boasting 662 hp and 631 lb-ft of torque, the GT500 is the most powerful production car made in America and a fitting tribute to the late Carroll Shelby, one of the leading generals in Ford's decades-long war against Chevy.

For our first official drive of the 2013 GT500, we headed to Atlanta, where we sampled the latest super 'Stang at the track and on the open road. Rolling along on the highway, the GT500's extra power and torque aren't as noticeable as you might think. In top gear at around 80 mph, turning roughly 1500 rpm, the GT500 is a complete pussycat, with minimal engine and exhaust noise. No, it's the getting to 80 that's the fun part. Hammer it from a stop, and the rush of 631 lb-ft engulfs the cockpit, pinning your head and torso to the optional $1595 Recaro bucket as the GT500 blasts from 0 to 60 mph in a scant 3.5 seconds, toward a quarter-mile time of 11.6 seconds at 125.7 mph.

For context, the previous GT500, which put out 550 hp and 510 lb-ft, needed 4.1 seconds to reach 60 and 12.4 seconds at 115.8 mph to pass the quarter, while the aforementioned ZL1 required 3.8 and 12.1 at 117.4, respectively. Big power brings big improvements to the new GT500. But beware of that big power: Get overzealous with the throttle, and the

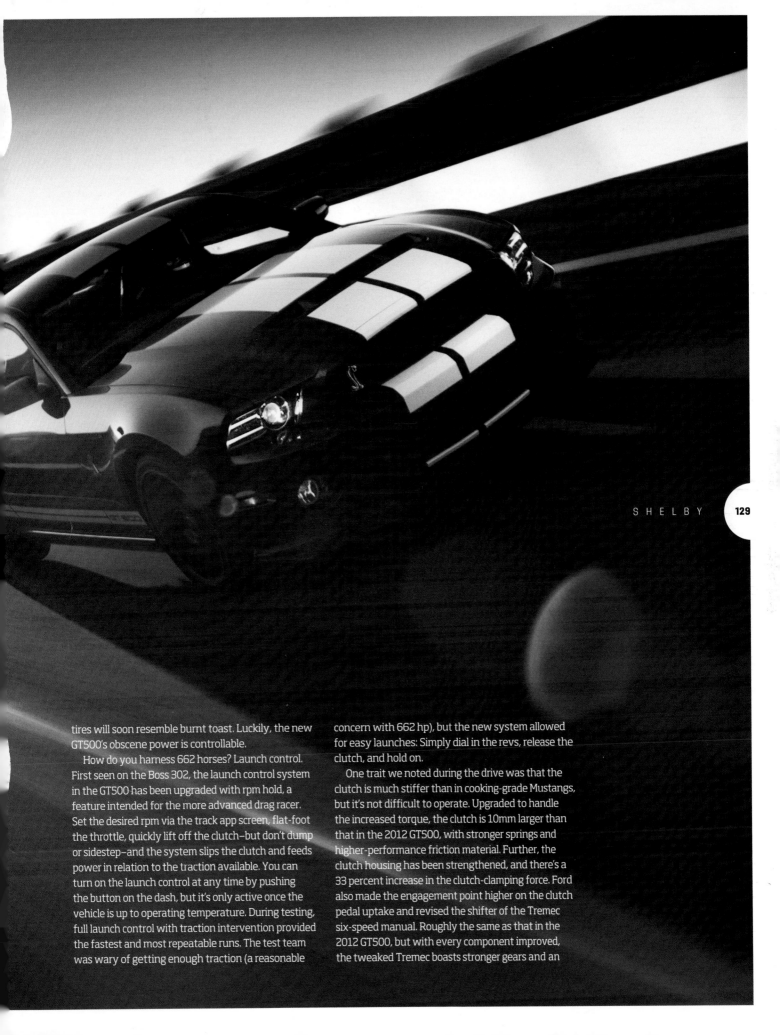

tires will soon resemble burnt toast. Luckily, the new GT500's obscene power is controllable.

How do you harness 662 horses? Launch control. First seen on the Boss 302, the launch control system in the GT500 has been upgraded with rpm hold, a feature intended for the more advanced drag racer. Set the desired rpm via the track app screen, flat-foot the throttle, quickly lift off the clutch—but don't dump or sidestep—and the system slips the clutch and feeds power in relation to the traction available. You can turn on the launch control at any time by pushing the button on the dash, but it's only active once the vehicle is up to operating temperature. During testing, full launch control with traction intervention provided the fastest and most repeatable runs. The test team was wary of getting enough traction (a reasonable

concern with 662 hp), but the new system allowed for easy launches: Simply dial in the revs, release the clutch, and hold on.

One trait we noted during the drive was that the clutch is much stiffer than in cooking-grade Mustangs, but it's not difficult to operate. Upgraded to handle the increased torque, the clutch is 10mm larger than that in the 2012 GT500, with stronger springs and higher-performance friction material. Further, the clutch housing has been strengthened, and there's a 33 percent increase in the clutch-clamping force. Ford also made the engagement point higher on the clutch pedal uptake and revised the shifter of the Tremec six-speed manual. Roughly the same as that in the 2012 GT500, but with every component improved, the tweaked Tremec boasts stronger gears and an

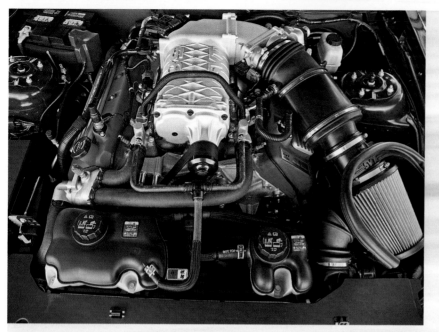

output shaft with a new 40-tooth setup. As a result, some of the shifter's notchiness is gone.

The 2013 GT500 also comes with a one-piece carbon-fiber driveshaft, another key to cracking the 200-mph barrier, according to Ford. The driveshaft is 14 pounds lighter, which helps reduce rotational inertia, noise, and vibration while increasing durability.

All-new Bilstein electronically adjustable dampers, part of the $3495 SVT Performance Package, can be set to Normal or Sport at the push of a button. Normal provides a smooth, comfortable highway ride, while Sport is specifically tuned for the track or a favorite canyon road. Not surprisingly, over the few seams and road irregularities we did encounter, the softer setting seemed to absorb the imperfections, while Sport relayed every nook and cranny. It

Compared with the previous car's charged 5.4-liter V-8, the 2013 GT500's 5.8-liter ups the ante with 112 more horsepower and 121 extra lb-ft. And the Boss 302? It's down 218 horses and 251 lb-ft.

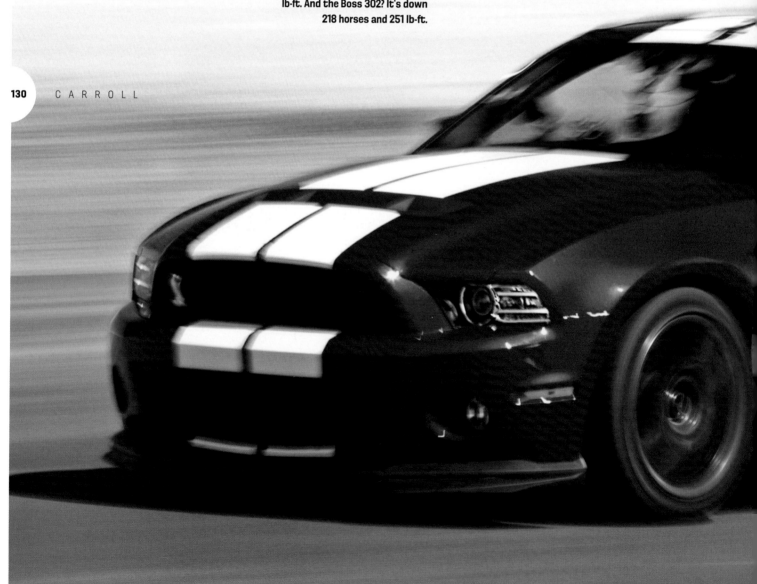

doesn't rattle your teeth, but it's noticeably firmer. New 19-inch front/20-inch rear forged wheels also were deemed necessary to help handle the GT500's higher performance capabilities. Nodules protruding from the wheels' bead surfaces are embedded in the tires to help prevent the Eagles from slipping on the rim under hard acceleration and braking.

The track was where we really got to experience how the new GT500 differs from the previous car. Whereas the old car tended to exhibit front-end push, the 2013 displays crisper turn-in, with the front Goodyears really biting into the asphalt and responding quickly to steering inputs, allowing you to be more aggressive with the throttle application mid-corner. In Normal mode, there's a hint of body roll, but in Sport the car stays nice and flat. With all that extra ooomph, it's easy to kick the rear end out, but, unlike the old car, when you get the tail loose in the 2013 GT500, its slide is progressive. The last-gen car would start to go, then suddenly it was gone. The 2013 is far more predictable, so it's easier to modulate exactly how far you want to swing the rear out.

During figure-eight testing, the GT500 posted an impressive 24.2 seconds at 0.80 g, managing an equally impressive 0.98g (avg) lateral acceleration. Even better: Comparing the new Shelby with its predecessor, *Motor Trend* testing director Kim Reynolds declared it "simply a much easier car to drive." Part of the improvement is attributable to the Torsen differential—another piece of the SVT Performance Package—that provides a full-time torque-sensing system that helps optimize traction and handling. Still, the old car, while more of a handful, was no slouch, edging its successor with a figure-eight time of 24.0 seconds at 0.82 g and maximum lateral acceleration of 1.01 g (avg).

Hammer it from a stop, and the rush of 631 lb-ft engulfs the cockpit, pinning your head and torso to the Recaro bucket.

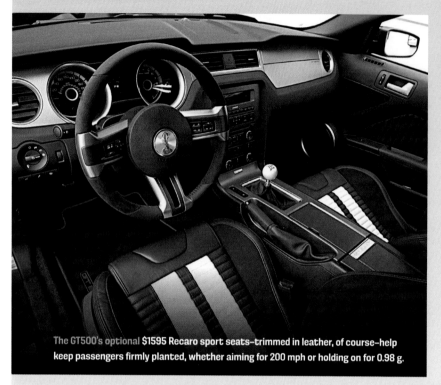

The GT500's optional $1595 Recaro sport seats–trimmed in leather, of course–help keep passengers firmly planted, whether aiming for 200 mph or holding on for 0.98 g.

To achieve the GT500's monumental performance increase, Ford first upped the engine displacement from 5.4 liters to 5.8. Since the cylinder walls are thinner, Ford used plasma-transferred wire arc cylinder-liner coating technology, replacing the old cast-iron-sleeve design. The new liners improve performance and durability, reduce friction, and lower heat transfer. The cylinder heads are cross-drilled into the engine block, adding 3mm coolant passages. Oil squirters are aimed at the underside of the piston to help keep heat in check. Ford extensively reworked the rest of the GT500's cooling system to further beat the heat. All GT500s have a charge air cooler with its own separate heat exchanger fed by a separate coolant pump. If you opt for the $2995 SVT Track Package, you also get an axle cooler and pump, a transmission cooler, and an external engine-oil-to-air cooler.

Numerous other engine internals have been redesigned or modified. A cast-aluminum oil pan allows for complex shapes and now holds 8.5 quarts. The windage tray/pan gasket keeps windage below 5 percent, even at high rpm. The new forged-steel crankshaft was developed in an

"How do you harness 662 horses? Launch control–a feature intended for the more advanced drag racer. **"**

effort to handle the extra strain on the low end. A bigger engine needs more fuel, so injectors have been increased from 47 pounds per hour to 55. To deliver all that juice, two 5.0-liter Mustang pumps were added, capable of pumping 79 gallons per hour. Force-feeding the new 5.8-liter is a new Eaton TVS 2.3-liter Roots-type supercharger that has an increased displacement over the 5.4-liter's and uses a smaller pulley at 69mm as opposed to 72mm.

Significant modifications had to be made to the car's front end to help achieve the lofty 200-mph top-speed goal Ford set for the new GT500. Every opening was modified to minimize drag, maximize downforce, and optimize cooling. The most notable changes are the new front splitter and downforce-generating front grilles. Ford says the changes have resulted in a 14 percent reduction in drag and a 66 percent increase in front-end downforce—essential to getting the GT500 to its claimed 200-mph Vmax, which engineers had personally promised Carroll Shelby they would deliver.

To be an all-around performance vehicle, the GT500 has to stop as well as it accelerates, and it more than gets the job done, erasing 60 mph

An homage to the classic Shelby Cobras, the GT500's gaping grille is devoid of any wire mesh, which would obstruct—albeit slightly—the air necessary to fuel 662 horses. Note the new integrated air dam.

in just 101 feet (the previous GT500 needed 104 feet). Ticking the Performance Package box gets you a larger front stabilizer bar (34.6mm—an increase of 1.4mm), which helps keep the GT500 flatter, minimizing body roll during cornering. The front Brembo brakes have massive 15-inch vented rotors and six-piston aluminum calipers with high-performance friction pads. The rears are 13.8 inches (2 inches larger than a Mustang GT's) with single-piston calipers. New front-brake dustshields provide maximum cooling airflow.

Even with all this newfound power, the 2013 Shelby GT500 is more liveable and user-friendly than ever before. Ford has improved its monster Mustang in every way—better handling, more technology, increased power, and even a 1-mpg bump in highway fuel economy, avoiding the gas-guzzler tax.

This is truly the most potent factory ponycar the Blue Oval has ever produced. Savor it while you can, because this is likely the last major change to the GT500 before the next-generation Mustang debuts with an independent rear suspension. Will that car make 700 hp? If it's still wearing the Shelby name, you can bet the answer will be a resounding yes.

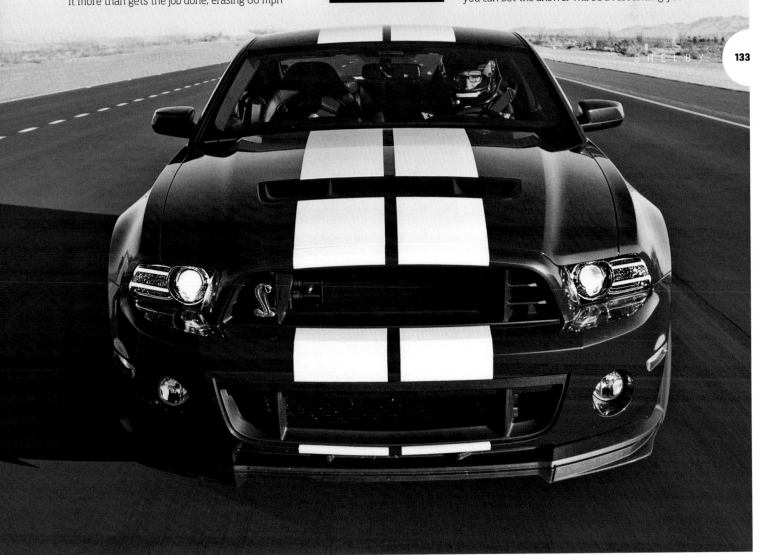

CARROLL

Gunning for 200

The day after Mortara attended the launch of the Shelby GT500 in Atlanta, Georgia, *Motor Trend* photographers Brian Vance and Mike Shaffer picked up the keys to the red GT500 you see on these pages and blew out of town. At dawn. Why so early? Our two road warriors needed to meet the rest of our crew two days hence, at Chrysler's Proving Grounds in Kingman, Arizona.

Why there? As mentioned in the preceding pages, Ford claims the GT500 will break the 200-mph barrier, but we want to find out for ourselves. A rep tells us the Shelby needs about 17,000 feet of tarmac to hit top speed, and that the SVT team used one of the world's largest test tracks, the Nardo Ring in southern Italy, to confirm the 200-mph claim.

After researching a number of test tracks, military bases and airports across the country, we decided on Chrysler's Arizona Proving Grounds, which recently reopened after a $10-million overhaul to its 5-mile oval track. By our calculations, this facility's mile-long straightaways of freshly laid asphalt, upgraded guard rails, and professional staff would give us the best—and safest—shot at hitting 200 mph on this side of the Atlantic. The only knocks on the facility are temperature and elevation—we saw triple-digit air temps by

midday, and the thin air at nearly 2000 feet above sea level will hurt even the GT500's blown V-8.

Some 41 hours and 1900 miles after rocketing out of Atlanta, Vance and Shaffer pulled into the In-N-Out parking lot in Kingman for Animal-Style Double Doubles and pats on the back. The biggest, most difficult piece of the puzzle to obtain arrived safe and sound. We'll try for 200 mph the very next day.

We spend Sunday morning, May 20, putting the GT500 through *Motor Trend*'s standard battery of tests. At noon, the proving ground's head mechanic performs a mandatory safety check before the high-speed runs.

Of particular interest are the Shelby's Goodyear Eagle F1 tires. Ford mounted a fresh set in Atlanta, but that was 2000 miles ago. As a back-up, our partners at Tire Rack sent us a set of heat-cycled F1s we plan to mount just ahead of the run. That's when championship-winning racer and frequent *MT* hot-shoe Randy Pobst chimes in: He'd rather run on the broken-in set of tires. Testing director Kim Reynold's brow furrows, but after close inspection of the tread and sidewalls, we follow the experienced driver's wishes.

At 2 p.m. we begin our first shakedown runs, and

Ford claims the 2013 Shelby GT500 will do 200 mph. We say, "Maybe."

temps are as feared: 101 F in the air, 150 F on the track. Yet Pobst manages to clock 190.6 mph on his very first run—a very good sign.

"This car is just yawning at 150 mph...it's not working at all," says Pobst, excitedly. "It's not hard to drive the car. It's a combination of the speed and the unknown. It's a new territory I don't normally deal with—this car, this track."

We decide to push the second attempt to 6 p.m., hoping cooler temperatures will increase speeds. We also discuss strategy: Pobst needs to carry more speed off of the banked turns if he has any hope of hitting Vmax in the oval's 1-mile straightaways.

The evening brings cooler temps, and our strategy works, but neither is enough to bridge the considerable 10-mph gap. Though Pobst picked up roughly 7 mph at the corner exit, that translated to only 2 mph of gain down the straight. We end our day with 193.2 mph. We'll run again at dawn, when air and track temps could be as much as 40 degrees cooler.

The next day, conditions are ideal: 64 degrees F and 15 percent humidity. The only issue is a slight headwind, which gives Pobst another thought: Let's flip the Shelby around and run in the opposite direction, taking advantage of the oval track's slight decline.

Pobst's first pass clocks in at 195.8 mph, so it's obvious the lower temperatures helped, as did his growing confidence at speed. He's exiting the corner more than 24 mph faster than the day prior. But is it enough? Our expensive window of full oval shutdown is closing, and temperatures are climbing like the morning sun. We have one, maybe two more attempts at most.

After a quick stop to verify data, camera mounts, tire temps and pressures, Pobst roars out of the pit

lane, heading counterclockwise once again. This direction gave us a different look from that of the day before, when we saw him exit the banking onto the straight, toward the 200-mph goal. Flipping the car around means we get to see him come straight at us, foot to the floor, at 195-plus mph. It all happens so incredibly fast: At Vmax, Pobst is going about a mile every 18 seconds.

Fortunately, the bundle of wires Reynolds strapped inside and atop the GT500 provides early warning. Out of the still morning air, we hear a faint growl in the distance as a tiny dot drops off the far banking. Reynold's quiet tenor rebroadcasts the data his laptop is picking up: "190, 191...192, 193...194..."

About a second and half after Reynolds announces 195, the GT500 punches a Mustang-shaped hole in the atmosphere in front of us. The full exhaust roar indicates Pobst still has his foot all the way in it—a ludicrous proposition because the banking of the next turn is only an eye blink away. We see a brief flash of the brake lights as the Shelby shoots up and around the turn and hums down to the mere 150s. When Pobst pulls back in, our test crew breaks it to him: 196.0 mph.

"I think that's about all we're going to get," says Pobst. "At this point, I think it's just an issue of a longer straightaway or a lower elevation. You can see that as we raise the speed off the banking we're not getting much at the end of straightaway.

We're definitely near the top. We're not at the top because the car is still accelerating."

So, we failed to validate Ford's claim of 200 mph, but not for lack of effort. Yes, 196 is close to 200 numerically, but when talking top speed, the difference is a lot greater than 4 mph would suggest.

"I doubt, given an infinite-length straight, we would've seen 200," says Reynolds, after analyzing the data. "I plotted the GT500's speed as it approached 196 with 200 as a line drawn above it, and I doubt they would meet—but they'd get really close. Seems certain it would've at a lower elevation with denser air, despite the greater air resistance."

Curious about the 2013 Shelby GT500's theoretical limits, we bid goodbye to Chrysler's Arizona Proving Ground and immediately headed to the headquarters of K&N Filters in Riverside, California, for some time on its dyno. First order of business: verify the claimed output of 662 hp and 631 lb-ft of torque (see chart at right). It's all there.

Then we run it flat-out to see what the GT500 could do at a lower elevation, unimpeded by air resistance. The digital readout confirms two things: 211 mph, and, comically, an overspeed warning for the dyno equipment. What to do now?

We'll throw it back to Ford and the SVT team. It looks like a trip to Southern Italy is in order.

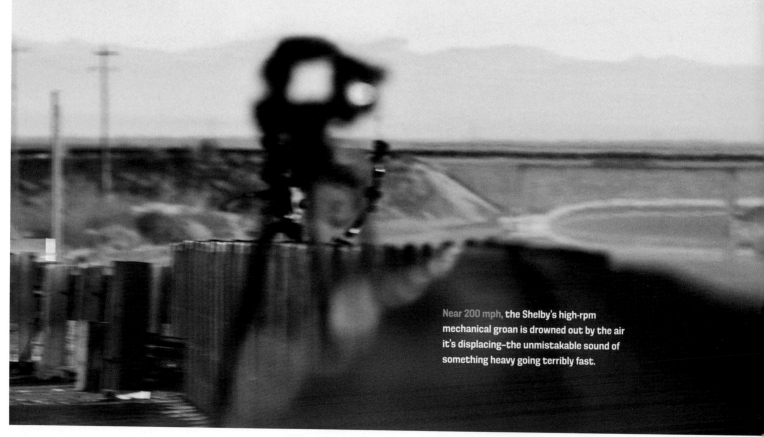

Near 200 mph, the Shelby's high-rpm mechanical groan is drowned out by the air it's displacing—the unmistakable sound of something heavy going terribly fast.

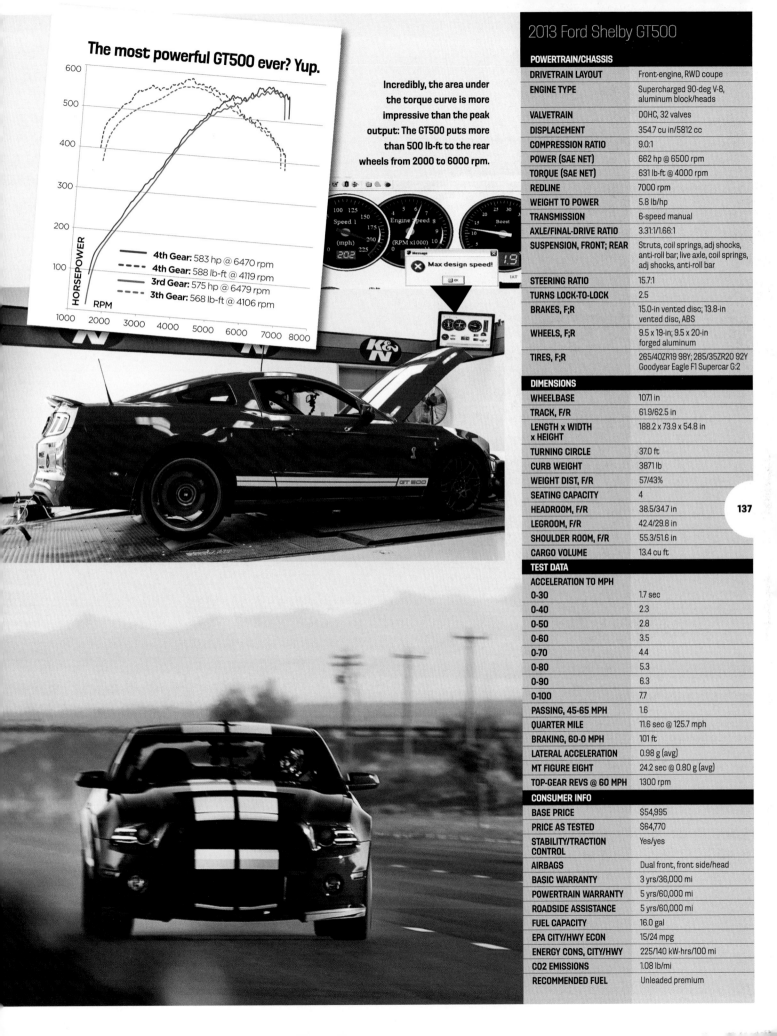

The most powerful GT500 ever? Yup.

—— **4th Gear:**	583 hp @ 6470 rpm
- - - **4th Gear:**	588 lb-ft @ 4119 rpm
—— **3rd Gear:**	575 hp @ 6479 rpm
- - - **3th Gear:**	568 lb-ft @ 4106 rpm

Incredibly, the area under the torque curve is more impressive than the peak output: The GT500 puts more than 500 lb-ft to the rear wheels from 2000 to 6000 rpm.

Max design speed!

2013 Ford Shelby GT500

POWERTRAIN/CHASSIS

DRIVETRAIN LAYOUT	Front-engine, RWD coupe
ENGINE TYPE	Supercharged 90-deg V-8, aluminum block/heads
VALVETRAIN	DOHC, 32 valves
DISPLACEMENT	354.7 cu in/5812 cc
COMPRESSION RATIO	9.0:1
POWER (SAE NET)	662 hp @ 6500 rpm
TORQUE (SAE NET)	631 lb-ft @ 4000 rpm
REDLINE	7000 rpm
WEIGHT TO POWER	5.8 lb/hp
TRANSMISSION	6-speed manual
AXLE/FINAL-DRIVE RATIO	3.31:1/1.66:1
SUSPENSION, FRONT; REAR	Struts, coil springs, adj shocks, anti-roll bar; live axle, coil springs, adj shocks, anti-roll bar
STEERING RATIO	15.7:1
TURNS LOCK-TO-LOCK	2.5
BRAKES, F;R	15.0-in vented disc; 13.8-in vented disc, ABS
WHEELS, F;R	9.5 x 19-in; 9.5 x 20-in forged aluminum
TIRES, F;R	265/40ZR19 98Y; 285/35ZR20 92Y Goodyear Eagle F1 Supercar G:2

DIMENSIONS

WHEELBASE	107.1 in
TRACK, F/R	61.9/62.5 in
LENGTH x WIDTH x HEIGHT	188.2 x 73.9 x 54.8 in
TURNING CIRCLE	37.0 ft
CURB WEIGHT	3871 lb
WEIGHT DIST, F/R	57/43%
SEATING CAPACITY	4
HEADROOM, F/R	38.5/34.7 in
LEGROOM, F/R	42.4/29.8 in
SHOULDER ROOM, F/R	55.3/51.6 in
CARGO VOLUME	13.4 cu ft

TEST DATA

ACCELERATION TO MPH	
0-30	1.7 sec
0-40	2.3
0-50	2.8
0-60	3.5
0-70	4.4
0-80	5.3
0-90	6.3
0-100	7.7
PASSING, 45-65 MPH	1.6
QUARTER MILE	11.6 sec @ 125.7 mph
BRAKING, 60-0 MPH	101 ft
LATERAL ACCELERATION	0.98 g (avg)
MT FIGURE EIGHT	24.2 sec @ 0.80 g (avg)
TOP-GEAR REVS @ 60 MPH	1300 rpm

CONSUMER INFO

BASE PRICE	$54,995
PRICE AS TESTED	$64,770
STABILITY/TRACTION CONTROL	Yes/yes
AIRBAGS	Dual front, front side/head
BASIC WARRANTY	3 yrs/36,000 mi
POWERTRAIN WARRANTY	5 yrs/60,000 mi
ROADSIDE ASSISTANCE	5 yrs/60,000 mi
FUEL CAPACITY	16.0 gal
EPA CITY/HWY ECON	15/24 mpg
ENERGY CONS, CITY/HWY	225/140 kW-hrs/100 mi
CO2 EMISSIONS	1.08 lb/mi
RECOMMENDED FUEL	Unleaded premium

137

CARROLL

WORDS DONALD FARR

After Four-and-a-Half Decades, Shelby Picked Up Where He Left Off

Most men in their 70s are content to retire and relax. Not Carroll Shelby. In the mid-1990s, he opened a new production facility near Las Vegas Speedway to build continuation Cobras and his all-new Series 1 sports car. For a decade, Shelby Automobiles cranked out a handful of cars per year. Then, in 2005, Shelby found himself back in the Mustang business.

With his renewed association with Ford and a new retro-styled '05 Mustang in showrooms, it was only natural that Shelby would become involved in building high-performance Mustangs, just like in 1965. After recruiting president Amy Boylan from Mattel's Hot Wheels division, Shelby Automobiles' production facility was soon bustling with Mustangs–rolling in as stock GTs and driving out as Shelbys.

It started with a new Hertz Shelby, the 2006 Shelby GT-H, in black and gold. The program was

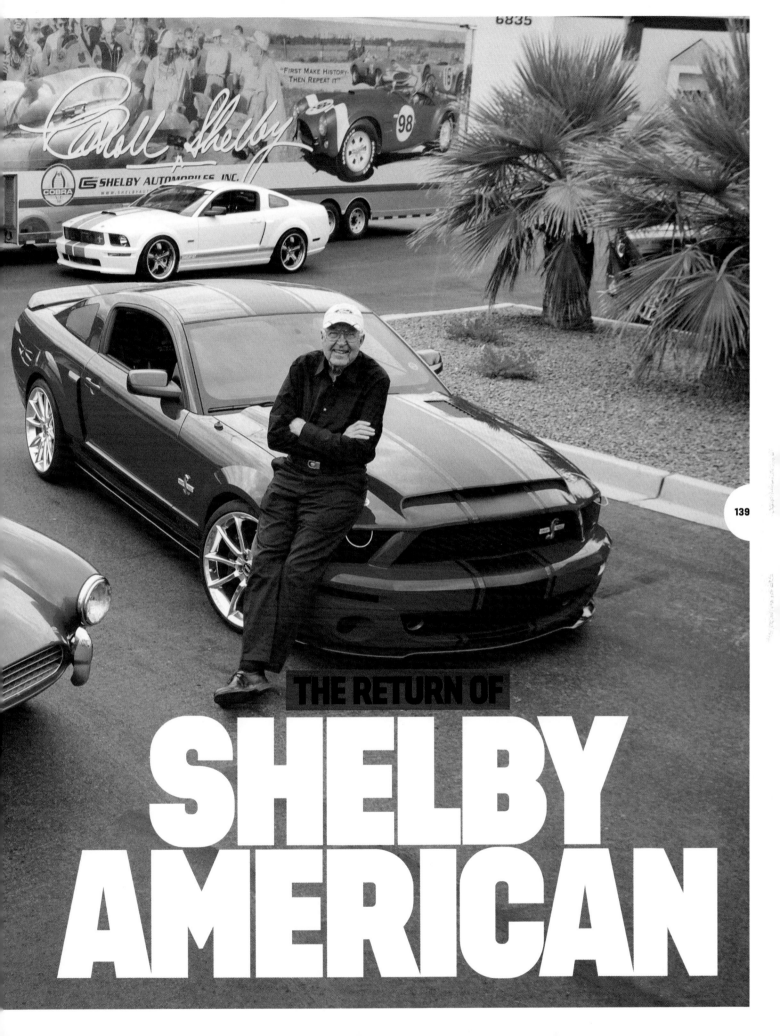

THE RETURN OF

SHELBY AMERICAN

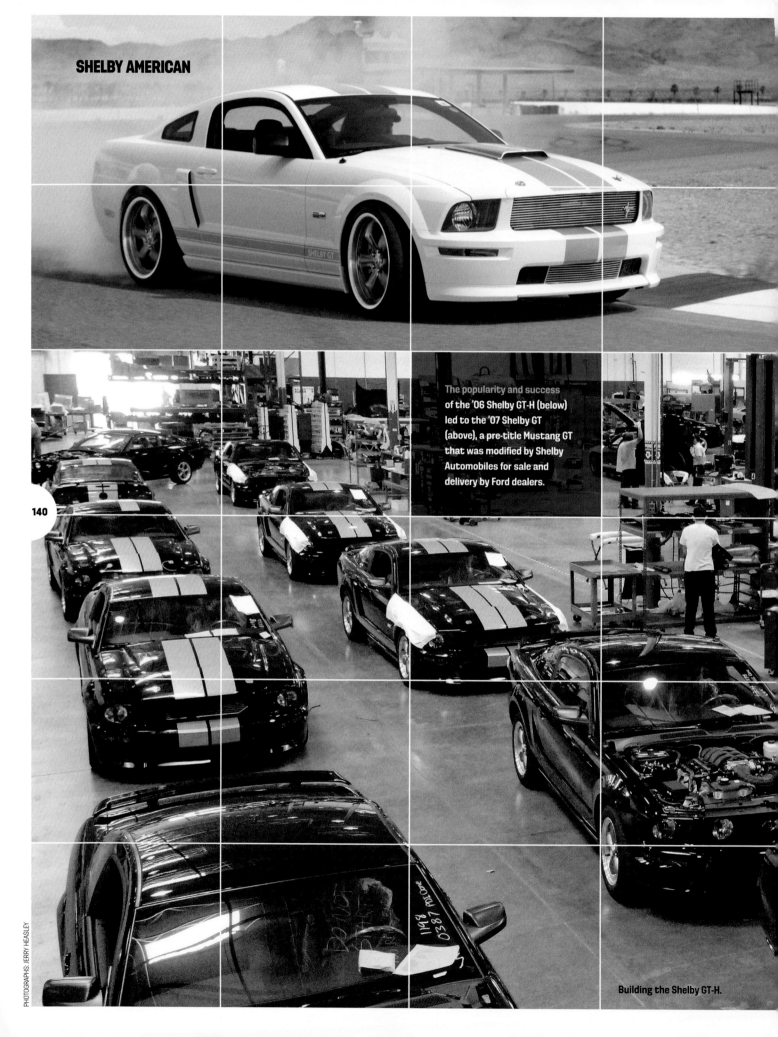

The popularity and success of the '06 Shelby GT-H (below) led to the '07 Shelby GT (above), a pre-title Mustang GT that was modified by Shelby Automobiles for sale and delivery by Ford dealers.

140

Building the Shelby GT-H.

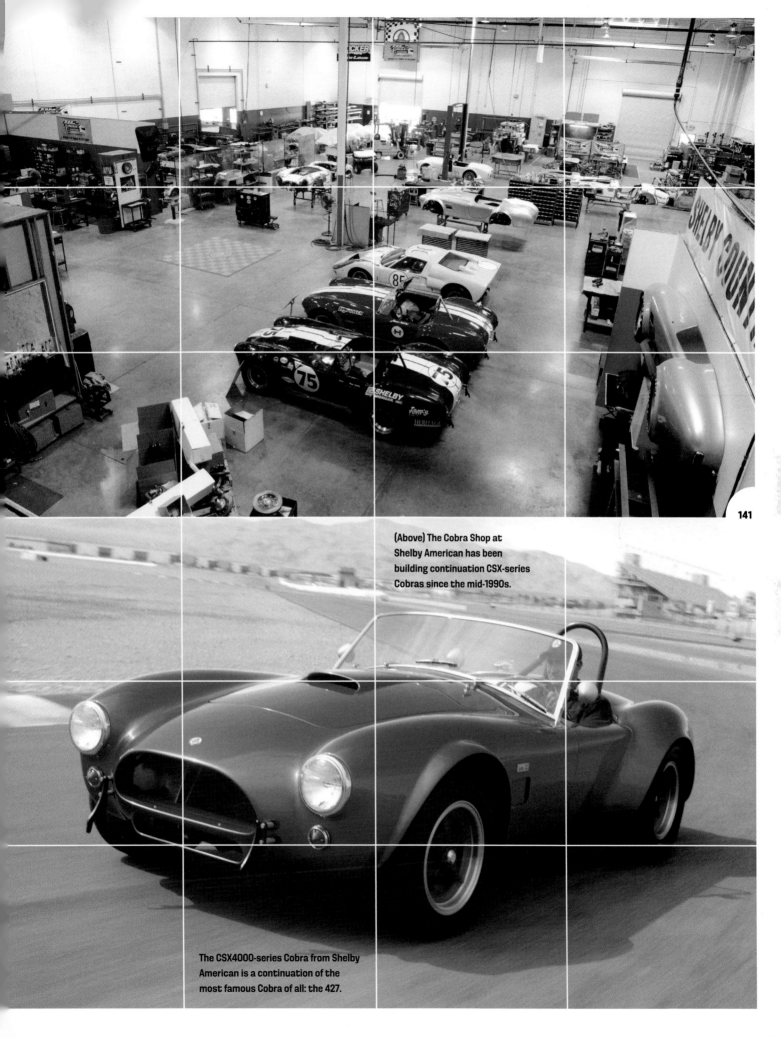

(Above) The Cobra Shop at Shelby American has been building continuation CSX-series Cobras since the mid-1990s.

The CSX4000-series Cobra from Shelby American is a continuation of the most famous Cobra of all: the 427.

142 CARROLL

In His Own Words

"I can't do anything in particular except pick people. During the Depression, I learned that you better learn to work with people because they're the only thing you have to make anything work.

That's the thing I'm most proud of, out of everything that's happened in my life outside of my children.

We had the same thing 40 years ago when we took some hot rodders and just welded them together. Most of them didn't have an education as far as engineering goes. But enthusiasm and luck will do a hell of a lot more than education sometimes."

so popular that Ford asked Shelby Automobiles to ramp up the program for 2007 to make a Shelby GT available to everyone, not just rental car customers. More than 7500 were built, including a limited number of convertibles for 2008.

By the time the Shelby GT program ended, Shelby Automobiles had moved on to another project: taking customer-owned Shelby GT500s built by Ford SVT and converting them into GT500 Super Snakes by adding more horsepower, more aggressive styling, and improved handling. These "post-title" builds would set the stage for future Shelby Mustangs, including the 40th Anniversary GT500 (to commemorate the first GT500 in 1967), low-cost GTS, and more recently a new GT350 based on the Mustang GT. There was even a Terlingua model, available as a six-cylinder or V-8, and designed, either in yellow with black or

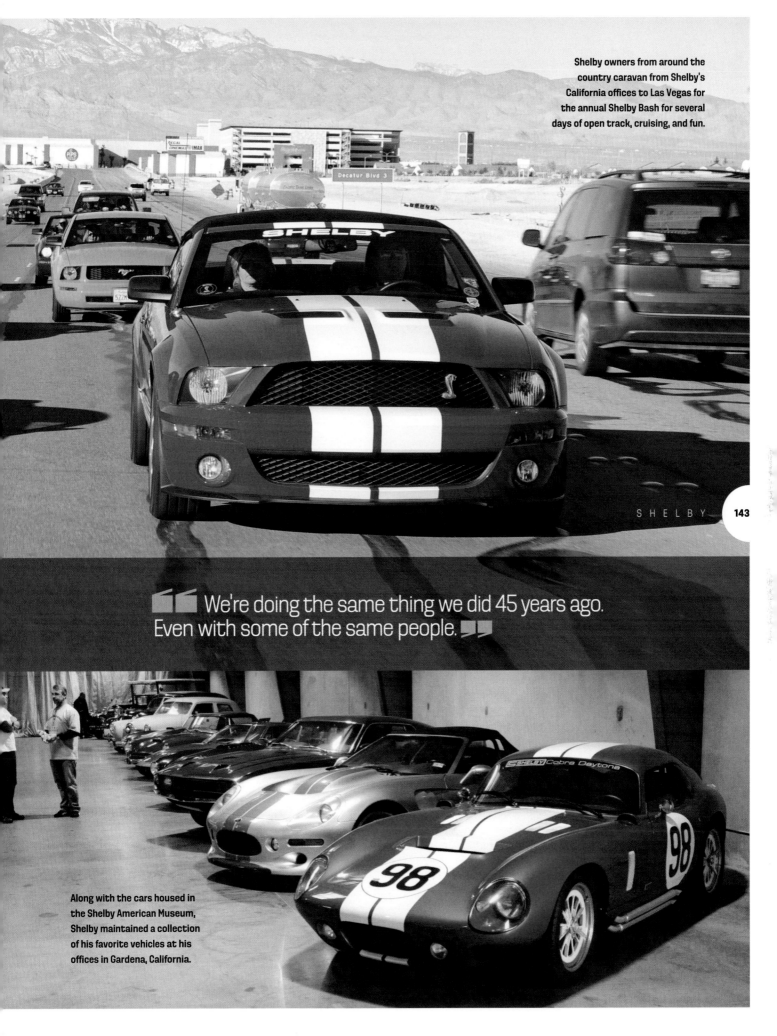

Shelby owners from around the country caravan from Shelby's California offices to Las Vegas for the annual Shelby Bash for several days of open track, cruising, and fun.

> We're doing the same thing we did 45 years ago. Even with some of the same people.

Along with the cars housed in the Shelby American Museum, Shelby maintained a collection of his favorite vehicles at his offices in Gardena, California.

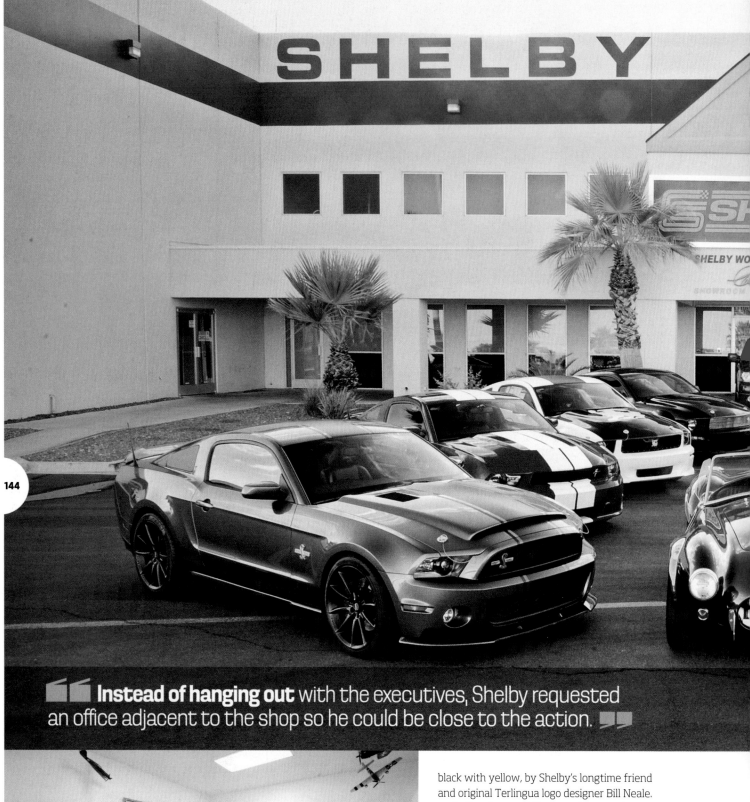

SHELBY

> **Instead of hanging out** with the executives, Shelby requested an office adjacent to the shop so he could be close to the action.

black with yellow, by Shelby's longtime friend and original Terlingua logo designer Bill Neale.

Shelby often said "business is my main hobby," and he stayed involved in a number of his companies, including his Goodyear tire distributorship, Carroll Shelby Enterprises, Carroll Shelby Engines, Carroll Shelby Wheel Company, and Shelby Performance Parts. In 2010, Shelby Automobiles was renamed Shelby American to reclaim its 1960s heritage.

When Amy Boylan departed, Shelby asked John

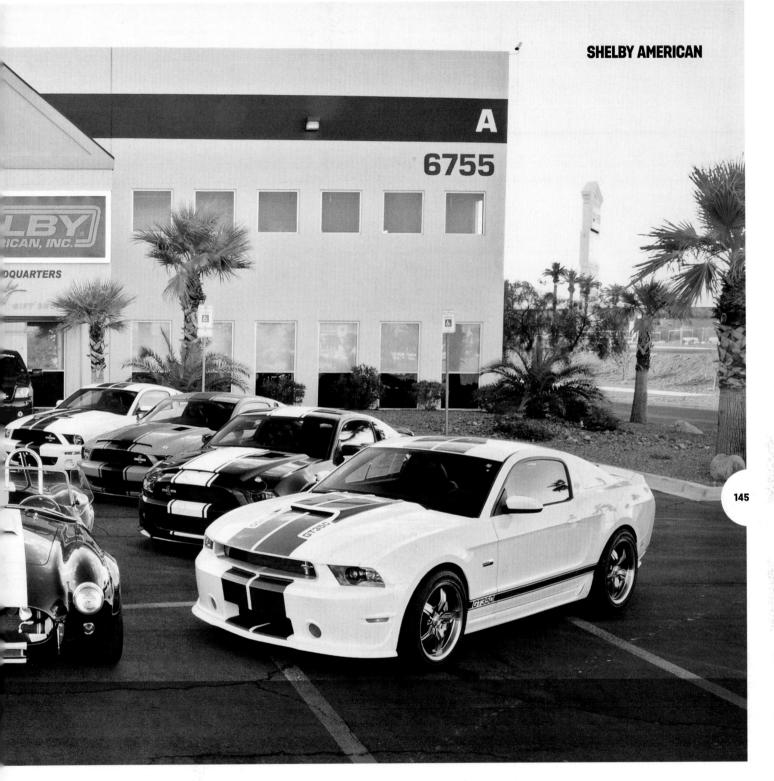

Luft, his longtime licensing manager, to take over the day-to-day operations at Shelby American. As always, Shelby knew how to pick the right people to run his company. In the 1960s, it was Phil Remington, Chuck Cantwell, Ken Miles, and Pete Brock. Today, Luft has the luxury of working with VPs Gary Patterson and Gary Davis (with the company since 1996 and 1998, respectively), plus a talented team that includes Vince LaViolette, Gil Nevarez, Roger Sorel, and Robert Lane.

Shelby loved visiting Shelby American, spending most of his time in the Shelby American Motorsports area, asking questions about new technology and inquiring about the status of his number-one goal: a 1000-hp street car. Instead of hanging out with the executives, he requested an office adjacent to the shop so he could be close to the action. A peek inside reveals a tidy desk flanked by a pair of guitars (yes, he played them), and model airplanes hanging from the ceiling.

Carroll Shelby may be gone, but his legend and his cars will live on.

Carroll Shelby liked to say that every vehicle from Shelby American carried Cobra DNA.

In His Own Words

"It's the same philosophy I started with Shelby American in the 1960s: That a small company in partnership with a large company can do things a lot quicker than they can do it back there with all the checks and balances a large company has to have. And we're operating today in Las Vegas in the very same philosophy in the very same way we operated back then. And that is, we're partners. We decide that some cars should be built, and in three to six months we can be in business. And it takes them a couple of years to be building that automobile. But Shelby couldn't do it without the partnership of Ford, particularly to take care of emissions and safety, which they have thousands of engineers working on. So we're doing the same thing we did 45 years ago. Even with some of the same people. They're old and wobbly, but they're still great people."

At his ranch, Shelby was able to spend time with another of his loves: animals. He raised Watusi cattle, Shetland ponies, chickens, goats, and other livestock.

Shelby on the Farm In his later years, Shelby's main residence was in affluent Bel Air, a suburb of Los Angeles, and he also maintained a residence in Las Vegas. But he never lost his affection for east Texas, spending time there on his 60-acre ranch near Pittsburg, about a two-hour drive from Dallas and not far from where he was born.

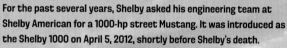

146 C A R R O L L

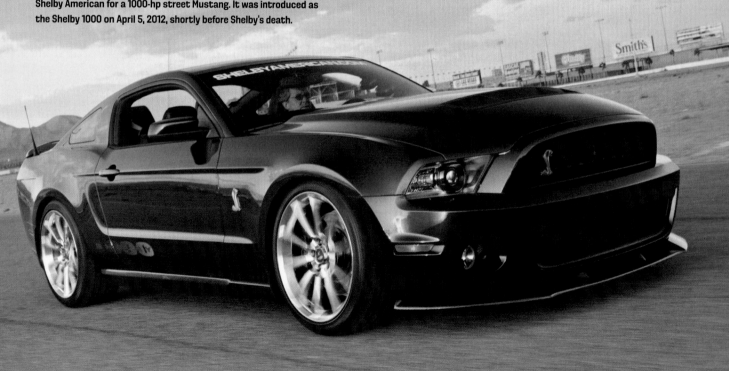

For the past several years, Shelby asked his engineering team at Shelby American for a 1000-hp street Mustang. It was introduced as the Shelby 1000 on April 5, 2012, shortly before Shelby's death.

PHOTOGRAPHS: JERRY HEASLEY

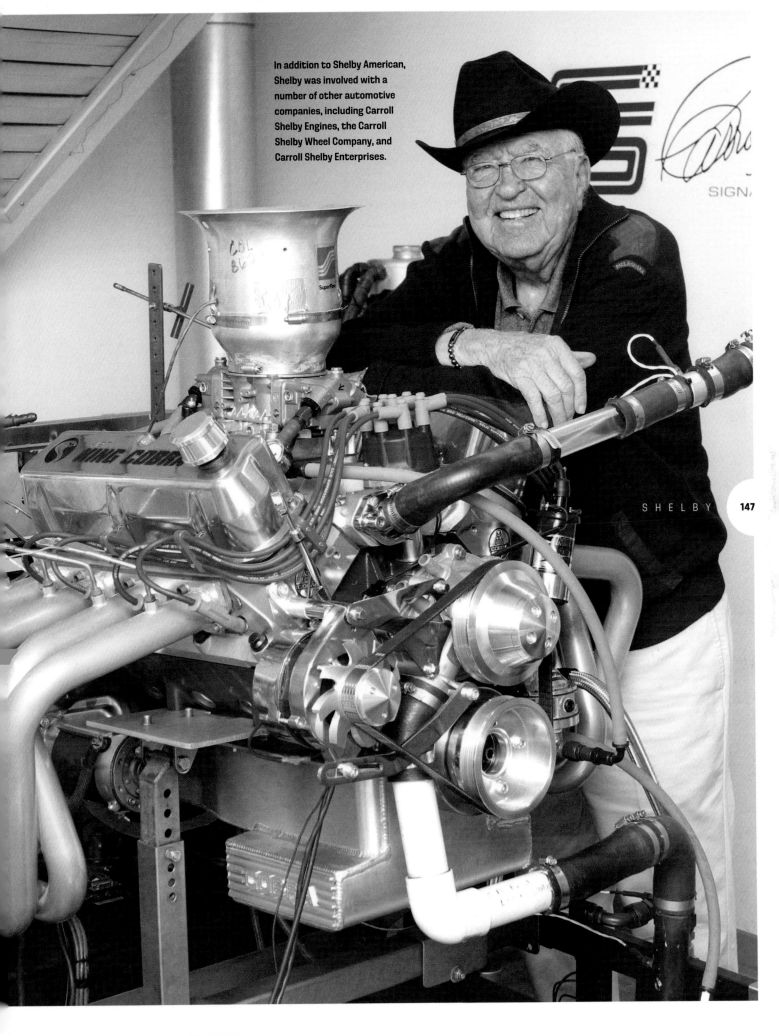

In addition to Shelby American, Shelby was involved with a number of other automotive companies, including Carroll Shelby Engines, the Carroll Shelby Wheel Company, and Carroll Shelby Enterprises.

SHELBY'S

Racing was just the beginning.

CARROLL SHELBY, who passed away May 10, 2012, at the age of 89, could have been finished five decades ago. He'd already earned more than his share of fame as the former Texas chicken farmer who'd conquered Le Mans in his trademark bib overalls. No one would have thought less of him had he spent the remainder of his life—not very long, doctors told him—trading racing stories for free beers.

Of course, as Shelby knew then and as we know now, he was just getting started. "My ambition was never to be a world-champion racing driver...I always had an idea that I could build my own car," he told AUTOMOBILE MAGAZINE earlier this year.

He managed to do that and more. Pictured here are eight—hardly all—of the production sports cars he built or heavily influenced. There were great cars, like the one and only Cobra, and not-so-great cars, like the cobbled-together Series 1. But most of all, they were *his* cars.

Shelby Omni GLHS
Snicker all you like at the humble Dodges, but the 1986 GLHS ("Goes Like Hell—Some more") was an impressive piece in its day, not to mention one of the progenitors of the hot-hatch movement. And Shelby always loved them.

Shelby Cobra 260
After the fact, everyone said it was obvious. But it was Shelby who connected the lithe AC Ace and Ford's new small-block V-8. More important, he had the snake-oil charm to make it happen. He convinced Ford vice president Lee Iacocca to provide funding in 1961 and within months created the original Cobra prototype, which happens to be the very car you see here.

Shelby Cobra 427
The Cobra 427 never had a chance to match its predecessor's brilliant record on the track—numerous SCCA titles and the 1965 FIA manufacturer's trophy—because Shelby American failed to produce enough competition-spec cars to meet the FIA sanctioning body's requirements. Instead, the big-block version went on to become the ultimate muscle car.

by **David Zenlea**
photography by **Jordan Shiraki**

L E G A C Y

In its homage to Carroll Shelby, *Automobile Magazine* pulled together a few of his most significant vehicles for this stunning spread in the August 2012 issue.

Shelby Dakota
Less an indictment of Shelby than the state of performance in the late 1980s, Shelby's souped-up Dakota had a limited-slip differential and a V-8 in place of a V-6. That'd be a 175-hp V-8.

Dodge Viper
Chrysler president Bob Lutz initiated the 1992 Viper after spending time behind the wheel of a Cobra clone and wondering why no new car matched its performance. Lutz then brought Shelby in to consult on the project and, just as important, to convince Chrysler chairman Iacocca to provide funding—just as he had at Ford in 1961.

Shelby Series 1
It's both Shelby's most ambitious car and his most flawed. It features an aluminum chassis built from the ground up, a carbon-fiber body, and a General Motors–sourced, dual-overhead-cam V-8. But Shelby was too sick to really hold the 1990s project together. The car missed its performance, weight, price, and, ultimately, sales targets. Worse, Shelby had invested millions of his own dollars in the project. "You're never so slick you can't be greezed," he told us.

Shelby GT350
Ford wanted to take the Mustang racing, and Shelby, as usual, knew how to make it happen. It wasn't simple: the humble, Falcon-based 'Stang needed a thoroughly reworked suspension and a breathed-on 289-cubic-inch engine. Peter Brock's blue racing stripes didn't hurt, either. In order to compete in SCCA racing, Shelby needed to sell 100 cars. He did quite a bit better than that, and a profitable new business was born. By the late 1960s, "Shelby" Mustangs were bloated muscle cars produced in-house by Ford.

Shelby 1000 Mustang
Like most new cars offered by Shelby American, the 1000 is a Ford-built Mustang that travels to his Vegas facility to become a "real" Shelby. In this case, that means taking a 2012 GT500 and upgrading the engine internals, exhaust, and supercharger to approach the output of a Bugatti Veyron—and surpass it if you opt for the S/C version. The final new product to see the light of day while Shelby lived certainly bears the mark of the man.

Jean Jennings, *Automobile Magazine*'s editor-in-chief, has been publishing her Vile Gossip column since 1987, and has had numerous, hilarious opportunities to profile Carroll. Here are our favorites from August 2012, September 1991, August 1992, and December 1993.

Godspeed, Ol' Shel.

by **JEAN JENNINGS**

WHAT I WOULD LIKE TO READ right now is a classic David E. Davis, Jr., obituary on his old friend, Carroll Shelby, who died two weeks before this issue went to press. (Too mean to die, I told Shelby last fall in Las Vegas, when he was only 88. "I love you, Lindermood," he replied, quite sweetly.) David E. had the naked stories, the ones you still can't tell. He knew Shelby in the glory days and the not-so-glorious '70s, when the Detroit deals dried up and he exiled himself to Africa to hunt and to run safaris. Shelby suckered Davis into investing in some exotic Rhodesian Tuli cattle that he brought to Texas. When the deal went south, the difference between the nonchalance of the well-heeled gambler and the horror felt by just *a* gambler banking on becoming well-heeled was a painful experience that Davis took a while to get over. Yes, he would have gleefully built a literary pyre of Shelby injustices and reprobate behavior, poured on the gasoline, lit a match, then…blown it out at the last second and dismantled it. Because he loved Shelby.

Face-to-face, Shelby's billion-megawatt charm obliterated common sense, negated all the rumors (and actual knowledge) of wrongdoing, and disarmed every alarm a wily operator like Davis and an old cabdriver like me relied on to make it out with wallet, hard heart, virginity—whatever needed protection—still intact.

I'm pretty sure I first met Shelby in 1984 when he flagged off Parnelli Jones, Walker Evans, and me from the halfway point of the first One Lap of America, at the Portofino Inn in Redondo Beach, California. I gave Shelby David E.'s regards—I was absolutely starstruck. But once we met, that was that. I ate the chili.

Shelby coaxed me to the 1991 Indy 500 with the promise of a ride in the Dodge Viper pace car. During our two hot laps (no helmets), he told me he was getting married "in a coupla weeks. Yeah. She was bugging me for a ring so I give her a big ol' rock." He busted into a good laugh. "She had it appraised and found out it was a cubic zirconia, and now I gotta marry her!" I was horrified. Less than a year had passed since his infamous heart transplant, and he hadn't let off the gas one tiny bit.

"I was out on Sixteenth Street the other night with Foyt," he told me. "I was going about 35, and this guy in a Chevrolet chops me off. Then he passes another guy, comes back, and chops me off again. So I drove into the side of him. I didn't think nothin' of it. But I didn't think I'd tear him up as bad as I did.

"I forgot about my mirror. It wiped out his window and the whole side of the door. He jumped out of the car yelling, 'You're a crazy man! You're a menace!' It was Eddie Cheever! Foyt really gave him a ribbing at the drivers' meeting. He said, 'I guess that'll teach you to screw with an old man!'" As if.

In early 1992, I convinced Carroll to play himself as a mad scientist in the pilot of a TV action series called *Running Wilde,* which had landed Pierce Brosnan to play the lead, Austin Wilde, an automotive journalist. The grateful executive producer gave me a part as his assistant Igor's assistant. Shelby's part called for

a maniacal laugh, and mine called for a terrified scream. We practiced in his minivan all the way there. They taped me first. My scream was so stunning that the crew cheered, and when I stumbled off, Shelby declared, "I was afraid you were gonna pee in your pants."

"Here goes the village idiot," he said to me, as he stepped into position. The director, Mark Tinker (*Deadwood, John From Cincinnati*), was convinced Shelby wouldn't do it. Of course, Shelby howled like a total lunatic, and the crew cheered for him, too. The show never aired.

There were many other good times, but the best were the few quiet days in 1993 that I spent with him and his Swedish wife, Lena, (number four) on the ranch in East Texas. We fed the miniature animals, fished from the float boat, and laid around in the evening reading. Lena hated that ranch and ended up dying in a car accident near there.

Shelby came to my second wedding, when I became Jennings. "You'll always be Lindermood to me," he declared. My Aunt Red was tending bar and making name tags. "Oh, I don't need one of them," Shelby told her. "Look," she answered, "if you want a beer, you need a name tag. I don't give a shit if you have a question mark on it." Which is why Carroll Shelby was seen wandering around at my wedding with a question mark on his name tag. As if.

"I suppose she indented your life the way she did mine," he told my husband, Tim, that day. My life? It has been indented forever by his friendship. I will always remember him in the same way he once described me to Tim: He had the personality of a fart on a hot skillet.

And I loved that old fart. **AM**

ANDY SACKS

VILE GOSSIP
BY JEAN LINDAMOOD
. .

A day and a half in the life of Carroll Shelby.

East Texas—Carroll Shelby is looking pretty good for an old fart with a borrowed heart, although his wife, Lena, says he ought to go back to wearing overalls like he did in the Fifties, since he's so skinny he can't seem to keep his pants up. Plumber butt is what we call that condition around here. I guess you ought to have more respect for Carroll Shelby than to just call him plumber butt.

Speaking of no respect, we had a roast for Shelby down in Dallas, although the Shelby Cobra Association of Texas (SCAT) didn't exactly plan its event to be a roast. But you can hardly talk about the man without taking at least a little poke at him.

Automobile Magazine friend and contributing artist Bill Neale put it all together. He has known Shelby a lifetime or two, and he owns a few Shelby cars. I got to drive GY001 ("Gawd-afful Yeller")—an exceptionally fine 1967 Shelby Mustang GT350R painted up and adorned in the old Terlingua Racing Team colors and logo. When I finally put Gawd-afful Yeller away in the garage, all sweaty and wild-eyed and foaming at the grille, I almost removed from my speech the worst things I had planned to say about the man. What a car. What a car. *What. A. Car.*

But I didn't. I left it to the winningest Shelby Mustang racing driver in history, Charlie Kemp, to say all the nice hero stuff. Kemp showed up from deepest Mississippi. A Mississippi accent even amuses Texans, so you can imagine what this honey-dripping, drawled-out, multisyllabic-even-when-it-shouldn't-be oratory was like to my Midwest twanged-out ears. When Kemp was

finished, Shelby got up and said, "I'm sure glad Charlie drove faster than he talks," and everyone laughed.

(A funny story came out of Kemp's talk that you should hear; he says it is maybe only the second time he has ever told it. College student Kemp went to Sebring with some buddies in 1958 to see the famous Carroll Shelby race. They parked their cars—Kemp brought an MG—inside a turn and commenced drinking. Plenty late in the evening, a well-sloshed Kemp began to boast. "I can do that!" he told his friends as the racing cars hammered by. Right, they said. "I can do that!" he continued to insist, getting louder and more garrulous as they taunted him. "Oh, sure," they said. "And so it was," Kemp told the SCAT dinner, "we tore out a section of fence, I jumped in my MG, and I entered the 1958 Sebring race." Apparently, the race was never stopped because there was such a battle among the front-runners. "The best part was, I actually passed a couple of cars," Kemp remembered. He said he was unnerved when cars started spinning in front of him, and he eventually exited through the hole he and his buddies had made in the fence. He still looked sheepish thirty-five years later.)

Shelby had a very good evening, listening to our stories about him, although I don't pretend to have been around long enough to actually know him. To last through even a couple of business dealings with your sense of humor intact, though, is to kind of get to know him. We've developed a warm spot in our hearts for each other in the past decade. If I'd been in this business back when he was *really* cruising for a bruising, I probably would have given him one. But now, I think he's priceless. Just when you think he's doing you dog-dirty on some deal, he's dragging you home for dinner. Which he then makes. Which is fantastic.

I canceled other plans on a Monday when he invited me to ride along with him and Lena to their ranch in East Texas. He first had to sign autographs for two hours at the SCAT concours in the hotel parking lot, for which he collected a whopping $2400 for his heart fund. The heart fund is an unusually pure charitable concern for Shelby. Having paid an awesome sum to secure his own replacement heart three years ago, Shelby is now lobbying the U.S. House and Senate to create legislation that would guarantee donor organ availability for everyone, not just for those who can bid the highest.

The second we left the parking lot, jammed into a red Chrysler Shelby Daytona, he went from hero to hick, gunning the engine, stopping at Taco Bell, Jack In The Box, *and* the 7-Eleven (Hershey bars, Dr. Pepper, potato chips, and ice cream) for all our favorite junk food. It was as hot as a smoldering skillet as we passed from the parched grassy Dallas area to East Texas. ("The difference between chicken shit and chicken salad" is Shelby's description of the

two parts of the state.) East Texas, despite suffering a drought, still looked lush. Trees, lakes, hills, and bustling ranches rocketed by as Shelby took the winding, bounding two-lanes at about 100 mph.

He wanted to see his animals (horses, sheep, goats, donkeys—all in miniature—and a wide variety of birds), but he mostly wanted to see Arnold, his hog-dog. Or is it dog-hog? Or doglet? In any case, Shelby's farmhands had trapped a wild pig, setting it free when they realized it had babies. One of the piglets (Arnold) became separated from the mother, so they took him home for bottle feeding. Arnold found, instead, a bitch German shepherd, which welcomed him to nurse alongside her litter. Arnold now thinks he's a dog, plays with the puppies, and will eat only puppy food. Shelby was beside himself and took an entire roll of Arnold photos.

He made what we call stinky beans (fresh green beans cooked to oblivion with salt pork and onions) for dinner, and biscuits with sausage gravy for breakfast the next morning. Lena and I filled in where he let us. Like washing the dishes.

Every time the phone rang, he swore. But when it wasn't ringing, he was dialing up some business deal or other, shouting at one guy, ordering another around, plotting conspiratorially with yet another. And then we'd be out of the house, in the pickup truck (a Dodge, of course) (with no plates, of course), and off to the grocer, or the other farm to tour his artificial lake, or to his ranch hand's house to see the wild pigs being fattened, or off down the hill to take carrots and apples to the little horses. All this in a day and a half.

I think I like Shelby as a farmer best. There seems to be less trouble for him to get into over at the ranch in East Texas than there is back in the rotting hulk of Southern California. I have been thinking about this a lot as his borrowed heart beats on. ⬢

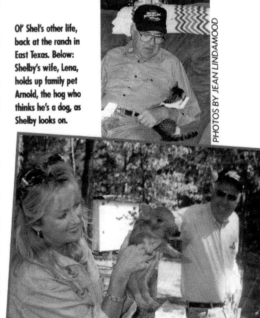

Ol' Shel's other life, back at the ranch in East Texas. Below: Shelby's wife, Lena, holds up family pet Arnold, the hog who thinks he's a dog, as Shelby looks on.

PHOTOS BY JEAN LINDAMOOD

VILE GOSSIP

BY JEAN LINDAMOOD

. .

If Hunter S. Thompson lived my life, this is what it would look like on television.

Valencia, California—The sky over the San Fernando Valley looked like a seven-layer bean dip. Carroll Shelby and I were heading up I-5 to a sound stage in the orange-grove community of Valencia. "Ugh," I said. "When the sky looks like this in Michigan, it usually means there's going to be a tornado." It didn't look real. But then, nothing is real in California—not the traffic, not the sky, not the people, and certainly not what Carroll Shelby and I were about to do.

We were on our way to Valencia to appear in a television action-adventure series about the misadventures of an automotive journalist. I should have such misadventures; then I could write scripts for this show and get rich. Actually, if I did have such misadventures, I'd *have* to write scripts for this show, because David E. would fire me, and I'd need work.

"Running Wilde" is the name of the show. NBC bought six episodes from writer/executive producer Gary Markowitz. Networks don't usually make such commitments to new shows, but Markowitz landed a big name, Pierce Brosnan (late of "Remington Steele"), to play automotive journalist Austin Wilde. If Markowitz can pull this off, you are going to love Austin Wilde, because his life is the epitome of what you think goes on in the production of a car magazine: Editor gives Wilde assignment to test a hot car. Wilde drives like a maniac, runs afoul of the law, picks up girls, ends up two states away from where he's supposed to be, maybe trashes the car, and eventual-

ly turns in a potential Pulitzer Prize–winning account of his ordeal. Editor can't fire Wilde because he's a brilliant writer with a loyal following.

To give future scripts more potential for drama and sizzle, Wilde is a former racing driver who raced at Le Mans. He may also be a Vietnam vet if they need him to be one. Sounds like TV all right, but in real life, we do have both in our ranks.

Shelby was kind of grumpy at first about doing this cameo appearance. "They're gonna screw around all day, and I'm gonna be bored," he told me on the phone.

"Well, I'm going up there the same day," I told him. "I'm also going to be in it, playing a mechanic in your shop."

I had to ask him to stop laughing.

So there we were, heading up to Valencia, Shelby at the wheel of his Chrysler Town & Country minivan (having turned down the nervous studio bosses on their offer of a chauffeur), while I read the script. It looked like this:

1D INT. GARAGE—NIGHT
LIGHTNING FLASHES AND THUNDER CRACKS in the medieval dungeon cum service bay. A lab-coated man with a CARROLL SHELBY name patch operates a crude winch, assisted by his grease-covered chief mechanic with an IGOR name patch. Dangling from a chain is a monstrous engine spitting fire and making deafening, dragsterlike noises. Below it, a small, frail-looking two-seater sports car waits, victimlike, on a lift. Igor turns a crank on a Jaws of Life that stretches and spreads its groaning engine bay to prepare it for its fearsome load. As the engine descends, Igor averts his eyes in pity.

1E ANGLE ON CARROLL SHELBY
Illuminated by lightning as his maniacal laughter reverberates off the walls.

Whew. Wait until I tell Shelby about the maniacal laughter part, I thought.

We walked up the alley between two sound stages—actually, they were two big warehouses. Shelby was carrying a pair of cowboy boots and his trademark black hat when we were intercepted by a guy with a clipboard and headset.

"You must be here to play Carroll Shelby," he said.

How convenient that he actually *was* Carroll Shelby.

We were escorted to Pierce Brosnan's trailer, Brosnan having finished the shoot and cleared out. Lots of St. Pauli Girl in the fridge. Lots of magazines. Air-conditioned.

It was decided that, because Igor had already been hired, I would be Igor's assistant. I would turn the crank instead of Carroll. And I would get to scream.

Now, think about this. Where does one practice screaming? I guarantee you—scream and people will come running. I was worried that it would end up like my worst

nightmare: Murderous villain raises the hatchet, I open my mouth in terror, and nothing comes out. Guess again.

My costume was coveralls with a name patch that said IGOR'S ASS'T. This and worn-out work boots. Miss Camille, the makeup artist, made me look like a dirt bag with black grease from a jar labeled "clean grease." Then Mr. Robert ratted my hair to look like the bride of Frankenstein. "*Don't* comb this. *Don't* brush this. Don't *touch* your hair," said Mr. Robert. "There is so much *product* in there that it will *break* if you don't wet it down first." Eeeewww.

Shelby put on his black hat and the lab coat with the CARROLL SHELBY patch. Then we sat around for a really long time.

The set was wonderful: a medieval dungeon with lots of smoke and sparks and weird transformer-looking contraptions that lit up. Two huge gargoyles with red eyes held the chains that went to the crank. When I cranked, the chains pulled on hooks that spread apart a hole in the hood of a little MG. Igor lowered the engine. As it got near the hole, I was supposed to scream in terror. Meanwhile, Shelby would stand on a platform above the whole scene, wave this huge wrench, and laugh like a madman.

First they shot me and my scream. I hauled back and let 'er rip. When I was done, there was a stunned silence on the set. Then they cheered. I could hardly walk back to my seat, my legs were shaking so badly. I sat down, and Shelby said, "I was afraid you were gonna pee in your pants."

"I think I did," I said.

Then it was his turn.

"Here goes the village idiot," he said as he climbed up to his platform. The director, Mark Tinker, was nervous. "He's not going to do the maniacal laugh," said Tinker to Markowitz. "He's going to do it," said Markowitz. What neither knew was that we had been practicing screaming and laughing in the trailer. Shelby laughed like a total lunatic. They cheered for him, too.

You'll be able to see "Running Wilde" in September on NBC.

"That was just the darndest thing," said Shelby on the way home, a little grin on his face. "This better make it to TV, 'cause no one's gonna believe us." ◼

Wardrobe applies clean dirt to movie star Lindamood. Carroll Shelby practices laughing like a loon.

VILE GOSSIP

BY JEAN LINDAMOOD

Indianapolis—I haven't been to the Indy 500 in years. The last time I went, I punched a guy in the nose. He was a big, fat, half-naked, sweaty, greasy, beer-swilling, drunk, gross slob who screamed, "SHOW ME YOUR TITS!!" about an inch from my face. So I punched him in the nose. Then I started crying. I swore I would never return.

But Carroll Shelby promised a ride around the track in a Dodge Viper if I came down for the seventy-fifth anniversary of the race. The air felt like it was oozing fluid, and it was about 90 degrees when I arrived on race-weekend Friday. Carroll was sitting on pit row, disgorging a smiley-faced passenger into the swarm around the last-minute pace car. (The Dodge Stealth was supposed to be the official pace car, but after some corporate sleight of hand, the Viper slid into the lead-car slot, despite the fact that it is not yet a production car.) Take a ticket for better service, it looked like.

Shelby was having a ball. He gave me two laps in the fiery red roadster, launching it neatly into Turn One as he asked, "So what have you been doing, honey?" He ran the Viper up to 140 mph on the back straight. The noise of the all-aluminum, 400-bhp V-10 rumbled sweetly around us as Shelby poked and prodded me about my personal life, told me I had the personality of a "fart on a hot skillet," told me he was getting married "in a coupla weeks," and said he'd probably put more miles on that track (1500!) in May than any of the racing drivers. We caught a little wiggle in the rear between turns Three and Four. We had no helmets.

"I was out on Sixteenth Street the other night with Foyt," said Shelby. "I was going about 35, and this guy in a Chevrolet chops me off. Then he passes another guy, comes back, and chops me off again."

Uh-oh, I thought. Shelby mad in a car is

not a pretty sight. "So I drove into the side of him. I didn't think nothin' of it. But I didn't think I'd tear him up as bad as I did.

"I forgot about my mirror. It wiped out his window and the whole side of the door. He jumped out of the car yelling, 'You're a crazy man! You're a menace!' It was Eddie Cheever! Foyt really gave him a ribbing at the drivers' meeting. He said, 'I guess that'll teach you to screw with an old man.'

"Hell, I told him if I'da known it was him, I'da never done it."

Okay. On to race day. This is the part I really dread. The brain-dead, mud-covered drunks from the Snake Pit. The motorhome with Ontario plates, its neatly lettered Show Us Your Tits sign leering from the back window. Show Us Your Tits T-shirts hanging from vendor stalls lining the path to the main gate. Show Us Your Tits buttons pinned proudly on polo shirts. Show Us Your Tits, Inc. Women, if you're coming to Indy, leave your breasts at home.

Or get an invite from Dodge so you can hang out in its well-chilled hospitality room and eat Kit Kats while you're watching closed-circuit coverage. I enjoy the drama in pit lane before the start, so I moseyed on down to catch the pre-race action. It was a madhouse, with fans, mechanics, the press, celebrities, drivers, car company bigwigs, and sponsors in a jam-packed promenade. A guy rushed up to Jim Nabors and yelled, "Say 'Shazam' for us!" And Gomer Pyle, all sweetness and light in a white linen suit, obliged. Then he blew a kiss to Dan Quayle as the vice president and his wife, Marilyn, clambered aboard a parade car.

The next big moment came when Stormin' Norman showed. The crowd came apart as the general, in civvies, made his way to a

car. Several members of the marching band broke formation to take pictures. I took pictures. The head of Chevrolet motorsports, Herb Fishel, took pictures of Gomer. I saw my pal Albert Arciero, whose dad was fielding Pancho Carter, and took a picture of him. Two guys walking in the pits behind me said, "Who was that guy?" and snapped off a couple of pictures of Albert, too, just in case he was someone famous.

I saw Eddie Cheever and stopped him to ask if Shelby had really rammed him on Sixteenth Street. "God, no," he answered. "Who said that?" And he hurried off.

I watched the start from the grassy strip

inside Turn One, standing as close as the marshals would allow, in order to get the full effect of all that energy in my face. I had forgotten how exhilarating it was, and then Kevin Cogan and Roberto Guerrero came together and nailed the outside wall on lap twenty-five immediately in front of us. They retired—Cogan bent, Guerrero bruised. I retired to the press room.

When the racing settled down, I sat on a folding chair in the alley behind the pit row bleachers and watched those who came to party: A young girl in cutoffs covered in mud, from scraggly head to bare toes. Two glazed frat boys wearing tiny child-size plastic racing helmets from the souvenir shop. Boys with video cameras following girls with good genes. A bagpipe band. A drunk following the bagpipe band, trying to look up one member's kilt. A drunk following the bagpipe band trying to bite the swinging tassel from the last bagpiper's big hat. More drunks. Lots of very fat naked bellies. Lots of Desert Storm camouflage.

When the mud-encrusted denizens of the Snake Pit began to talk to me on my folding chair, I retreated to the Kit Kat room for the final race laps. Journalist Jim McGraw was tuned in to Mario Andretti's pit frequency on a shortwave radio. The race was down to the wire, with Rick Mears leading Michael Andretti. With thirteen laps to go, Mario was having engine problems. Evidently, though, his race wasn't quite over.

"Does Michael need a yellow?" Mario's voice crackled over the airwaves. We stared at McGraw, holding the radio. "I can create a yellow," came Mario again.

All eyes in the room swiveled from McGraw and the radio to the television. Nine laps to go, and Mario was slowing to a stop, blocking pit row. The yellow came out.

It wasn't enough to boost Michael past Penske's golden boy Mears, who took the checkered flag 3.1 seconds ahead of Mario's boy.

I guess I would say that I had a pretty good time this year. I got my Viper ride, I saw a lot of old friends, the race was a good one, and I didn't sock anyone in the nose. Still, I think I'll stay home next year. 🛑

The Indy 500 spectacle included (clockwise from far left) Lindamood and Shelby in Viper, Dan and Marilyn Quayle, Jim "Shazam!" Nabors, and Stormin' Norman.

1923-2012

SHELBY REMEMBERED

Quotes, Jokes, and Anecdotes From Those Who Knew Him Best

On May 30, 2012, Carroll Shelby International and Ford Motor Company hosted the official Carroll Shelby Memorial at the Petersen Automotive Museum in Los Angeles. Master of ceremonies Jay Leno and a veritable who's who of racing and auto industry icons ensured it was an evening full of love, laughter, and amazing stories.

As a final tribute to the legendary man, we captured a few of the evening's best quotes and anecdotes and combined them with comments from the many different worlds Carroll Shelby touched.

Carroll Shelby was young when both motor racing and the automotive industry were young–barely half the age that they are now. Our country was less exhausted then, exhibiting a youthful freedom that provided the right atmosphere for a man of his talents and ambitions. He was a man of contradictions: kind on one hand and very cunning on another; charming and mean; romantic and rough. A friend to many and a foe to some. He loved cars, women, and business. As a salesman, he had no

peers. As a negotiator, he would've given Bernie Ecclestone a run for his money. He had charisma and courage. He was a visionary.

As a driver, Carroll was no slouch. I rated him very highly. I think he could've had a successful Formula 1 career if he'd been able to continue.

Carroll suffered very severe health problems for most of his life. He had a heart transplant, a kidney transplant; he inspired and endured the ups and downs of big-time motor racing with its ecstasies and tragedies; he built a car empire; he had multiple marriages; he flew planes and cooked chili; he traveled the world and hunted in Africa. The mind boggles at this man's energy and spirit.

It's a cliché to say they threw away the mold when they made him. In his case, that is a good thing, because whoever would try to make a new one would get sued by him for copyright infringement.

Dan Gurney, left, former Shelby driver and 24 Hours of Le Mans champion, All American Racing

We have lost a legend in Ford Motor Company's history, and my family and I have lost a dear friend. Carroll Shelby is one of the most recognized names in performance car history, and he's been successful at everything he's done. Whether helping Ford dominate the 1960s racing scene or building some of the most famous Mustangs, his enthusiasm and passion for great automobiles over six decades have truly inspired everyone who worked with him. He was a great innovator whose legend at Ford never will be forgotten. Our thoughts and prayers go out to his family and friends.

Edsel B. Ford II, member, Ford Motor Company Board of Directors

We each joined the service as buck privates and we ended up going through flight training. Carroll was so superior to everyone else that he was way up in front of the class. It was a great thing to think he taught people, officers, as an enlisted man. They in turn became superb bombardiers and navigators. Most people didn't realize this, but he became one of the Living Legends of Aviation because of his accomplishments, not for automobile racing. That's about as high you can get–it's like the Oscars night for the movie industry. Most aviators since the beginning of aviation have said, when we lose a friend–a pilot friend–he has gone west. Carroll, on behalf of all of your friends, we love you and on your journey west, godsend and Godspeed.

Bob Hoover, highly decorated military and civilian aviator and test pilot

154

I'd like to tell ya a little bit about his sense of humor, and I've seen a lot of that. It's a lot easier when you're not being sued.

Invariably, if I had a trip involving production of video material for the advertising agency, I would always call him and he'd pick me up. Consequently, a lot of times he'd call from Dallas and I'd pick him up. He called me one day and he said would I pick him up. I had my boss with me and we pick him up at the front of DFW. He gets in the car and we had no more than moved like 40 feet, and Shelby lets one fly. It not only was noisy; it was pretty bad. I hit the brakes and I said "Dammit, Shel!" And he looked at me and he said "What's a-matter, Neale, that won't spring the doors on a Cadillac, will it?" I gotta tell you, he was different in a lotta ways. Not everybody got to see that sense of humor. A lot of you did, and I hope you'll remember it. Our world is gonna miss Carroll Shelby.

Bill Neale, automotive artist, longtime friend, and associate

Above all else, Carroll Shelby was a hot rodder. We've had a relationship with him here at the publishing company for a long time. So long, in fact, that in Carroll's own words, the magazines were responsible for the success of the Cobra.

David Freiburger, editor-in-chief, *Hot Rod*

I can't remember a time in my life when I wasn't thinking about a Shelby creation. When I finally met him at the 1998 Goodwood Revival, I was speechless! Carroll was approachable and charming–everything I had imagined and more. When I came to Ford, Carroll and I would talk often about the next big project. He always wanted to go one better than the Corvette, that's why the new GT500 had to be at least 650 hp! I once asked him what his favorite project was. He gave me his sly, trademark smile and said, "The last one!" Carroll Shelby truly was a real-life hero, inspiring generations of us. Our industry has lost a giant, and it won't be the same without him.

Jim Farley, group vice president of Global Marketing, Sales and Service, Ford Motor Company

I have a lot of respect for him, for the way he's persevered with the health problems. He stepped on a lot of people's toes. There are people who hate his guts and others who think he's God. But, by and large, he is pretty well-respected. I've always had a good relationship with him, and he has a lot of respect for me, I believe, so I kind of go along with what he's thinking.

Phil Remington, master fabricator and former director of Research and Development, Shelby American

He was a very fine man. He was honest, he had integrity, he worked very hard, and he was driven. Despite his heart and other health issues, he had the will and the fire to do things others couldn't. He made his mark; he left his footprint. He will be missed.

Andy Granatelli, former racer, team owner, and CEO of STP

Someone asked me, "Hey, Jay, how come you don't have any Ferraris?" and I said, "'Cause Carroll Shelby told me 'he was a mean son of a bitch.'" Now, I never saw Enzo Ferrari smile; I never saw Carroll when he wasn't smiling.

There's a lot of reflected glory. You know, I meet kids, 12, 13 years old, that like cars and they go, "You met him?" And I go, "That's right," and then I'm pretty important. I get to steal a little bit of that.

Jay Leno, television personality and car collector

He was driving an Austin-Healy 3000, I believe it was, in the Panamericana Mexico race, and this is how Shelby ended up: The car crashed, went down an embankment, came back up again on the other side of the road. He had a broken arm and broken ribs, and the Mexicans were very happy to help him out, feeding him whiskey to kill the pain because there was no medical help.

[Later] We started shooting photos of him in my studio, and we made, like, 500 prints of each and he would take those to the Shelby events and whatever, where he gave autographs to people for whatever they donated to the heart fund.

Bob D'Olivo, former photography director, Petersen Publishing Company

I was sitting in my office, and in walked this guy in coveralls with a crazy idea. He had the rights to the AC Ace body and chassis, and wanted to stick a Ford V-8 in it and go racing. I saw the potential of that and put him in touch with the right people in Engineering.

Hal Sperlich, former product planning manager at Ford Motor Company and former president and CEO of Chrysler, on first meeting Shelby

Carroll Shelby was a giant among us, one whose contributions to automotive performance–both on the track and on the street with American icons like Mustang and Cobra–will live forever. I can't walk past a Cobra without wanting to put my hands on it and drive it. Everything he did, he did to the utmost. He took speed and turned it into grace.

Mark Reuss, president, General Motors North America

He gave me my big break racing in Europe, in the Cobras. We went there to beat Ferrari in the World Manufacturer's Championship. The neat thing about driving for Shelby, he was a race driver and a good one, so he didn't tell you what to do–you just do it, he said. The right people together, the right time. I always wanted to race against the world's best, and they were in Europe at the time, and we got to do that. We almost won the championship the first year, so Shelby sent me back the second year, in '65. I won seven of the 10 races, and we won the race at Reims, France, on the Fourth of July–it gave us the championship. That was fantastic. Well, I would have to say that I was at the right place at the right time with the right talent, and with Carroll Shelby, I was with the right man.

Bob Bondurant, former Shelby driver and 24 Hours of Le Mans winner

Carroll was not only a great friend to Ford, but he was a great friend to all of us. I can recall several times just listening in awe to Carroll talk about his highs and lows and how his path crossed so many other great drivers and industry leaders again and again. He was a legendary race car driver and a legendary storyteller, and the industry and Ford are better off for knowing him for so many years.

Mark Fields, left, president of the Americas, Ford Motor Company

He was one of the best people in motorsport. He was a mentor, a beloved friend, and like a father to me. He was a business partner with George Hurst, so we worked with him on a lot of projects. He helped me through a lot of things both business and personal, and he appreciated my gray matter.

Linda Vaughn, former Ms. Hurst Golden Shifter and auto industry icon

Sad to hear legendary Carroll Shelby passed away. His automotive contributions made him a real icon.

Mario Andretti, former F1 World champion, via Twitter

We have a little space at the Bel Air Country Club we call "The Smart Table," and it says: "If you don't have anything nice to say about anyone, pull up a chair." So we pulled up two chairs. We became fast friends. You spend a lifetime looking for your best friend. I found him there.

Walter Miller, television producer

I was a Firestone race tire distributor and he was a Goodyear race tire distributor, so even though we were good friends, we were always on different sides of the fence and I didn't get a chance to race more for him. I ran a couple of races [for him], won the Times Grand Prix, and we had a couple of Mustang races in the SCCA, but I had lunch with him often. I enjoyed his company and I respected where he come from and the fact he was a race driver and became a business man. I was kinda in that same boat—not as good a salesman maybe as he is—but we're really gonna miss a great friend. I'm gonna miss calling him. He called me Ruf, my first name being Rufus, and he used to call me: "Hey, Ruf." You know, it was nice to hear that from him. Now that he's gone, I appreciate him more.

Parnelli Jones, above right, former Indianapolis 500 champion

We did a lot of concepts with him. One was the Cobra Roadster Concept. It was a full-blown prototype with an aluminum spaceframe. We worked all night to get it ready. We shipped it from Dick Hutting's [Ford Design] Valencia studio to Irwindale Speedway [in California].

Carroll said, "I'd like to take it for a ride." Dick Hutting got in the passenger seat and Carroll did the first few laps at a relaxed pace. Suddenly, he just gunned the thing. He did five laps at 130 mph. He absolutely scared the hell out of Hutting.

[On another drive] the Learning Channel followed Carroll driving the car, with a helicopter. He did about three minutes of donuts. Bloody hell, that's Carroll Shelby.

J Mays, Ford Motor Company group vice president, Design, and chief creative officer

Beyond his amazing and legendary racing exploits, Carroll was an enthusiast, a champion for performance, and was always looking for ways to get things done through his friends and connections within a large organization. He enjoyed and even relished his role as an outsider with some clout to get things done. My spouse will always remember those evening calls when she would answer the phone and hear "Hello, darlin'," before he

would ask if I was there.

Carroll will be remembered for his many accomplishments, and those of us fortunate to have crossed paths and enjoyed his friendship will savor the memories as long as we live. May he rest in peace.

Tom Gale, former head of Chrysler Design

On Shelby's 80th birthday, we were asked to write letters and stuff. Somebody was having a party for him, I think at Barrett-Jackson or something, and I wrote: "Carroll, you're just like your cars—there's no stopping you." And there wasn't, for a long time. He has touched a lot of people, and it's great to have been part of his life for a short time. I broke his shoulder in Nassau playing touch football. He forgave me by saying, "Well, you're big enough to go bear hunting with a switch." He was full of a lot of great remarks, some of which really can't be repeated, or at least won't, because I can't print out his asterisks."

Denise McCluggage, pioneering female automotive journalist and former racer

Met Carroll at Pebble Beach years ago, we chatted like best friends. Incredible grace. He will be missed as we thank him for paving the way.

Ralph Gilles, president and CEO of the SRT Brand and senior vice president, Design, at Chrysler Group LLC, via Twitter

We've lost a friend and an American original, who, quoting his first wife, Jeanne, could sell anybody "white blackbirds," a man you could count on when needed, who had the marketing skills of P.T. Barnum with just a touch of Billie Sol Estes thrown into the mix. Years ago, while visiting him in his office in Gardena, I spotted a sign over his desk. It read, "Will those who say it can't be done please get out of the way of those of us who are doing it." Classic Shelby.

Bill Warner, founder and chairman, Amelia Island Concours d'Elegance

Carroll Shelby was a giant in the motorsport industry and the automobile industry overall. Known primarily as an innovative automotive designer, he started building his legacy as an outstanding driver. Along the way, his name became iconic. On a personal level he was simply a good friend to so many of us.

Mike Helton, president, NASCAR

We are all deeply saddened and feel a tremendous sense of loss for Carroll's family, ourselves, and the entire automotive industry. There has been no one like Carroll Shelby and never will be. However, we promised Carroll we would carry on, and he put the team, the products, and the vision in place to do just that.

Joe Conway, president, Carroll Shelby International

My personal experience with him was on the GT program, and I think that'll be the lasting impact for Carroll. I mean obviously it's a tremendous legacy, but for us at that SVT team, he mentored so many guys. Hau Thai-Tang, for example, our VP of engineering, worked closely with him—the whole Mustang team worked so closely with him—it's a tremendous loss to us. Certainly one of the

things that we have in our mind is continuing his legacy, to make sure he'll always be proud of those types of products that have his name on them.

Raj Nair, group vice president, Global Product Development, Ford Motor Company

If Carroll really liked you, he called you "Dad." Maybe that was a Texas thing, or just a Shelby thing–I never knew for sure. But it was a badge of honor to have him call you that. Every couple of weeks, Carroll would check in with me at *Motor Trend*. The calls would always start out the same way: "Tune, it's Shelby. How ya doin', Dad?" And when he hung up it was almost always with a "Love you, Dad." Love you too, Carroll.

C. Van Tune, former editor-in chief, *Motor Trend*, and former PR spokesperson for Shelby

Everything he did, he wanted to do a little bit better than he did last time, including the charity. I think his deal was, "Let's see what we can do. Let's just see what we can do. Let's see what this thing'll do." You know like, you get in a car, "Let's see what this'll do." You have a problem, "Let's open it up, let's see what it'll do. We'll make it better. We'll tweak it, we'll improve it, we'll change it and then it'll get better and we'll save some lives. That's what we'll do." That's how Carroll was. He went about everything like that in life. "Let's improve this, let's change that. Modify this. No, this isn't right. Let's improve that. We'll go faster. Let's see what it'll do." That's Carroll Shelby. That's how I'm always going to remember him.

Mark Krocker, board member, Carroll Shelby Children's Foundation

I grew up admiring Carroll Shelby. Of course, he was synonymous with vehicle performance. But more impressive to me was that Carroll had a knack for going his own way, and making it work. He was a giant in this industry, and his presence will be sorely missed.

Tadge Juechter, vehicle line executive and chief engineer, Chevrolet Corvette

Carroll formed a foundation to give something back to those who have not been as fortunate as him, in both medicine and education. The foundation is well-endowed to continue Carroll's vision.

M. Neil Cummings, Carroll Shelby Foundation board member

Carroll was a friend and a mentor to me. He taught me that when it comes to performance cars, the more outrageous, the better. We took that to heart on the 2013 GT500.

Jamal Hameedi, Ford Motor Company, SVT chief nameplate engineer

Carroll admittedly was not a designer, fabricator, or anything of the like. His strength was as a leader and super salesman–maybe even super isn't enough. He could just flat sell! Whether you liked Shelby or not, you always knew where you stood with him. Because of that, even if you didn't like him, you had to like him for that!

Edward R. Justice, Jr., president and CEO, Justice Brothers, Inc.

He was larger than life, responsible for some of the most legendary cars, including the Cobra, the GT40, the Shelby Mustang, and the Viper. His cars command some of the highest prices on our auction block, and for good reason: When you buy a Shelby, you know you're going to own a piece of automotive history. His passing is a true loss for all of us at Barrett-Jackson and within the industry as a whole. He was an icon I was proud to call a friend.

Craig Jackson, chairman and CEO, Barrett-Jackson

In the history of our company, there are a handful of men who have stamped their imprint on the heart and soul of what we do at Ford racing, and Carroll Shelby is definitely one of them.

James Allison, director, Ford North American Motorsports

Carroll Shelby was a dear friend of our family. Galpin Ford was one of the first Shelby dealers in the country, and it was through this initial business relationship that we forged a family friendship lasting nearly 50 years. He meant so much to me as mentor and friend; I really loved the man. There was no one else like him. It was an honor to know him. My father [Bert Boeckmann] was with me when we got the news, and we are both very saddened. Dad calls him a free spirit who was wonderful to work with and a lot of fun. We will all miss him tremendously.

Beau Boeckmann, vice president, Galpin Ford

Shelby was my car dream. When I was a young teen, Shelby was taking on the world's OEMs and winning. I saw that and it inspired me to go into the industry and build cars like Shelby would do. Shelby opened my eyes.

Kazutoshi Mizuno, chief engineer, Nissan GT-R

He was an incredible innovator, entrepreneur, marketing guy, and salesman who produced one fantastic product that will be cherished for generations to come.

Buddy Pepp, executive director, Petersen Automotive Museum

People asked me why Carroll Shelby needed a PR person when he was the ultimate publicity machine. Carroll needed someone to respond to the flood of press people any time he used that silver tongue.

Scott Black, PR spokesperson for Shelby

My first meeting with Carroll, when I walked in, and he said to me, "Little girl"–he loved my song "To Know Him Is to Love Him," I was the lead singer of the Teddy Bears–and he said, "If you write a song about my car, and it goes to number one and it's a hit, I'll take ya to Le Mans and you'll have a Cobra." The rest is history. I had three Cobras and I went to Le Mans.

Carol Conners, songwriter of "My Little Cobra"

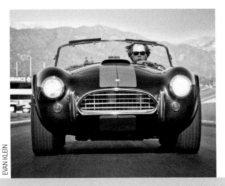

EVAN KLEIN

CARROLL SHELBY
1923-2012